# TRIBAL AND THE CULTURAL LEGACY OF STREETWEAR

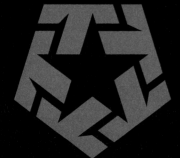

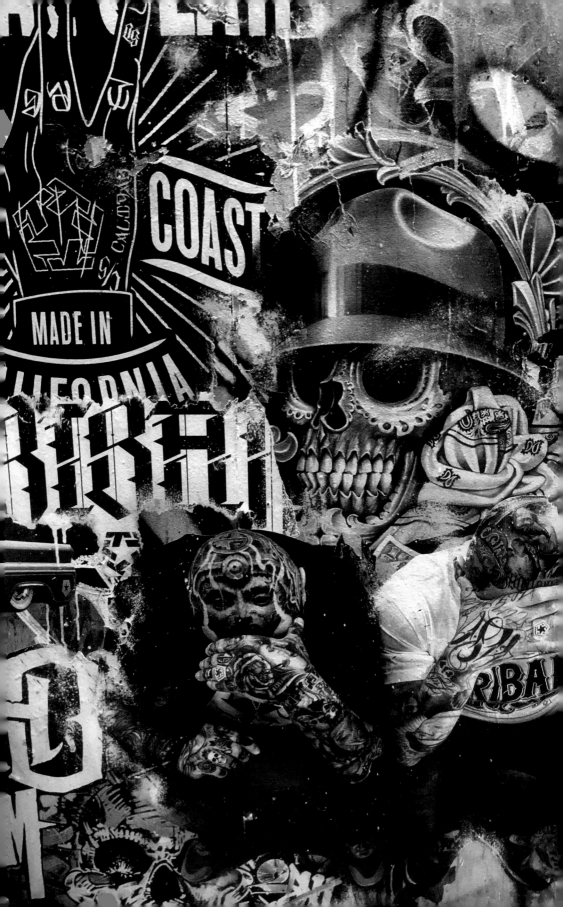

# TRIBAL AND THE CULTURAL LEGACY OF STREETWEAR

EDITED BY
G. JAMES DAICHENDT

First published in the UK in 2024 by
Intellect, The Mill, Parnall Road, Fishponds, Bristol, BS16 3JG, UK

First published in the USA in 2024 by
Intellect, The University of Chicago Press, 1427 E. 60th Street,
Chicago, IL 60637, USA

Copy editor: MPS Limited
Cover designers: Tanya Montefusco and Herman Plasencia
Cover image: Herman Plasencia
Frontispiece image: Herman Plasencia
Layout designer: Holly Rose
Production manager: Sophia Munyengeterwa
Typsetter: Holly Rose

Paperback ISBN 978-1-78938-808-4
ePDF ISBN 978-1-78938-809-1
ePUB ISBN 978-1-78938-810-7

Printed and bound by Gomer

To find out about all our publications, please visit our website.
There you can subscribe to our e-newsletter, browse or download our current catalogue and buy any titles
that are in print.

www.intellectbooks.com

This is a peer-reviewed publication.

Figure Credits
Page 5: J. Insoe
Page 6: Origi
Page 7: Shepard Fairey
Page 9: Gane, Zodak
Page 10: Buster Duque
Page 12 (top): Herman Plasencia
Page 12 (bottom): Photograph of G. James Daichendt and Bobby Tribal at Street Legacy exhibition

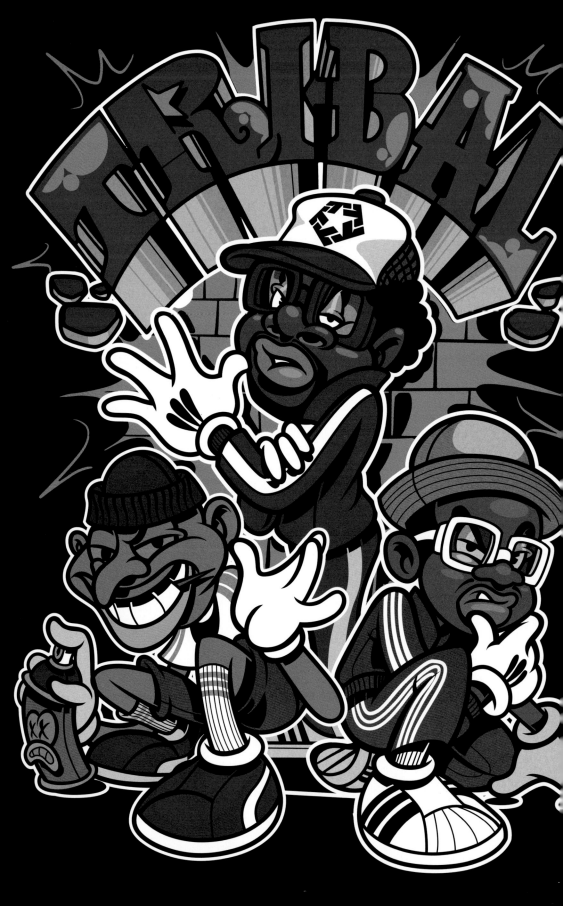

# CONTENTS

# ACKNOWLEDGMENTS

## G. JAMES DAICHENDT

I am incredibly grateful to Bobby Ruiz for opening up his life and business to be part of this project. Bobby was gracious with his time and was available to every one of the contributors when they needed to talk with him or someone connected to Tribal. The pressures of running a business during a pandemic are intense and it's credit to his personality for always being supportive and understanding, even amidst difficulties.

Each of the contributors, which includes Clayton Funk, Jefffrey Ross, Marvin Milian, Evan Senn, Rachel Daichendt, Chumahan Bowen, Monique Charles, Ben Cater, James Wicks, Luis Saldaña, John Ulloa, Denise Sandoval, and Michael "Tank" Gonzales, brought their unique viewpoint and expertise inside and outside of academia to the project. To truly be a resource for street culture and streetwear, this diversity of thought and expertise was desperately needed. Isaac Ruiz and Herman Plasencia at Tribal were also very helpful and contributed toward the final realization of this project. I am also thankful to each of my children Samantha, Trey, and Logan for being supportive of dad's projects and understanding the time and resources needed to complete them.

## BOBBY RUIZ

I could not have achieved any of this without the ever-present support, love, and patience from my wife Sabrina and our children Seychelle, Isaac, and Robert. Huge thanks to my parents Joe and Alicia for their love, inspiration, discipline, and guidance. My Brother Joey from day one. My sister Veronica, the Springfields and all our Ruiz, Alva, and Mendoza family from Laredo Texas.

Special thanks to Carl Arellano, Herman Plasencia, Wilfred Siy, Satoshi Furuya, Jim Daichendt, James "Brisk" Germani, Zodak, Mike Giant, OG Abel, Estevan

Oriol, Risk, David De Baca, Dyse One, Huit, Cartoon, P.O.D., Soul Assassins, Fred Durst, Dave Lively, Bill Mc Mullin, Ratty, Brown, The Lower Left, Johnny Ballon, Owen Bagstad, Mario Quintero, Arturo Gonzalez, Slappys, Big Tiny, Bobby Romero, Sami Antar, Franco Vescovi, Jack Gonzalez, Nigga Tone, Tank Gonzalez, DJ Artistic, Stevo Spahr, The Chucks, Carlos Macias, Steve Soto, Bryan Bell RIP, Greg Marquez RIP, Hurley, Palm City, Mira Mesa, San Diego, all the brand contributors and the whole T-Star Ring Rock'n Tribal Clique. C/S

# PREFACE

## G. JAMES DAICHENDT

I am pleased to present a series of chapters, essays, and personal reflections that explore the various dimensions of Tribal Streetwear, a company established in San Diego that seeks to represent a variety of subcultures including graffiti, street art, tattoos, lowriders, music, skateboarding, surfing, and breaking to the rest of the world. In addition, Tribal has strong Chicano roots in its aesthetic and since its inception in 1989, the impact of its designs continues to balance the precarious act of being relevant and responsible with its resources.

The edited volume uses Tribal as a lens for examining the history of streetwear and the subcultural aspects that make it such an exciting development in cultural studies, art history, and sociology. This text also accompanies a significant exhibition at the California Center for the Arts in Escondido that will explore these subcultures visually.

In the summer of 2019, thousands of fans flooded the Broadway Pier in San Diego to celebrate 30 years of Tribal Streetwear. Rows of lowriders and custom cars with candy-coated finishes wowed visitors as they mingled among the vendors, food, music, drinks, and skateboarders. Inside, a carefully curated art exhibit featured artists who have collaborated with the brand on clothing designs over the past three decades. Titled "The Legacy Show," the experience exemplified these creative subcultures and the corresponding visual language that has made the San Diego-based company more of a lifestyle than a brand. From the sounds of skateboard decks banging on the concrete to the buzz of a tattoo gun or the hiss of an aerosol can these disparate disciplines all find a home in a clothing line that symbolizes and represents their collective interests and identities.

I hope each of these chapters collectively furthers our understanding of how and why Tribal is able to be more than a clothing company to hundreds of thousands of people around the world. While streetwear fits within the larger discipline of street culture, an emerging academic field interested in understanding urban environments and the disparate subfields that involve practices, styles, and values, studying Tribal in-depth allows us the opportunity to move beyond generalities and consider the real thing as it continues to evolve year to year.

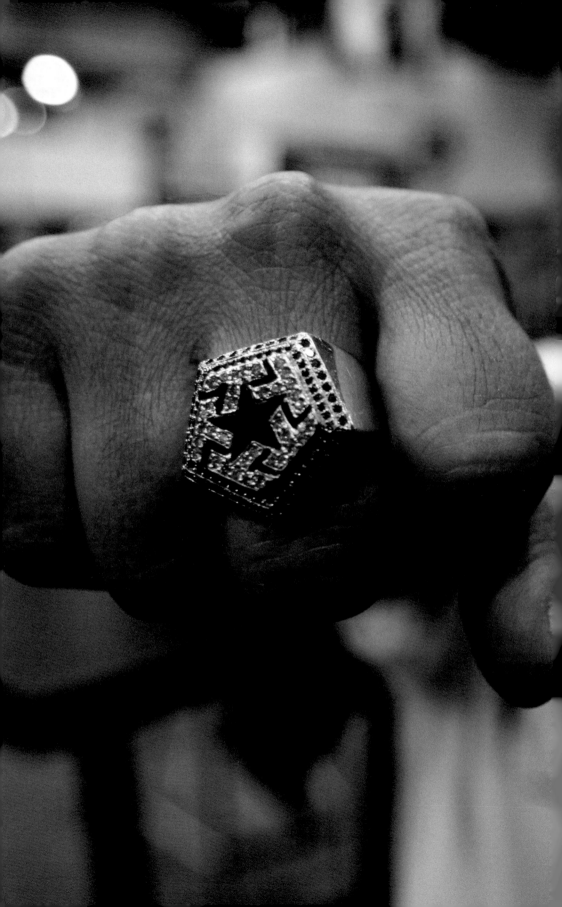

# SECTION 1

## INTRODUCTION TO TRIBAL STREETWEAR

# G. JAMES DAICHENDT

G. James Daichendt is an art critic, curator, and art histori-
an that writes for audiences inside and outside higher ed-
ucation. He is the author of seven books, including *Robbie
Conal: Streetwise: 35 Years of Politically Charged Guerrilla
Art* (Schiffer Publishing, 2020), *The Urban Canvas: Street
Art Around the World* (Weldon Owen, 2017), *Kenny Scharf:
In Absence of Myth* (Cameron Books, 2016), *Shepard
Fairey Inc.: Artist/Professional/Vandal* (Cameron Books,
2016), *Stay Up! Los Angeles Street Art* (Cameron Books,
2012), *Artist Scholar: Reflections on Writing and Research*
(Intellect Books, 2011), and *Artist-Teacher: A Philoso-
phy for Creating and Teaching* (Intellect Books, 2010).
Daichendt is the recipient of a 2021 Lifetime Achieve-
ment award from the Office of the President of the United
States for his service to the arts community. He has
also authored over 100 peer-reviewed articles, book
chapters, and art reviews. Daichendt currently
serves as vice-provost for academic
studies and dean of the colleges,
which includes the College of
Arts & Humanities and the College
of Natural and Social Sciences at
Point Loma Nazarene University in
San Diego. He is the founding and
chief editor of the academic journal
*Visual Inquiry: Learning and Teaching Art
and, in addition*, holds two master's de-
grees and a doctorate from Harvard
University, Boston University, and
Columbia University.

# THE LEGACY OF TRIBAL STREETWEAR

G. JAMES DAICHENDT

## INTRODUCTION

Streetwear is a core aspect of street culture and is arguably the most widely seen characteristic and expression of this concept. Backing up further, the concept of street culture is a broad term used to capture a variety of subfields connected to urban environments that involve dispositions, practices, and styles (Ross et al., 2019). Tribal Streetwear, based in San Diego, has embraced many of these subcultures that would be considered part of street culture and their location in San Diego has helped create a unique mixture of expressions that are represented in their products. The articles of clothing produced by Tribal, including shirts, pants, jackets, hats, and a variety of fashion accessories, have become symbolic of these subcultures and are distinctly rooted in their community, and have progressed from reflecting a culture to being a hub for culture making and artistic production. Over the course of 30-plus years, Tribal designs and their collective influence have spread well beyond southern California to communities around the world. For example, it's not unusual to see Tribal retail stores in Asia, an international breaking competition produced by Tribal, or a martial arts event in Europe surrounded by Tribal banners. The distinct cultural components that were once only part of southern California street culture are now global in the twenty-first century as subcultures travel faster and farther than at any other time in history.

While Tribal is a brand, it is also representative of a variety of lifestyles and activities that include aspects of the previously mentioned subcultures, which include graffiti, street art, tattoos, lowriders, music, skateboarding/surfing, and breaking. Much like the Tribal T-Star logo

that is made up of several small "T" letters that form a star in the negative space, the subcultures that inform and reflect Tribal's ethos and philosophy come from many different corners of southern California, yet they find a home in Tribal's aesthetic, the people associated with the company, and the shared experiences of street culture. While one can name each of these subcultures, too often they blend together and create a street cocktail of mutual admiration and creative expression.

Through the following pages, I present a general introduction to Tribal that contextualizes the brand within the history of streetwear. In addition, southern California as a location and inspiration for each of the street cultures mentioned plays a major role in the Tribal's connection to the street and its reach globally. By examining the development of streetwear through the lens of Tribal, the following essay also provides a distinctive history and a better understanding of the development of streetwear as a concept. While Tribal is no longer a small niche brand, it has remained closely connected to the streets. The tensions associated with good business practices and/or entrepreneurship while maintaining a close connection to the roots that inspired Tribal are an important component of its ongoing story. As streetwear companies become larger or extend beyond their base audience, it could be argued that their connection to the street (or street culture) is lost, an aspect that Tribal has strove to maintain throughout its development from a T-shirt company to a major brand.

# STREETWISE

The loyalty that individuals have for Tribal goes much further than simply wearing an item of clothing while participating in a form of street culture. It's not unusual to see Tribal designs tattooed on skin, graphics applied to custom cars, or custom jewelry featuring the logo. There is a multitude of visual evidence and creative ways that folks have used to demonstrate their allegiance to Tribal and what the brand represents to the individual subcultures. So many of the creatives associated with the brand have also created paintings, drawings, prints, and sculptures that include the "T" star logo as a sign of respect for the brand. These examples number in the thousands as one can see a few hundred just by walking through an art show sponsored by Tribal or a community event held at their brick-and-mortar location. The T-Star is sometimes intertwined with imagery or a larger story, and in some cases, the logo actually becomes the subject matter

# TRIBAL

CHUEY QUINTANAR

👑 THE WORLDWIDE CLIQUE 👑

CELEBRATING  YEAR

itself. In this way, the T-Star logo has become a symbol of affiliation to a club, or culture, or in some cases, it's illustrative of a person's identity.

The representation of the subcultures listed and their connection to Tribal goes beyond the visual representation of physical things and includes active culture-making as well. Each of these subcultures (or perhaps Tribes might be another way to think about them) lives within Tribal headquarters in their downtown San Diego offices. The Lower Left is Tribal's San Diego-based retail store and within the overall complex, one can find a skate shop called Slappy's Garage, a plethora of tattoo shops, a tattoo supplier, several artists' studios that range from music to visual, and a garage that always has a few lowriders parked inside. Frame the entire structure in graffiti, street art, fine art by hundreds of artists, occasional food trucks parked outside, and music blaring from all corners of the structure and you get the essence of how these subcultures cross-over into the brand and represent a lifestyle. More than just a retail location, it's a destination that facilitates events, shows, and experiences every few weeks that attracts visitors from around the world.

As I have demonstrated, Tribal clearly takes inspiration from the street but the street also supports Tribal. This circular formula appears to make the streetwear company more relevant and important to each of the subcultures mentioned. While the design and fashion of Tribal products change over time, there is a

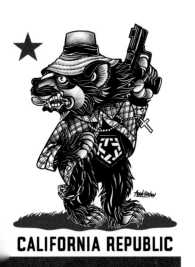

**CALIFORNIA REPUBLIC**

general belief that the product is not intended for the masses. On more than one occasion, I've heard from street artists, lowrider builders, or streetwear aficionados that Tribal has managed "to keep it real" for all these years by staying true to their inspiration and by not adopting a pattern nor selling through big retail outlets. There are a number of streetwear brands that have become luxury conglomerates and big companies like Nike and Adidas have joined the ranks as streetwear designers. By fusing fashion with activewear, companies like Nike have made a huge impact on streetwear but they are often criticized as having more in common with McDonald's than Chanel (Tungate, 2012).

Yet it's the growth of small skate companies like Supreme who have become billion-dollar companies that are somewhat concerning to fans of brands like Tribal. What was supposed to represent something unique and particular like Supreme has become generalized and overly commodified through its growth and move into luxury goods.

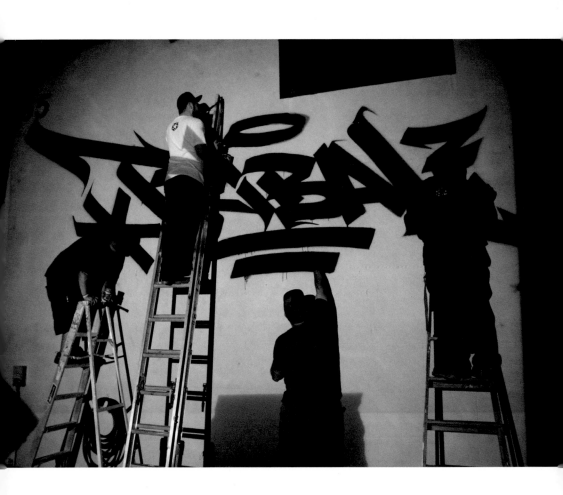

In a similar fashion, big businesses like Nike have capitalized on the streetwear aesthetic with their own lines of clothing and products. This transition into another market by these big companies points to the relevance of streetwear worldwide. While neither example is framed in a negative or positive manner, Tribal exists somewhere in between these extremes. They have taken cues from the street and grown into a worldwide brand, yet somehow still retained a local San Diego flavor that makes them distinctive and personal. Bobby Hundreds (2019) writes about this struggle when he debated whether to sign a licensing agreement with American Eagle Outfitters and how that partnership would change his streetwear company The Hundreds. It's a balancing act that results in fans of the brand acknowledging their realness and genuine interest in street culture. In fact, it's more than being a fan, one feels like they are part of a community. A feeling that a big brand cannot replicate at the grassroots levels and something luxury brands leave behind when they move into the high fashion world.

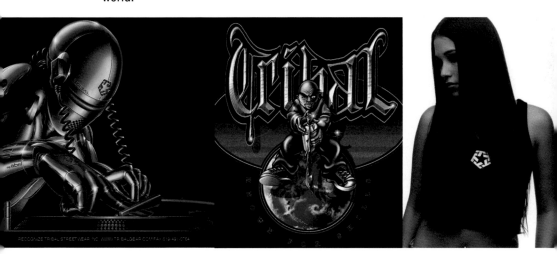

## TRIBAL BEGINNINGS

In the spirit of punk rock and alternative fashion, streetwear has a history in the do-it-yourself (DIY) movement and mantra. Mainstream companies didn't make clothing that was adequate for alternative subcultures like the punk, hip-hop, and skateboarding communities. Instead, these groups often created (or adapted) their own clothes that had an attitude, aesthetic, and/or feel that represented their interests and identities. The aesthetic was something that could not be faked because you had to be part of the culture to understand it. In a similar vein, DIY fashion in the 1960s was considered an alternative to consumer-created culture and it involved thrifting or repurposing older clothing products. We see similar movements in the art world during this time period

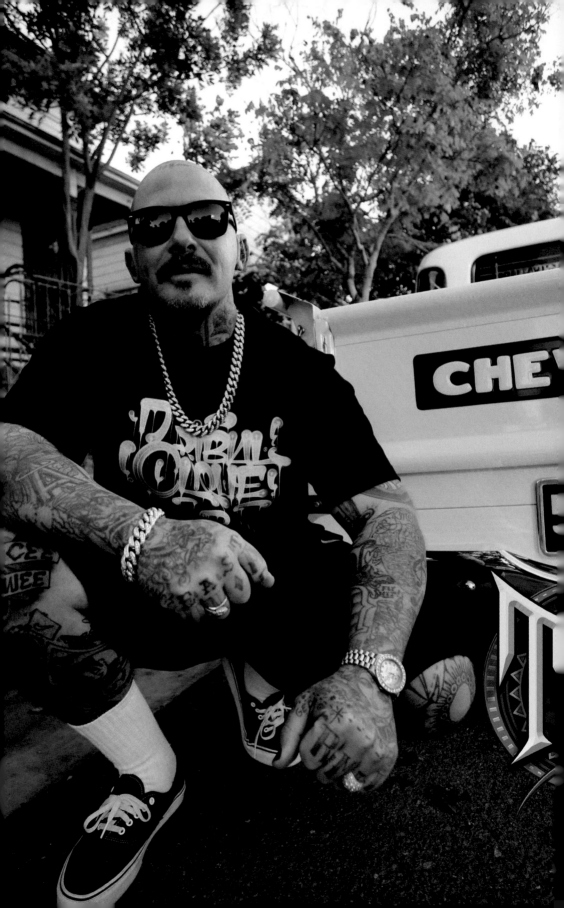

when performance art, earth art, and other postmodern art practices left the art studio or traditional gallery to make art outside the traditional marketplace. This rejection of commonly held practices suggests that there is not one way to make art and that the major markets are missing what is happening in these smaller communities, especially the street.

Streetwear is connected to this DIY history but deserves its own branch as it materialized as something distinct in the 1980s and 1990s. Often associated with countercultural activities like graffiti, street art, hip-hop, skateboarding, and surfing. All these subcultures maintained a casual style that typically consisted of sneakers, T-shirts, and ball caps. These items sometimes were silk screened in places like skate shops and bypassed much of the ordinary retail channels and were available in limited quantities from a local retailer. Many artists like Keith Haring and Kenny Scharf in the 1980s and later Shepard Fairey in the 1990s made small runs of T-shirts and other items and sold them through local venues while pushing their art careers forward.

In November of 1989, Tribal Streetwear was founded by brothers Bobby and Joey Ruiz. Bobby, the younger of the two, was curating a graffiti art benefit show and was looking for supporters in and around San Diego. This is how Bobby met Carl Arellano, who offered to sponsor the exhibit. Arellano owned a silk screening business and this partnership allowed them to print their designs on simple white T-shirts. Joey's designs were inspired by his tattoo design and Bobby was drawn to his history as a graffiti artist. However, most of the company's initial imagery was infused with Mayan and Aztec lines and shapes—a characteristic that was instrumental to the name Tribal and an aesthetic that has become synonymous with San Diego and its diverse community.

California and New York were two of the major epicenters for streetwear in the 1980s and 1990s. Largely because the subcultures associated with streetwear thrived in these major metropolitan centers. Bobby and Joey's connection to the tattoo culture of San Diego was one of the aspects that made their design unique from other streetwear companies developed at this time. Add to it, their unique Chicano aesthetic, and a new brand was born that represented southern California and a variety of street culture touchpoints that were dear to both Ruiz brothers. Far more than a trend in fashion, streetwear histories are less about a development in fashion and more of a pivot back to the community and making clothes that reflect what is important to them. In this case, the artists, athletes, and creatives sought out the Tribal designs because they represented what was important to them.

Reflecting on these early influences, Bobby Ruiz (2019) says:

> My brother and I grew up in south San Diego and later Mira Mesa, so we
> brought the lowrider and Chicano-style graffiti culture to the skate and
> surf communities. All these things combined to establish an open-mind-
> ed aesthetic that continues to this day.

This mindset is what allowed the brothers to start something new that reflected
what they cared about and something that was missing from other clothing
styles. In a similar vein, street art developed because traditional artists took
notice of trends in the graffiti world and were able to capture some of these
elements and combine them with aspects from the fine art world that resulted in
a new category or type of art making (Daichendt, 2012).

The designs continued to evolve as the brothers sold more shirts in the commu-
nity and their name became a bit more well-known and respected. Eventually,
Bobby started to invite other artists to contribute designs to the brand. Whether
these collaborators came from a hip-hop, graffiti, or tattoo background, these
artists brought their aesthetic and then became part of the unfolding story of
the brand, extending the influence and a stronger association with the sub-
cultures related to the particular artist. Going forward, partnering with artists
and creatives for clothing designs, car shows, and art exhibits has been a large
part of the way culture has been created at Tribal. Some collaborations result
in a new product while others may just be an opportunity to create something
special like a concert or experience. This may be a lowrider show over the week-
end, a location for a print drop for local artists, or a one-day art show to feature
friends of the brand. In more recent days, social media collaborations are more
common as Tribal will often share their followers with another brand or person
closely connected to a street culture to cross pollinate their shared interests.
This has resulted in community events where there will be giveaways, food,
and/or music to celebrate events or just to help the community. In every case,
hundreds of visitors and participants will be wearing Tribal gear even if it's not
an opportunity for purchasing merchandise.

As the network of artists widened from these humble beginnings, the language
and audience of Tribal also grew in reputation. These collaborations with
artists have remained a central part of the design process for the company as it
reflects the aesthetics and issues of importance within the street culture. There
is a soulful connection to the various subcultures as they are directly connected
with the brand because of friendships and a history of shared experiences over
the past three decades. The imagery may seem somewhat darker and edgier

to the newcomer compared to large commercial brands, yet it's just light and accessible enough to be understood by outsiders. This is a balance that enables Tribal to be deep-seated within the street culture with a variety of insider symbols and references yet digestible enough to be worn by every member of the family.

# STREETWEAR IN THE 1990S AND 2000S

The term "streetwear" eventually caught stride in the 1990s and was generally understood to be in alignment with the various subcultures referenced earlier. The clothing style also evolved to include several variations that were reflective of the country or city it was from, but the base of T-shirts, hats, and sneakers remained the same. While there are a variety of price points for streetwear, the connection to the street is central to its success. Street artist and founder of Obey Giant, Shepard Fairey describes streetwear as

> much more populist than fashion, it has a very strong do-it-yourself mentality and is very avant-garde, in the sense that it doesn't follow the obvious design cycles of fashion […] I also think that that streetwear has a certain level of pride attached to it, unlike fashion, since it is made for individuals, and people with the same ideals as you.
>
> (Vogel, 2007, p. 192)

In this way, streetwear is practical and is meant to be worn and seen. It's less about a high-end concept and represents the here and now.

It was during the 1990s that Tribal took part in several trade shows that facilitated their exposure to the expanding market. The Action Sports Retailer Convention (ASR) was a surf and skate trade show that was based in San Diego for twenty years (in California from 1981 to 2010). ASR held its trade show at the San Diego Convention Center twice a year and it attracted visitors and retailers that sought the latest trends and fashion. This big show however did not fit the emerging street culture-inspired brands like Tribal and an alternative location appeared to be the best fit for this new genre of clothing.

Bobby Ruiz (2019) reflects on these early experiences: "I believe that streetwear was born in San Diego," he says. "A small clothing show called 432F was held for several years in San Diego in the 1990s that featured streetwear and alternative clothing brands because they didn't fit with the established surf and skate brands." 432F was considered the stepchild of the big ASR trade show that was held at the same time. The smaller 432F clothing show seemed to be just right

for Tribal and its edgy designs. It was during this time that other upcoming and eventual popular streetwear brands like Marc Eckō, Conart, OBEY, and Third Rail all started to get attention.

According to Marc Eckō (2015), "ASR was generally referred to as the commercial trade show while the 432 Streetwear Show, which was run simultaneously was definitely the lesser but perhaps more authentic and graffiti-centric show." Initially launched in 1993, the 432F Clothing Show was noted by reviewers for the funky labels and the brightly colored designs among the 100+ exhibitors (Dang, 1994). Bobby's involvement with 432F was significant: "It was the first time there was a movement and scene for these brands to come together to showcase their goods on an international scale" (Ruiz, 2019).

To capture the excitement around Tribal, Bobby facilitated B-boys to perform, murals to be painted, and tattoo artists to work alongside the clothing line. He created a scene and their booth was packed every year as folks angled themselves to see what the commotion was all about in their corner of this clothing show. This energy around the Tribal brand attracted retailers and other artists who desired to be part of something special. Street culture came alive in the Tribal booth and just as Bobby did his best to curate a creative community locally, he also sought to do it at every event like 432F to ensure visitors understood the multidimensional aspects behind Tribal designs.

The significance of these initial tradeshows and the many more that followed had an important impact on Tribal Streetwear. It was during this time in the mid 1990s that Tribal developed an international presence as the company sent its products to Europe, South America, and Asia to more trade shows, while also establishing retail stores. These openings always included bringing artists, musicians, and dancers with them to showcase their unique southern California culture. Connecting a streetwear brand with important artists, celebrities, and musicians has the ability to elevate a brand's reputation and value, something that was not lost on Bobby as he curated each experience. While Tribal's aesthetic and southern California perspective was once unique in each location they visited, over the years each continent has further developed these influences within their own subcultures, an exciting progression as lowriders, graffiti, and breaking have their own flare and style in a variety of countries that Tribal sponsors and supports.

The difference between being authentic and brands that copy a style became an issue as streetwear gained more momentum in the mainstream. Bobby (Ruiz, 2019) shares: "There is a version of streetwear from the keyboard and another

that is from the streets." The continued involvement with the street is the key aspect of Tribal's continued success from its origins to its most recent endeavors. There is a humbleness in this perspective that one cannot own street cultures since they are always changing and evolving. Nurturing and maintaining these connections to the street is essential to understanding what is important to the folks involved in them.

The streetwear landscape has shifted quite a bit since the 1990s as we enter into the 2000s. Once small companies have collaborated with luxury brands like Louis Vuitton to create new categories of streetwear that are considered luxury goods. While streetwear started with humble DIY beginnings, it has since become flooded with hybrid approaches and sports-influenced products that all reference the original casual authentic clothing products that were once simple T-shirts. In addition, streetwear genres have developed their own aesthetic in each continent that is unique to their own cultural history and the creatives who live in these regions.

While Tribal maintains a global influence and network, they still live with these subcultures on a daily basis and have adapted to each of the subcultures as they change around the world. Skateboarding as an example has gone through massive changes in style, technique, and the products used in the sport. These changes then are reflected in the collaborations and design Tribal uses or who they partner with for future drops. Yet it's not difficult to keep up to date when part of the subculture lives outside your office. Bobby shares in an interview:

> I have to wait for skaters to move when I arrive in the morning, then I walk in and greet the guys in the tattoo shop. Plus there are artists continuously working in the building on new pieces, and of course there are always cars.

<div align="right">(Ruiz, 2019)</div>

This continuous activity makes the big changes seem minor when they evolve in small increments day to day. By working on these interactions and influences into the daily routine at Tribal, there is a direct connection to the street that is missed by others.

## TRIBAL'S LEGACY

It's hard to believe that a company can be so closely tied to the identity of a variety of people but that is exactly what Tribal has been able to do over its 30-plus years of existence. When the T-Star logo is reproduced in the details of lowrid-

ers, proudly tattooed on skin, or worn as a badge on hats, jewelry, and of course clothing, it's symbolic of this close connection. This loyalty is more akin to club or family and without context it would be easy to misinterpret this devotion and enthusiasm and not realize that it promotes a sense of belonging.

Streetwear is generally thought of as a type of clothing that comes from a particular lifestyle and the design of the clothing is directed at street culture. In the case of Tribal, Chicano-style graffiti culture, lowriders, and surf/skate communities were a big part of its origin. There is an authenticity to the design of streetwear that is recognized by the subcultures associated with it. The success of the brand can be measured by its reception in the community. One might ask if individuals within each culture can recognize the designs, do they want to be part of it by wearing the clothing, and lastly if the material and aesthetics are done at a high level. If so, as was the case with Tribal, it's a combination that has afforded longevity.

Streetwear certainly fits within the larger discipline of street culture, an emerging academic field interested in understanding urban environments and the disparate subfields that involve practices, styles, and values. I appreciate how Ross (2018) captures the blurry borders of the field when he writes: "Street culture is *the beliefs, dispositions, ideologies, informal rules, practices, styles, symbols, and values associated with, adopted by, and engaged in by individuals and organizations that spend a disproportionate amount of time on the streets of large urban centers*" (p. 8). The casual sportswear-inspired clothing that Tribal has produced over the years continues to evolve through a number of variations depending on what is happening in culture.

In the summer of 2019, thousands of fans flooded the Broadway Pier in San Diego to celebrate 30 years of Tribal Streetwear. Rows of lowriders and custom cars with candy-coated finishes wowed visitors as they mingled among the vendors, food, music, drinks, and skateboarders. Inside, a carefully curated art exhibit featured artists who have collaborated with the brand on clothing designs over the past three decades. Titled "The Legacy Show," the experience exemplified these creative subcultures and the corresponding visual language that has made the San Diego-based company more of a lifestyle than a brand. From the sounds of skateboard decks banging on the concrete to the buzz of a tattoo gun or the hiss of an aerosol can, these disparate disciplines all find a home in a clothing line that symbolizes and represents their collective interests and identities.

One of the keys to success for any brand is longevity. A number of streetwear brands have been established only to fade away over time. With commercial success, sometimes companies become timid and only follow the formula that got them there and don't evolve and keep pace with larger street culture. Tribal on the other hand has been able to stay connected, active, and relevant. There is a dedication to the various subcultures that make up Tribal that has kept the brand connected to its roots. While it certainly has become more professional than a screen printing business, it still remains a brand that is embedded within the streets of southern California, something that has kept it relevant over time.

Authenticity is another important concept within the streetwear community, and Tribal's collaborations with artists appear to be an important component of keeping this relationship strong. The literature suggests that consumers prefer brands that reflect their own identities (Escalas & Bettman, 2005). Yet identity marketing can backfire on companies because the purchaser may feel there is a threat to their own expression when the company explicitly defines the consumer's culture (Bhattacharjee et al., 2014). There needs to be some agency or a perceived agency on behalf of the purchaser, they don't want to be put in a defined box when they buy and wear a brand. The variety of artists that collaborate with Tribal have kept the imagery fresh and offered options for consumers that relate to each of the subcultures yet such distinctions are not marketed or categorized in a particular manner (i.e., fans of lowriders buy this clothing or this particular shirt from Tribal). The absence of marketing directly to a subculture allows the purchaser to embrace the parts of the Tribal that best reflect their individual interest.

Tribal has never succumbed to marketing stunts to get attention. Instead, the brand has relied on its close connections with San Diego's art community. Tribal has collaborated with like-minded partners such as Dogtown Skateboards or the surf brand Hurley and continues to partner with performers in the music industry and seeks opportunities where art, cars, graffiti, or tattoos might be featured. These partnerships feel authentic and real to fans of Tribal because they are not outside their interest or world-view.

Tribal is uniquely situated in San Diego, and Bobby Ruiz is proud of what the city represents for streetwear. On the success of Tribal becoming an internationally known brand, Bobby (Ruiz, 2019) reflects: "It's not always about being financially wealthy. I think wealth is in your lifestyle, your community and being close to the people who you love and love you. It's more about how you live your life." Again, the Tribal T-Star logo serves as an excellent representation of the company's philosophy. Made up of several "T" letters that lock together like

a puzzle, the logo showcases a star in the negative space. A metaphor for the various aspects of street culture and family coming together to form something special. "Tribal is San Diego," Bobby says (Ruiz, 2019). "We represent this part of southern California all over the world. From skateboarding to Chicano culture, everything that comes from here is wrapped up in our work."

# REFERENCES

Bhattacharjee, A., Berger, J., & Menon, G. (2014). When identity marketing backfires: Consumer agency in identity expression. *Journal of Consumer Research, 41*(2), 294–309.

Daichendt, G. J. (2012). *Stay up! Los Angeles street art*. Cameron Books.

Dang, K. (1994, September 7). Buyers mix it up at sports expo, 432F. *WWD*. https://wwd.com/fashion-news/fashion-features/buyers-mix-it-up-at-sports-expo-432f-1166631/

Eckō, M. (2015). *Unlabel: Selling you without selling out*. Atria Books

Escalas, J. E., & Bettman, J. R. (2005). Self-construal, reference groups, and brand meaning. *Journal of Consumer Research, 32*(December), 378–389.

Hundreds, B. (2019). *This is not a T-shirt: A brand, a culture, a community—A life in streetwear*. Farrar, Straus and Giroux.

Ross, J. I. (2018). Reframing urban street culture: Toward a dynamic and heuristic process model. *City, Culture and Society, 15*(1), 7–13. https://doi.org/10.1016/j.ccs.2018.05.003

Ross, J. I., Daichendt, G. J, Kurtenbach, S., Gilchrist, P., Charles, M., & Wicks, J. (2019). Clarifying street culture: Integrating a diversity of opinions and voices. *Urban Research & Practice, 13*, 525–539. https://doi.org/10.1080/17535069.2019.1630673

Ruiz, B. (2019). In-person interview with James G. Daichendt. San Diego, 1 November.

Tungate, M. (2012). *Fashion brands: Branding style from Armani to Zara* (3rd ed.). Kohan.

Vogel, S. (2007). *Street wear: An insider's guide*. Chronicle Books.

**Section 1 Figure Credits**

Page 14–15: Bobby Ruiz photographed by Willie Toldedo
Page 16: Shepard Fairy
Page 18: OG Abel
Page 19: Tribal headquarters in San Diego photographed by Bobby Ruiz
Page 20: Chuey Quintanar
Page 21: Honkey Kong
Page 22 (top): Mural outside Tribal headquarters photographed by Bobby Ruiz
Page 22 (bottom): Shepard Fairey
Page 23: P. Hoelck
Page: 24–25: Keaps
Page 26: Tattoo artist Ames photographed by Billy the Kid
Page 27: Erni 1
Page 28–29: Willie Toldeo

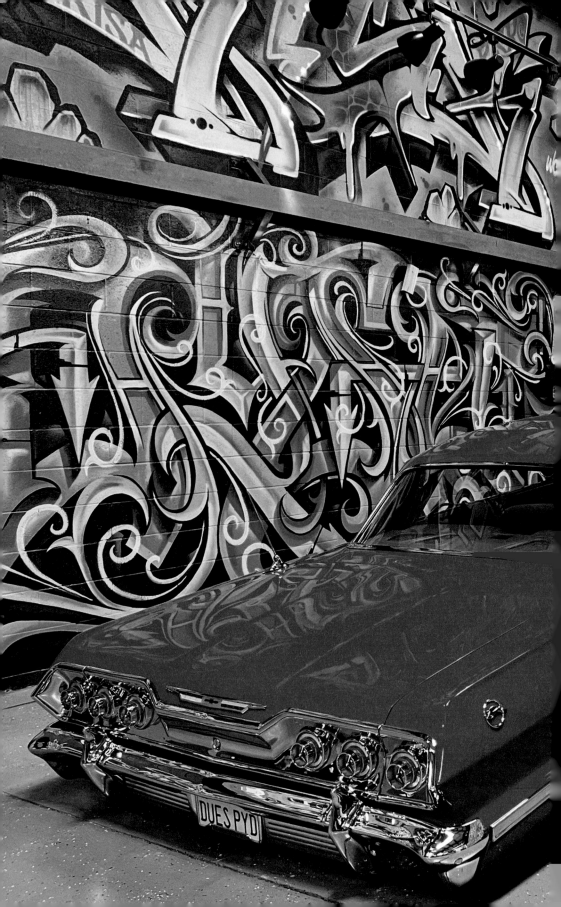

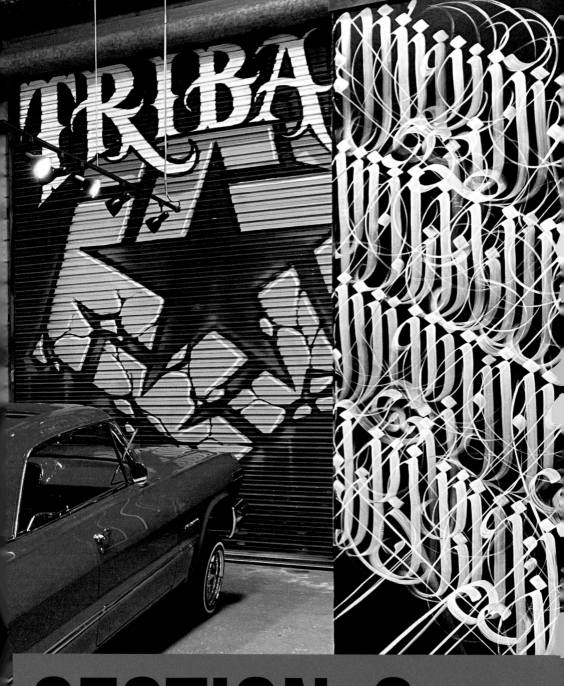

# SECTION 2

## STREETWEAR AND ITS HISTORIES

# CLAYTON FUNK

Clayton Funk is an associate professor of teaching in the Department of Arts Administration, Education, and Policy at The Ohio State University. His articles, book chapters, and encyclopedia articles on the history of American art education focus on lenses of material culture, technology, and learning, which reveal learning filters, learning ways, and learning machines, as formal and informal education about art in schools, museums, theaters, and streets, and in virtual locations in the cloud.

# WHAT'S IN A NAME: BASEBALL CAPS AND IDENTITY IN AMERICAN CULTURE

## CLAYTON FUNK

Names are personal and expressive and many names in the same space create patterns of our being together. Sometimes names are spoken and sometimes they are displayed on articles of clothing, and on walls in the forms of graffiti, posters, and murals. When all these names, or signifiers, are read in such public places as the streets, the patterns and their relations shift and move as a crowd changes. In this way, culture forms and shifts according to relationships among its members, and this becomes a conceptual space where the culture is produced.

In urban spaces, naming is given personal expression through graffiti, street art, and the personalization of body decoration like tattoos and clothing. Writing a name on a wall or anywhere is a tangible extension of the writer themselves. In Chicano neighborhoods of the Southwestern United States, a writer's name on a wall claims it for themselves, and these names are protected by a copyright, not an official copyright issued by the Library of Congress, but a cultural insignia known as "C/S" or "con safos," which translates to English as "with safety." It is common to find the C/S insignia in graffiti, and in tattoos, especially among Chicanos. The insignia also serves as a "surrogate for a physical bodyguard which can protect a written name being written in connection or direct association with it" (Grider, 1975, p. 134), as if to have your back and keep you safe. Exactly how *con safos* originated is unclear, but the use of C/S dates back to the 1940s and 1950s when it was used as a "sign-off" on Chicano "Placas" and graffiti. This is common in East

Los Angeles, where writing on walls tends to reflect Mexican-American artistic influence from the Pachuco counterculture in the 1940s. Among the writing traditions that emerged were "placas," or a stylized signature (Soergel, 2021). *Con safos* is central to a larger material culture of everything from custom cars to music, and particularly street clothing.

One article of street clothing that has become common in many public spaces is the baseball cap. Most baseball caps have symbols or logos—or names—that carry the social status of professional athletics, group affiliation, connoting power and respect and these logos become part of the street signifiers we read. The streetwear company Tribal has produced a baseball cap that carries its own kind of power and respect, bearing the C/S insignia. The hat also carries all the implied protections and serves as a reminder of this important signifier in Chicano culture, and in the United States at large. An interesting story is found in the migration of baseball caps from their early days of baseball and mostly White athletes, into the Chicano cultures of the Southwestern United States.

In this discussion of baseball caps in American culture, we will begin with a sketch of the history of baseball caps, then we move to baseball caps' associations with power and status and how their meanings have broadened and moved into other cultures, particularly where the hat becomes associated the signifier, *con safos*.

## SOCIAL SPACE

To unpack the layers of the cultures in which names and baseball caps are read, let us look at how street culture is produced. Street culture can be considered as an array of social relations, customs, discourse, and meaning, which flow into confluence as neighborhood identity. This dynamic formation occurs in what Henri Lefebvre (1991, p. 38) terms social space, which he frames in three currents of formation to explain the production of social space: spatial practices, representations of space, and spaces of representation.

1. Spatial practices or perceived space: Relates to the way we dress, especially in hats—baseball caps specifically—we think of what the caps signify interchangeably about the wearer's identity and the way onlookers see us at a given time and place, as if two sides of the same coin. And as this coin flips over and again, the meaning of any given baseball cap can shift in the dynamic cultural mix. Lefebvre (1991, p. 38) would say that "[t]he spatial practice of a society secretes that society's space." Along with the production of the relations, customs, and artifacts, it is a fluid, need-to-know space—to know how to navigate and negotiate relations in a social space.

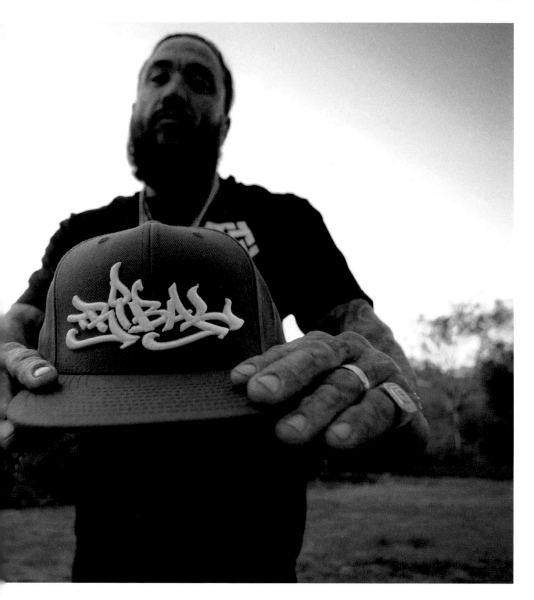

2. Representations of space or conceived space: Eventually,, baseball caps were mass-manufactured and they usually promoted the logo of an athletic team, a significant event, or even a political party. On the one hand, the wearer of the cap is part of a mass-manufactured phenomenon and, on the other hand, they adapt their hats to arrive at some personal meaning for themself. Likewise, street culture is often subject to regulation by scientists, planners, urbanists, and social engineers, who conceive of space formally in maps, diagrams, and models. This control can even be embedded with ideology, which may even determine the relations in spatial production.

3. Spaces of representation or lived space : The first two points, previously mentioned , taken together show we live in and through space made and

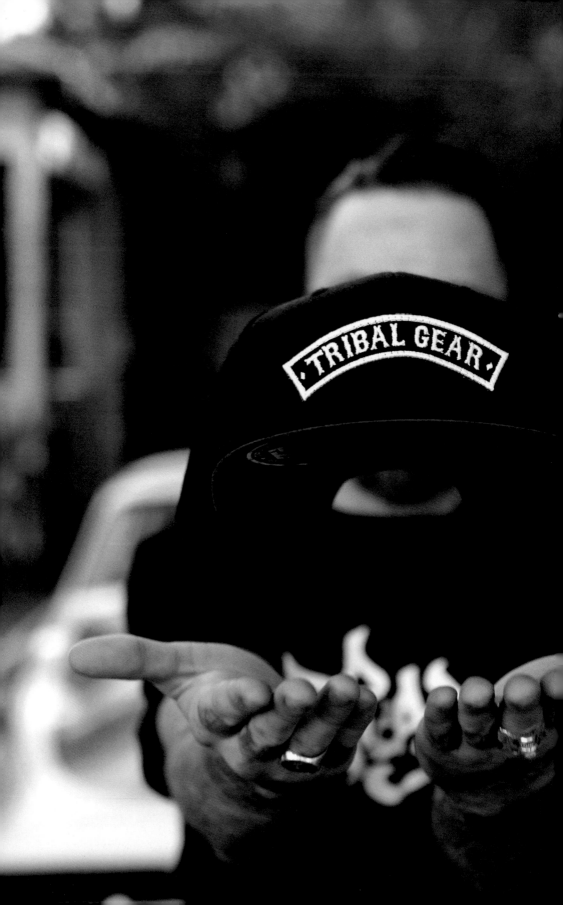

controlled by others, which we situate for ourselves. In our navigation of the space, we make sense of and function in it. What forms in the community is a neighborhood identification, or what brings residents together psychologically with something larger than themselves. Baseball cap wearers also signal their place in a community by taking a mass-produced hat and appropriating it with a personal style and meaning—or even in transgressive moves across sport, work, and everyday life—all in their responsive and fluid social space.

With this framework in mind, we turn to discuss hats, their social status, and where baseball caps are positioned in social and cultural ways to help members of a community navigate the dense cultural layers of the streets.

## HATS IN AMERICAN CULTURE

Names often signal social status and reputation, and hats can carry these qualities, as well. Whether the status and prestige of sports like professional baseball, or other affiliations, or even the power of a signifier like *con safos* (C/S), hats carry significant cultural weight. Until the 1960s in American cul-ture, the article of clothing with the strongest indication of social distinction, especially among men were their hats. Men usually represented their families in social settings, and so their hats signified the family's social status and cultural place. Women frequently appeared in hats, as well, but their hats signified social status and fashion conventions. Women's hats tended to vary more in style and expense and were individualized more as personal symbols. Back-tracking through history, we see that several new kinds of men's hats appeared during nineteenth-century Europe, which were also adopted at different levels of American society (Crane, 2000).

The two most important men's hats in nineteenth-century England were the top hat and the bowler (or derby). The silk top hat emerged in the mid nineteenth century usually worn by upper and middle-class businessmen in cities. Top hats were worn on formal occasions and the bowler hat was part of business and less formal attire. By the end of the century, the hat selection also included felt hats, and in summer, straw hats, with straw boaters, and panamas being common. Eventually, hat styles migrated across all social classes. In England, for exam-ple, top hats were soon adopted early in the nineteenth century as part of the uniforms worn by coachmen and police officers. By the 1830s, working-class men appeared in their Sunday apparel with top hats, and, by mid nineteenth century, men from any social class might appear in a top hat. The bowler (or derby) was designed in the 1850s for hunting and gamekeepers but was rapidly adopted in the upper classes to wear for sports. By the next decade, the popu-larity of the bowler spread through the middle and working classes of all types.

Other hats were common, like a cap with a visor as part of military uniforms, which were eventually worn by working men. Farmers were known to wear straw hats and sometimes wide brimmed felt hats. But it was the top hat and bowler that showed an important trend of popularity when they spread from the upper classes, downward and outward throughout the working classes. There was a shift in the social code associated with these two hats from identifying original wearers as elite men, and then spreading to men in the working classes who made it their own fashion, maybe with some social climbing in the mix. These shifts were driven by deeper drives for higher social status, which proliferated through professional education and the rise of the middle classes.

## A NEW GAME IN TOWN

To associate one's name with a profession was a way of earning higher social status by way of a diploma, certification, or other qualifications. Early baseball caps in nineteenth-century America were also associated with social status as part of the public fascination with professional athletics. In the nineteenth century, it was a new phenomenon for mostly Anglo-American fans to watch expert athletes play their games and make a living at it. To understand the early projections of status on baseball caps is to also understand America's preoc- cupation with professionalism, the social space created around fan loyalty for a baseball team. The story begins as we rewind to the late nineteenth and early twentieth centuries. This was a time when applied science and efficiency became the foundation of economic growth and industrial production and efficiency and consistent standards of production were also hallmarks of pro- fessionalism. It was all part of the upward climb of the Anglo-American middle classes, as worker's wages increased 60 percent between 1860 and 1960. Factory employees and corporate workers needed additional skills to work in increasingly larger and more complex jobs. So, one of the options for self-im- provement for White, middle-class individuals was the possibility of becoming a professional practitioner (Bledstein, 1976). Elite athletes modeled this kind of self-improvement for their fans, who would have witnessed this social status in the world of professional baseball.

During this shift to an upward social climb, elite collegiate athletics were also part of the professionalized universities, which housed professional training programs in law, medicine, social work, and other specializations. Following suite, students and other spectators could also watch expert—paraprofes- sional—athletes play and enjoy the community of fan affiliation. So, collegiate athletics became the object of fan enthusiasm, while simultaneously being associated with elite university professionalism.

Just as medical professionals needed specialized clinical and laboratory spaces, athletic games also required specialized spaces. Both professional and collegiate athletes required equipment designed with precise specifications—baseballs, baseball mitts, identical uniforms designed to accommodate the athlete's movement, and, eventually, the baseball cap. These playing fields were also uniquely shaped, measured, and standardized. Baseball diamonds, football fields, basketball courts, and so forth, eventually followed regulations of size and other specifications. Further, the space for play was separated from the space for spectators in specialized architectural structures known as stadia. Such structuring of space, words, and social relations in the form of professions—whether in baseball, medicine, or law—are examples of Lefebvre's (1991) production of what he termed conceived social space, which most American Mid Victorians knew as professionalism.

Over time, the enthusiasm for collegiate and professional baseball increased, and the sport eventually became the country's most popular late nineteenth-century pastime. As early as 1869, the first professional baseball club was organized as the Cincinnati Red Stockings. Players wore uniforms, which included a baseball cap with a bill to protect their eyes and face from the sun (Augustyn, 2021).

With the increased public attention to athletics as a spectator event positioned in front of this backdrop of professionalism and self-improvement, we can see the wave of popularity that rocketed baseball caps to a place of importance. In what Lefebvre (1991) called spaces of representation, baseball fans wearing their hats could be a part of something bigger than themselves, while climbing the social ladder of professional status and cultural place.

## WHAT IS A BASEBALL CAP?

It took some time for baseball caps to emerge, well before their style evolved into hats adapted for streetwear in our time, as with Tribal's C/S cap. Just as the earlier top hats and Bowlers eventually popularized among all social classes, a similar spread of popularity occurred with baseball caps.

The earliest baseball caps were worn by the players, not fans. The caps were part of a baseball player's uniform and they varied in style. The first professional men who started playing baseball in their private clubs wore professional jackets and ties and their baseball caps. Baseball uniforms with logos and team colors came along eventually. As more cities established their professional baseball clubs, they also developed a few variations on baseball

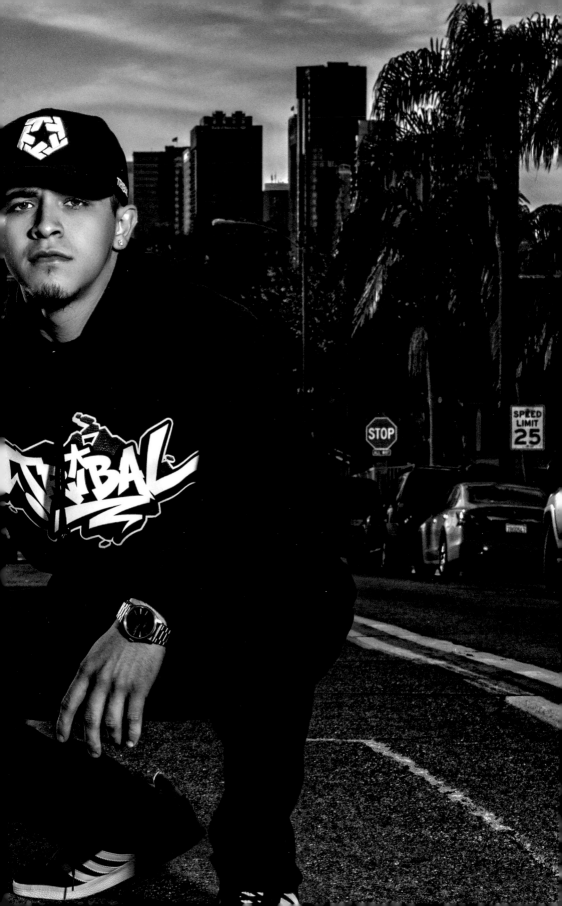

caps. The New York Knickerbockers, for example, wore broad-brimmed straw hats, and the Brooklyn Excelsiors developed a cap styled after a jockey cap, which became known as the "Brooklyn." It was designed with a rounded crown made of six triangular, cloth panels sewn together and finished at the top with a button. The Brooklyn turned out to be better suited to athletic activities outdoors than the straw hats and their popularity spread (Kelly, 2018).

There were other variants of the baseball cap. In the 1889 edition of *Spalding's base ball guide,* an advertisement illustrated ten different styles of baseball hats and caps (Spalding, 1889, p. 177). By 1922, though, *The Spalding guide* reduced that array to five styles; four of which were variants of the original rounded Brooklyn. A fifth style was the "Chicago," with a pillbox-shaped ventilated crown, with horizontal stripes (Chico, 2013; Foster, 1922). The "Brooklyn" style cap eventually spread to other professional baseball clubs in major cities within a decade, and, by the twentieth century, it was standardized across the professional game.

Baseball caps eventually had their own manufacturer. The New Era Cap Company was founded in 1920, in Buffalo, New York as a manufacturer of baseball caps. At first, New Era contracted with the major sports manufacturers Wilson and Spaulding, but by the 1930s, they were marketing directly to the major league teams, with the Cleveland Indians being the first, in 1934 (New Era Cap Company, para. 2).

Although team logos appeared on some baseball caps at the first of the twentieth century, logos were not universal in baseball until the 1940s. Bearing a team logo changed the significance of baseball caps and their popularity shot up along with the new status of professional baseball. That also meant that the hats worn by the baseball fans at the games and around town signified a bonding agent of the fans with their home team.

By the 1950s, the popularity of baseball skyrocketed with a professional team in almost every major American city. And as baseball expanded, so did the popularity of baseball caps. Along with this boom in professional baseball, came major growth in Little League baseball, which also put baseball caps in the hands of boys and some girls, who likely wore their hats through most of the off-season year-round. This attachment to baseball hats so early in life helps explain why the practice became widespread (Lilliefors, 2009; Patterson, 2015). Also at this time, New Era introduced a woolen version of the Brooklyn hat known as the 59Fifty, which became the standard cap across all major league teams. Players considered the 59Fifty stylish. Its stiffened front panels dis-

played team logos and team letters and the cotton sweatband inside was more comfortable than the leather band caps usually had (Kelly, 2018; New Era Cap Company, 2021, para. 3).

The popularity of baseball caps expanded quickly, riding the wave of increased professionalism in athletics and the rest of American culture, which made these hats important signifiers in their own rite by the mid twentieth century. Also at this time, in the 1960s, and in response to the countercultural influences of the late 1960s, men's dress hats began to fade from retail fashion and from popular culture. At the same time, fans showed up at ball games wearing the hats, which began a new kind of affiliation with professional and collegiate athletic teams. This shift in the popularity of baseball caps also opened the door to new purposes for the caps in the 1970s.

## NEW HATS, NEW HEROES

In 1969, the space mission team for Apollo 11, which landed the first American astronauts on the moon, wore custom-made 59Fifty baseball caps. This Apollo mission was widely televised and gave new visibility to the 59Fifty outside of a baseball stadium (Kelly, 2018). There were other influences in mass media, as well. Baseball historians often credit the Detroit Tigers cap, worn by Tom Selleck's character Thomas Magnum, as the beginning of the appropriation of baseball caps as everyday fashion, outside the stadium.

Baseball caps also became more common when manufacturers added adjustable headbands. Manufacturing caps that fit many different wearers was a much simpler process and a game changer, and baseball caps became even more plentiful. They became part of uniforms worn by fast-food workers and delivery drivers; and even farmers received a cap from equipment manufacturers, like John Deere, as a form of marketing. Finally, thanks to women's athletics and spectator sports, baseball caps eventually forged their way across the gender divide and baseball caps gradually became unisexual fashion.

The silhouette of a baseball cap's brim and crown carried the smart presence of a uniform in and of itself, which could add cultural status to many affiliations. These new uses for baseball caps were very influential, and caps that started out riding the wave of professional baseball's popularity soon became part of professional uniforms across the commercial landscape. By the late twentieth century, any group—from political parties to family reunions—wore baseball caps, often with logos. Whether a unifying signifier or symbol of fashion, wearing baseball caps gave a sense of belonging to an entity larger than oneself.

# SAME HATS, NEW WAYS

After their association with professional baseball, school athletics, and even little league baseball of the mid twentieth century, we might recall that baseball caps eventually emerged as part of counterculture during the 1970s and 1980s. Caps were a simple, inexpensive, yet expressively adaptable accessory, along with other athletic wear, like athletic jerseys, T-shirts, and jeans. These articles of clothing took on new meaning in American street culture as symbols of group affiliation and personal fashion.

Names don't float aimlessly in space. They carry meaning that is often tied to a community. We have discussed the affiliation of baseball hats with an athletic team or other organization for which they were made. But we also see in a street culture that baseball cap wearers have also adapted the caps' purpose to fit their own personal taste for themselves, or as part of countercultures. There is a story to tell about when their owners begin to adapt or even appropriate baseball caps as a part of street culture. Using a practice known as code-switching,[1] which usually is about adapting language to new situations as slang or other parlance, the logos or "names" on hats are appropriated to stand for a meaning other than its original. A New York Yankees cap, for instance, signals a new culture when it appears in the world of hip-hop. It is possible to study these adaptations of clothing to think about the way the meaning of a hat can change depending on who puts on the hat and how they wear it.

Most fashion magazines show at least five different styles of baseball caps. First is the snapback, named for the adjustable plastic strap to fit almost any adult. Next is the fitted cap, which is not adjustable and must be purchased in the correct size. Fitted hats are linked closely to the hip-hop scenes, where rappers wear them with the metallic sizing sticker still on the brim. The Rapper Jay-Z is known for wearing a New York Yankees cap, and Aaliyah, Chance the Rapper, and Easy E are known for wearing Chicago White Sox caps (Tinsley, 2017).[2] The dad cap is the most common style of cap, with its "backstrap," a canvas strap with a buckle for adjusting the hat to the wearer's head size. Less common is the unconstructed hat which has no panels stiffened to hold a certain shape. Finally, the five-panel hat is made of three panels that cover the crown from front to back with two side panels. It is not as popular as it used to be and is superseded mostly by the dad cap.

Caps took on new meaning depending on how they were worn in television and film and the folklore surrounding professional athletics and the street, and they were adapted in many ways—brim curled or straight, pulled low, or tipped

casually up. Caps could also be worn front-facing, cocked to the side, or turned around. Originally, baseball caps were worn backward so catchers could wear their protective catcher's masks. But in the late twentieth century, most people who lived outside of urban centers learned trends of street culture from television and film media. Turning a baseball cap 180 degrees, with the brim in the back, caught on following Sylvester Stallone's 1987 arm-wrestling film *Over the Top.* In the 1990s, the baseball athlete Ken Griffey Jr was also known for wearing his hat backward, something that began as a young man wanting to wear his father's hat, and backward was the only way it would fit. When Will Smith wore his hat backward on *Fresh Prince of Bel-Aire,* the practice of reversing a cap took on a youthful rebellious tone. Tupac Shakur, Jay-Z, and Limp Bizkit's Mr Fred Durst also helped popularize baseball caps backward (Elvidge, 2021). In this kind of adaptation of caps to a personal style, caps are appropriated from their original purpose and reintroduced as a part of personal style and, sometimes, embedded in counterculture. So, new names—or logos—of hats, other streetwear, and tattoos, which were appropriated for counterculture, became the names we read as patterns that shift with the remix of the crowds that make up street culture.

## REPUTATION IS EVERYTHING

We have established that hats throughout history signified social status and reputation and that baseball caps and their signifiers often bear deep meaning in that space. More so, after a discussion of social status and the ethos of professionalism in predominantly White communities, we need to remember that countercultural groups and ethnic and racial communities outside of predominant Anglo-American spheres usually don't follow the same elite professionalism, but they still operate on their own terms, with their own street code, and their own ways of achieving status and reputation. Just as so-called Anglo-American professionals seek self-improvement and social status from professionalism, other groups within street culture also strive for honorable conduct and respect, as parsed out in street codes focused on reputation-building and power (Intravia, 2021).

The relation of masculinity to Anglo-American professionalism was predominant, especially in its early years; and a world away in the countercultures of the streets, a set of masculine traits predominate street culture, as well. Just as elite mainstream professionals monitor power related to corruption, the role of men in street culture cannot be discussed without noting the overlapping scripts and symbols of both criminal and noncriminal influences on masculinity. This is not to say that crime produces street culture, but like any other areas,

like suburbs or rural locations, crime is present, though residents may avoid it. These residents negotiate their way through their days distinguishing criminal from noncriminal culture based on traits of courage, strength, toughness, and risk-taking (Mullins & Kavish, 2021).

Early studies of street culture from the 1920s, 1930s, and 1940s usually focused on gang activities, delinquent boys, and on criminality, as if to assume street culture came from crime. But Jeffry Ian Ross (2018) resets the lens to examine street culture in a broader cityscape composed of *"beliefs, dispositions, ideologies, informal rules, practices, styles, symbols, and values associated with, adopted by, and engaged in by individuals and organization that spend a disproportionate amount of time on the streets of large urban centers"* (p. 8, original emphasis). In the way of examples: a trait of criminal masculine power is seen in a brand of self-sufficiency, in which ties to others and their networks reduced one's freedom. It is common to trust no one. Independence from others translates into independence from legitimate work, which would only put one under the control of others, and diminishes one's power, or masculine capital.

While this way of thinking is common and well documented in social research, there are many other aspects of street life that are reinforced by what are considered solid traits of masculine character. Oliver (2006) describes a socialization process that young Black men undergo apart from the traditional education and family influences. The street becomes a space where young men learn the codes of the street and to act them out. In this way, whether criminal or noncriminal, the streets are their own cultural turf apart from traditional education and family.

# STREETWEAR

Just as the countercultural aspects of street culture exist apart from the predominantly Anglo-American world of professional classes, when members of the street decided to explore their own streetwear, they also diverged from corporate mass manufacturing. In the 1990s, a trend in streetwear emerged that shifted attention from large commercial manufacturers like Carhart, Nike, and others to home-grown companies within respective communities. One such company that began its retail business in the neighborhood near Chicano Park, in San Diego, CA, was Tribal Streetwear. Bobby and Joey Ruiz opened their business in 1989, in the neighborhood where they grew up. At first, they sold T-shirts with designs inspired by the cultural symbols of ancient Aztec and Mayan Indians.

Eventually, Tribal expanded with other streetwear, like jeans, etc. and, of course, baseball-style hats. Ruiz wanted the company to support the artists and local culture of the neighborhood and they have avoided gimmicks, like publicity stunts for the sake of spectacle (Daichendt, 2019). After over 30 years in business, Tribal headquarters is still in the space where they began, yet presently, Tribal has expanded internationally with outlets in Japan, Taiwan, the Philippines, and Europe.

Thinking about where we began this discussion, in street culture, particularly in the barrio, naming is given personal expression through graffiti. The stylized names on walls in public view are regarded as a tangible extension of the writer as if to claim it for themselves. To protect the writer's name from erasure or defacement is to add "con safos," represented with the insignia "C/S." We recall that the insignia's visibility in a graffiti piece represents protection and a sort of *de facto* copyright. Also, C/S can signify that the writer frees themselves from whatever ugly slur expressed against them. *Con safos* also appears in tattoos, and for someone to tattoo *con safos* on another means they have the utmost respect for that individual.

With the significance of C/S redressed, we turn to the significance of Tribal's introduction of a baseball cap bearing the insignia C/S on the front of the crown. In recent years, the C/S insignia has expanded globally, and it is not unusual to see the signifier in tattoos and clothing in other cultures, ethnicities, and races. In 2012, Bobby Ruiz established a website for promoting the heritage behind C/S and it was important enough to introduce a baseball cap bearing the insignia.

Crossing into the clothing customs of other cultures means that code-switching might occur, and the meanings behind a baseball hat with C/S on it might differ, depending on who wears the hat. Someone from the barrio of Chicano Park would understand the original power of the symbol, and wearing a hat with the C/S symbol is to adopt the same kind of honor and protection as a tattoo or a graffiti wall. Others outside the Chicano community might appropriate the same hat and symbol for a group affiliation or maybe even just for the sake of fashion. So, baseball caps with Tribal's insignia, logos of athletic teams, or even logos of brands like Nike or Reebok can acquire multiple, maybe even universal meanings.

# LASTLY ...

So, the constitution of street culture has always been about names, which are personal and expressive, and they are as common as baseball caps that bear logos, names with multiple meanings that transmit within and between complex cultures in which we find them. From the first baseball caps that were part of the first professional baseball uniforms, to their explosive popularity across the twentieth century, baseball hats stood and still stand for important groups, individuals, and other cultural groups, particularly the Chicano community and *con safos*.

Hats have been adapted to personal codes of self-fashioning and even for an appearance of social transgression. Baseball caps provide covering for personal comfort and have become part of more than a uniform of everyday life. It all boils down to what's in a name.

# REFERENCES

Barnard, M. (2002). *Fashion as communication*. London: Routledge.

Augustyn, A. (2021). Cincinnati Reds. In *Encyclopedia Britannica*. https://www.britannica.com/topic/Cincinnati-Reds

Chico, B. (2013). Baseball cap. In B. Chico (Ed.), *Hats and headwear around the world* (pp. 39–41). ABC-CLIO.

Crane, D. (2000). *Fashion and its social agendas: Class, gender, and identity in clothing*. University of Chicago Press.

Bledstein, B. J. (1976). *The culture of professionalism: The middle class and the development of higher education in America*. W. W. Norton.

Blom, J. P., & Gumperz, J. J. (1972). Social meaning in linguistic structures: Code-switching in Norway in directions. In J. J. Gumperez & D. Hymes (Eds.), *Sociolinguistics: The ethnography of communication* (pp. 407–434). Holt, Rinehart, and Winston.

Daichendt, G. J. (2019, December 1). San Diego's Tribal Streetwear still keeping it real as it turns 30. https://www.sandiegouniontribune.com/lifestyle/story/2019-12-01/tribal-streetwear-turns-30-and-represents-san-diego-around-the-world

Doran, M. (2004). Negotiating between Bourge and Racaille: Verlan as youth identity practice in suburban Paris. In A. Pavlenko & A. Blackledge (Eds.), *Negotiation of identities in multilingual contexts* (pp. 93–124). Multilingual Matters.

Foster, J. B. (1922). *Spalding's official base ball guide, 1922*. American Sports Publishing Company.

Grider, S. A. (1975). *Con safos*: Mexican-Americans, names and graffiti. *Journal of American Folklore, 88*(348), 132–142.

Intravia, J. (2021). The code of the street: Causes and consequences. In J. I. Ross (Ed.), *Routledge handbook of street culture* (pp. 219–228). Routeledge.

Kelly, W. W. (2018). The ubiquitous baseball cap: Identity, style and comfort in late modern times. *Journal of Consumer Culture, 18*(2), 261–278.

Lefebvre, H. (1991). *The production of space* (D. Nicholson-Smith, Trans.), Blackwell.

Lilliefors, J. (2009*). Ball cap nation: A journey through the world of America's national hat.* Clerisy Press.

Lytra, V. (2016). Language and ethnic identity. In S. Preece (Ed.), *Routledge handbook of language and identity* (pp. 131–145). Routledge.

Mullins, C. W., & Kavich, D. R. (2018). Street live and masculinities. In J. I. Ross (Ed.), *Routledge handbook of street culture* (pp. 183–193). Routledge.

New Era Cap Company. (2021). Wikipedia. Wikimedia Foundation, Inc. https://en.wikipedia.org/wiki/New_Era_Cap_Company

Oliver, W. (2006), "The streets": An Alternative black male socialization institution. *Journal of Black Studie*s, 36(6), 918–937.

Patterson, T. (2015, April 1). The common man's crown. *New York Times Magazine*, MM20.

Ross, J. I. (2018). Reframing urban street culture: Towards a dynamic and heuristic process model. *City, Culture and Society, 15*(4), 7–13.

Soergel, A. A. (2021). The writing on the wall: Exploring the cultural value of graffiti and street art. *University News*, September 14. https://news.ucsc.edu/2021/09/graffiti-street-art.html

Spalding, A. G. (1889). *Spalding's base ball guide, and official league book*. A. G. Spalding & Bros.

# ENDNOTES

1. Code-switching is a term used by linguistic scholars to

> describe the use of slang, a different language, or change in speaking form and style in different social settings to facilitate interaction with dissimilar ethnic groups, subcultures, or of their group identities. Code-switching can also be used to describe adaptations of clothing and conventions of behavior.
> 　　　　　(as cited in Blom & Fumperz, 1972; Doran, 2004; Lytra, 2016; Mullins & Kavish, 2021)

2. Justin Tinsley (2017) has provided a list of 28 rappers and the baseball caps they wear. In what is known as "wearing your city."

# MARVIN R. MILIAN

Marvin R. Milian, M.A., is an educator who seeks to innovate the classroom and change the way art history is taught. He earned an M.A. in modern art history, theory, and criticism from Azusa Pacific University and a B.A. in art history from the University of California Riverside. Marvin's M.A. thesis, Rust v. Sullivan and its influence on contemporary public art: A look at government infringement and censorship in American Public murals, explored the legal and political agendas that shaped public art in the United States from the 1990s onward. As a Ph.D. student in visual arts: philosophy, aesthetic, and art theory at IDSVA his work looks to understand the fluid evolution of art and aesthetics through philosophy and critique. He is also an author and a contributor to Art Radio Trending, a public art blog that examines the role of art in contemporary culture.

# LA VOZ DE LA CALLE

## ("THE VOICE OF THE STREET")

### MARVIN R. MILIAN

What is the relationship between *Muralismo Mexicano* or Mexican Muralism and contemporary street art culture? Mexican Muralism is defined as a movement that sought to cultivate a prosperous future in a Mexican population that stood precariously vulnerable in the wake of the Mexican Revolution in the early part of the twentieth century. In the early 1920s, monumental figures burst out of the Mexican art scene to establish a voice rooted in the cultural identity of the Mexican people, resulting in an aesthetic rich in storytelling, mythology, and passion. By revisiting the early Mexican mural movement, not as a temporal artifact of history but as a character toward an identity of its people, it becomes clear that contemporary street art, and more specifically Chicano street art, owes a debt of reference to the pillars of Mexican Muralism. That debt is being paid today as companies like Tribal Streetwear (Tribal) look to document a revolution of young voices that do more than date back three decades to the late 1980s. In the storied tradition of Mexican Muralism, San Diego institutions like the historic Chicano Park and Tribal Streetwear look to give voice to the Chicano community and tell their story in ways that make a difference in our shared cultures. The Chicano aesthetic clings proudly to the traditions of its Mexican ancestry. Still, it does so autonomously, independently, and free of normative influences, resulting in a visual culture uniquely representative of its people.

The Mexican Revolution that lasted a decade in the early twentieth century is recognized as a rejection of the increasingly unpopular dictator Porfirio Díaz, who held power over Mexico since 1877. Diaz's reign was characterized by an affinity toward powerful, wealthy landowners who controlled large farming properties named haciendas and exploited labor from low-skilled peasants.

By 1910, Diaz's power over the peasant population grew precarious, and Francisco I. Madero, a landowner exiled in California who sought the favor of the peasant population, called for a revolt. Successful in the northern state of Chihuahua, the peasant uprising looked to Madero's promise to return the land to those displaced under Diaz's rule but were disappointed when Madero demanded the peasant demographic disarm in exchange (Garner, 2014).

In May 1911, led by a charismatic and skilled horseman named Emiliano Zapata Salazar, and exhausted by the endless exploitation by both Díaz and Madero, the peasants of Zapata's rural hometown Morelos rose up and defeated the Federal Army in the Battle of Cuautla. The chaos that ensued over the next several years paved the way for figures such as the magnetic Francisco (Pancho) Villa to emerge from the ranks of obscurity into the chapters of history. In the hearts and minds of the Mexican people, Zapata and Villa would become heroes worthy of song and art, but in the eye of the West, they remained bandits, rebels, and horse thieves. The images of Zapata and Villa and the aesthetic of their rev-olution would cement itself as an undeniable representation and reflection of self-identity amongst the Mexican people. Visually, as John Womack notes in his exploration of the Mexican Revolution when seen together

> the two men made a "decided con-trast." Villa was "tall, robust, weighing about 180 pounds, with a complexion almost as florid as a German, wearing an English[pith] helmet, a heavy brown sweater, khaki trousers, leggings, and heavy riding shoes." Next to him,

Zapata seemed a native of another country. Much shorter than Villa, the American noted, "weighing probably about 130 pounds," he was a dark and "thin-faced" man, "his immense sombrero sometimes shading his eyes so that they could not be seen."

(Womack, 2011, p. 220)

This visual recount of the two men's first meeting in Mexico City would inspire a protagonist's aesthetic and graphic description of two of the most herald-ed men in Mexican lore. It's noteworthy that for the Mexican muralists of the 1920s, the rebellious mural artists that bathed Chicano Park in color during the 1970s, and the graphic design elements of companies like Tribal Streetwear, the image descriptions of these enigmatic figures generate a palette worthy of Chicano culture.

As Mexico recovered from its ten-year civil war, the Mexican population looked to the government for political and cultural direction, and to heal the wounds bestowed on a demographic of proud, indignant people. Led by the newly elect-ed President, a general during the revolution, Álvaro Obregón Salido, the focus turned to the Mexican people's cultural identity, an identity that had been lost under the dictatorship of Díaz and had withered during the revolution. Where in the first decade of the twentieth century, war was the catalyst of an identity divide, in the second decade, art became the vehicle by which the Mexican people would unify. Directly targeting the vast illiterate population of the time, the government-backed public mural program of the 1920s would prove pivotal in giving voice to those who felt unrepresented despite their sacrifice during the revolution. Sponsored by José Vasconcelos, then head of the Secretaría de Educación Pública (Secretary of Public Education Department) and led by David Alfaro Siqueiros, José Clemente Orozco, and Diego Rivera known as *Los Tres Grandes* ("The Big Three"), **Muralismo Mexicano** was born and would directly impact the art and culture of both the Mexican people and their American neighbors to the north for the next 100 years.

Murals serve a valuable role in defining a community's aesthetic; notwithstand-ing the history of Muralism as an arm of propaganda within authoritarian re-gimes, a subject not explored explicitly here, public art in the form of Muralism represents an autonomous dialogue. It serves as an advocate for the voice of the community. Much can be gained from examining the evolution of a commu-nity's aesthetic as it is presented in the dynamic of mural culture. For example, murals as artistic expression promote an investigation into temporal aspects of a demographic, revealing elements of ancestral pride and existential features

within that group of people. In the example of the mural tradition attributed to Mexican Muralism, art transcends time, and the community strives to identify with elements of pride and nationalism. Today, communities that have adopted murals as part of viable public art programs note that

> *Muralism*, a term coming out of the Mexican mural movement, has re-surfaced as a way of talking about contemporary mural-making, [where] Muralism is more about process and communication than decoration. It is about exchanging ideas, hopes, and visions over time, not individual expressions.

> (Golden, 2016, p. 16, original emphasis)

For the Mexican artists of the 1920s, the exchange of ideas was driven by a fervor toward an international avant-garde and a desire to establish identity amongst a changing Eurocentric landscape.

According to Robin Adèle Greeley's 2012 essay published in *Mexican Muralism: A critical history*,

> Mexican artists of the 1920s and 1930s, in constant interchange with an international avant-garde, radically reconceptualized European avant-garde precepts in terms of Mexico's specific historical conditions, and in doing so, began a vibrant exchange regarding the formulation of modernity in nations beyond Europe. Muralism's utopian vision of a shared cultural patrimony that interwove the avant-garde with popular opened up unprecedented space for public debate on the character of Mexican national identity.

> (Anreus et al., 2012, p. 14)

For the Mexican people still dealing with the memory of the revolution, this meant revisiting ancestral roots cemented in Indigenous pride and community empowerment, paving the way for an Aztec aesthetic deployed during the Revolution by Zapata and Villa, and in the political aftermath, nearly a decade ago. Nowhere is the practice of this aesthetic more evident than in the work of the early Mexican muralists.

The monumental public art of Siqueiros, Orozco, and Rivera would captivate a culturally starved audience driven by a curiosity toward modernity, and act as a reminder of the tenacity and resilience of the Indigenous mestizo people of the region. Often influenced by Marxist ideologies that sought fortitude over capitalist sensationalism, the aesthetic of *Los Tres Grandes* is laden with

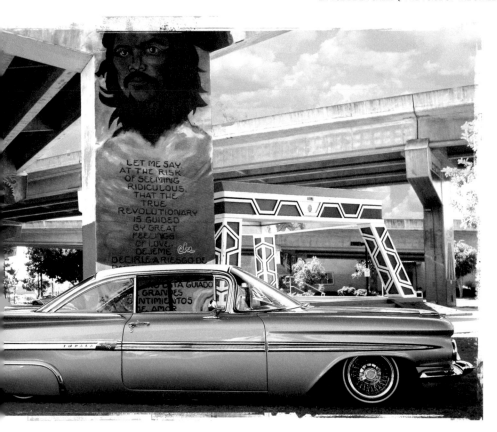

R E E T W E A R    E S T .  8 9  S A N  D I E G O ,  C A

socialist ideals and communist themes. The appeal to a powerful minority and an aesthetic of pride and historical significance would echo for decades beyond the Mexican borders becoming the root of the Chicano aesthetic in the twenty-first-century street culture.

On the surface, the monikers mestizo and Chicano seem similar in context, where the University of Pittsburgh Professor Joshua Lund defines mestizo as "an individual of mixed-race heritage, usually assumed to be of European and indigenous American ancestry" (2012, p. ix). Similarly, Chicano refers to an individual of Mexican American descent. There is, however, a philosophical difference between the two. The commonality between the two lies in the instability of existential identity or the split function of the self. However, both look to a temporal understanding of self-identity, leading to intimacy with ancestral landscapes lost to mythology and lore. In both cases, this traditional relationship thrives in public art, allowed to live autonomously in the community as public dialogue, unbowed to time and absent borders.

Over the course of 30 years, Bobby Ruiz, the founder and head of Tribal, has revolutionized Chicano street culture. Building on the tradition established in optimistic defiance by *Los Tres Grandes* in Mexico over a decade ago, Ruiz's designs are symbolic and powerful. The art appeals to a crowd that is empathetic and bound to specific histories. The brand, Tribal, through its aesthetic commands a retrospective look at the history of *campesinos* and *guerilleros* who profile the plight of the Mexican American community, common archetypes championed by Chicano culture. Turning his attention to the everyday stories of the barrio, inspired by the Mexican tradition of mural art, Ruiz has cultivated an empire rooted in Mexican storytelling. The stories that Tribal documents originate among the people and live in the streets. Stories that call upon Aztec legends, tales of revolutionary cowboys, and symbols of identity and pride. The art of Tribal transcends time, moving seamlessly through arcs of continuity frowning upon western normatives and flowing autonomously through a Chicano consciousness that identifies with its mestizo ancestry. The art is recognized as the visual manifestation of the mestizo people. It is an affinity toward this mestizo identity that drives the symbolic aesthetic to functioning outside western normatives.

The tradition of employing public art to document the plight of the community and give voice to the people can be seen in neighborhoods around the world, but located just seventeen miles north of the Mexico–United States border is an institution that for 50 years has been the gallery of the people, the visual diary of the community, the voice of the street. That institution nestled under the San Diego–Coronado Bridge in Barrio Logan is the storied 32,000 square meter Chicano Park in San Diego, California.

Fittingly, the development of what would become the canvas for over 70 murals began in controversy, seeing friction between city developers and local community activists. In April of 1970, the residents of the community learned that the 7.4-acre lot of unused land under the five freeway would not be invested into a community project as had been promised, but instead would be utilized in the erecting of a Highway Patrol substation. The news of this decision motivated hundreds of angered and frustrated barrio residents to rise up in demonstration. Leagues of Chicano men and women protested poignantly and indignantly for twelve days causing a halt to construction, and forcing state officials into negotiations with community leaders. Like the villagers of Morelos who followed Zapata out of the shadow and iron fist of the haciendas over 60 years prior, the residents of Barrio Logan rose up to defend their rights, they marched in defense of their identity, and in the mythical way of the Aztec warrior demanded their voice be heard. In 1971, the creation of Chicano Park was penned into law

and two years later local artists came out with brushes in hand, paint cans in tow, and mural painting began.

Today, Chicano Park serves as a safe haven to a community that refuses to be stripped of its identity, and clings definitely to a history battered in revolution and scarred by the labor struggles of past and present. The murals that blanket the park in color echo the vision of *Los Tres Grandes* who sought to invigorate a Mexican population with the promise of hope and prosperity. Images of the Aztec warrior Cuauhtémoc and colorful portraits of Siqueiros, Orozco, and Rivera alongside the Mexican artist Frida Kahlo penetrate the landscape as monumental guardians of Mexican culture but speak to the ambition of penetrating American culture. The murals of Chicano Park and the largely Mexican American population of Barrio Logan stand as beacons of promise and serve as a chorus of cultural and artistic aesthetics adopted by Mexican American street culture. Joining this symphony of community voices is Bobby Ruiz and the philosophy and graphic designs of Tribal Streetwear.

For over 30 years, Tribal Streetwear has associated itself with the San Diego community, thought by some to be the birthplace of street culture in the West. Birthed in 1989, originally a T-shirt company, Tribal morphed into a reflection of the community. The aesthetic adopted a unique identity and soon the brand reflected all aspects of street culture including lowriders, tattoos, and street art. Tribal has grown to be a voice of the people and is represented worldwide. The distinct interlocked "T" brands the company, but the philosophy behind Tribal invites the community to be part of an aesthetic and visual revolution. Tribal beckons an ideology that echoes what Mexican Muralism established. The Tribal aesthetic represents an intimacy with the people of the community. Like the murals that spoke to revolution in Mexico some 100 years ago, Tribal art lives autonomously as the narrator of the Chicano movement. A movement that looks beyond the present and pays homage to the struggles of those that fought to voice their stories. Often in collaboration with local artists, Tribal presents a new avenue for those that look to cement their voice in history. Those that look to share their unique story, and do so in the street.

The great Mexican muralists of the past saw the street as the only natural canvas, an autonomous gallery willing to listen and capable of documenting the essence of a people. The murals found their audience, not behind the hallowed gallery walls of the white cube, but rather rang loudest amongst the people nestled in the street. They spoke the language of the barrio, free of western designation or conformities, and the barrio spoke back. The recognition and appropriation of this dialogue are what makes Tribal special. It's what drives

Tribal beyond commodity. That is, Tribal rebels against the Marxist designations embedded in western business markets that often desecrate social relationships, and ignore ancestral sacrifice. In the same vein and inspired by the ground forged by *Muralismo Mexicano*, Tribal aesthetic speaks in concert with the community, and champions its mythology, its identity, and its voice.

The art that we see in the streets, whether on muraled brick walls that tell the story of generations past, or the graffiti that lines the streets and whispers the secrets of the neighborhood, tells a story and is inspired by the stories of the past. The stories of cowboys named Zapata, bandits named Pancho, and artists named Diego live in the voice of the community. Their voices ring loudest in the echo of the community. In the spirit of *Muralismo Mexicano* and in the tradition of street art, Chicano Park and Tribal continue to document *la voz de la calle*.

# REFERENCES

Anreus, A., Greeley R. A., & Folgarait L. (Eds.). (2012). *Mexican Muralism: A critical history*. University of California Press.

Coffey, M. (2012). *How a revolutionary art became official culture: Murals, museums, and the Mexican state.* Duke University Press.

Garner, P. (2014). *Porfirio Diaz*. Taylor & Francis.

Golden, J., Graham, D., Pompilio, N., Ramsdale, J., & Rice, R. (2006). *More Philadelphia murals and the stories they tell*. Temple University Press.

Kenny, J. (2006). *The Chicano mural movement of the Southwest: Populist public art and Chicano political activism* [theses and dissertations, University of New Orleans, 492]. https://scholarworks.uno.edu/td/492

Lund, J. (2012). *The mestizo state: Reading race in modern Mexico*. University of Minnesota Press.

Womack, J. (2011). *Zapata and the Mexican revolution*. Knopf Doubleday Publishing Group.

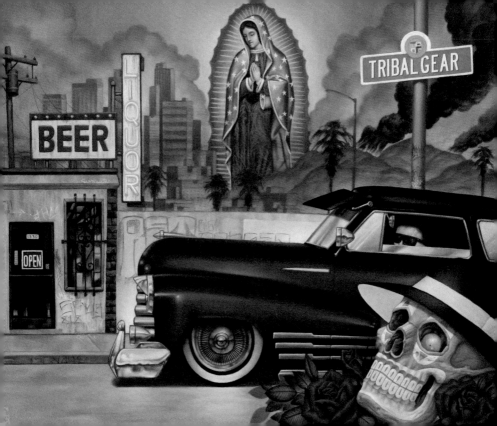

# JEFFREY IAN ROSS

Jeffrey Ian Ross, Ph.D. is a professor in the School of Criminal Justice, College of Public Affairs, and a research fellow at the Center for International and Comparative Law, and the Schaefer Center for Public Policy at the University of Baltimore. He has been a visiting professor at Ruhr-Universität Bochum, Germany, and the University of Padua, Italy.

# HOW GRAFFITI AND STREET ART STYLES, IMAGES, AND ICONOGRAPHY IMPACTED THE DESIGNS THAT TRIBAL STREETWEAR USES ON THEIR CLOTHING AND ACCESSORIES

JEFFREY IAN ROSS

## INTRODUCTION

Graffiti and street art have existed for centuries, but in the late 1960s, a more modern manifestation of this type of urban and public art emerged.[1] The presence of graffiti and street art has led to numerous effects (Ross, 2016b). This includes but is not limited to law enforcement scrutiny (Ross & Wright, 2014), public and political awareness, and the involvement of moral entrepreneurs (Ferrell, 1993). One of the most interesting and controversial effects of graffiti and street art, however, is what is generally referred to as the commodification and co-optation of these practices in different economic domains (Ross et al., 2020).

According to Ross et al.,

> graffiti and street art aesthetics are used to promote and sell other products or services [...]Commodification [...] is the way that graffiti and street art as both an object and a practice have been packaged as something to be sold. Graffiti-style (itself an evolving phenomenon) has been used to sell specific products, such as clothing items, while its association with illegality creates an aura within marketing campaigns that appeals to certain demographics and psychographics.

> (2020, p. 6)

Those items (especially lifestyle products), services, and businesses include cars, galleries, museums, publishing, real estate (including property), restaurants, skateboards, and tourism (including neighborhood development). Nowhere do graffiti and street art appear to be most prominent than in the contemporary fashion industry (Alabi, 2013). In general, two segments of this business have used graffiti and street art designs: streetwear/lifestyle and haut couture (Alabi, 2013; Mackanamee, 2013; Romano, 2021).

Although both parts of the clothing and apparel market are interesting, the domain that has used graffiti and street art iconography, images, and symbols (hereafter styles)[2] the most appears to be streetwear/lifestyle fashion. In order to better understand this phenomenon, this chapter briefly reviews how the styles of graffiti and street art have been used (i.e., integrated, reproduced, and represented) by Tribal Streetwear (hereafter Tribal), one of the largest and most well-known streetwear companies in the world.

In order to accomplish this task, the chapter briefly reviews the history of graffiti styles used in fashion, the streetwear industry, gang and Chicano/Cholo graffiti, and then how Tribal used graffiti and street art designs in their clothing. The case study demonstrates a progression in design influences based on the perception of the brand's founders, consumer demand, and new aesthetic and subcultural influences adopted by the company.

# THE HISTORY OF GRAFFITI STYLES BEING USED IN FASHION

Most, if not all cultures and subcultures (from business persons working on Wall Street to gangs operating in the back streets of Manila), wear unique styles of

clothing, jewelry, and accessories, and may wear these items in particular ways. This so-called presentation of self (Goffman, 1959) also extends to body modifications such as tattoos, piercings, plastic surgery, and hairstyles.

Styles of clothing, jewelry, accessories, and body modifications serve multiple purposes (Bruzzi & Church Gibson, 2014). One of the reasons why these items are selected by people (and consumers) is because they reflect our mood, personality, or self-image. Alternatively, particular types of garments, jewelry, accessories, and body modifications demonstrate group solidarity (including belonging and identity), and a means to distinguish oneself from outsiders (Hebdige, 1998).

Nevertheless, little has been written in scholarly contexts about the instances when clothing manufacturers have integrated graffiti or street art style into their garments or advertising campaigns, nor the reasons why consumers have purchased this kind of merchandise. The use of graffiti and street art styles, etc. is present and has ranged from T-shirts sold by street vendors in big cities, like New York, to high fashion brands using patterns in their clothes that use selected graffiti and street art styles (Anonymous, n.d.).[3] We have also seen both brick-and-mortar stores, including art museums and galleries' stores, and online vendors sell shirts with images produced by a variety of well-known graffiti and street artists (e.g., Banksy). One of the most noted street artists, whose images have also been commodified is Shepard Fairey, whose "Obey" icons have been reproduced on all manner of clothing (Daichendt, 2014). More recently Dior, the powerhouse French luxury fashion brand, partnered with famed street artist Kenny Scharf to produce a line of clothing (Jasman, 2020).

Most of the public attention that has been devoted to the use of graffiti and street art images on clothing has been the production of news media stories and reactions to them when well-known fashion brands (e.g., American Eagle, Coach, Just Cavalli, etc.) have been sued by graffiti writers and street artists

for copyright violations for reproducing their iconography on to their garments without their express permission (Ross et al., 2020, p. 14).

Why might consumers purchase clothing and accessories with graffiti and street art iconography on them? There are no definitive answers to this phenomenon, but it may be a unique combination of cultural identification, fascination, and voyeurism, including a perception that graffiti and street art makes the wearer of the clothes seem edgy, hip, and iconoclastic. Wearing clothing that has graffiti and/or street art iconography can also be a way to signify that you are part of a social group or movement, or believe in something (e.g., an ideology) that is unique and different.[4]

# THE EMERGENCE OF STREETWEAR BRANDS

Starting in the 1990s, a new casual type of clothing called streetwear emerged. It took its creative inspiration from a number of popular subcultures present at the time including hip-hop, punk, skateboarding, sportswear, and surf culture. Later, it also borrowed elements from haute couture. In general, it embodies,

> the production, promotion, sale and resale of casual fashion, principally of footwear, such as sneakers, but also T-shirts and other items—in ways that bypass traditional retail channels, often subverting the way the fashion industry has long defined and dictated how "cool" is made profitable.

> (Menendez & Nitschke, 2019)

Since this time, throughout the world, many streetwear companies have started worldwide, in order to manufacture and sell selected streetwear items or full lines of clothes available to interested consumers (Hundreds, 2011). Some of these fashion entities had brief lifespans, while others have become major brands (e.g., Stussy, Supreme, etc.).

Over the past three decades, the industry, including the sources of its designs, and methods by which the products it sells has changed (Banks, 2014). Prominent among the design influences have been graffiti and street art. Although numerous types of graffiti and street art exist, not all of them have been used in streetwear clothing. One of the most discussed and misunderstood, however, has been gang graffiti.

# GANG GRAFFITI

Gangs engage in numerous practices. Some of the more notable visual behaviors include the kinds of clothing members wear, hand signing, graffiti, tattooing, and violence (Miller, 1995). According to Phillips, "When gang members discuss their cultures, they talk about a practice called 'representing.' [...] the activities that keep their group going. Representing doesn't just reflect, it creates. Different kinds of gang activities become roughly analogous through representing" (1999, pp. 7–8). She adds, "Graffiti" is a way for members to "define their group within the spaces where they live." It is the "barrio's visual, tangible history—offers living proof of both changes and continuities in neighborhood concerns" (Phillips, 1999, p. 119).

Gang members are diverse in terms of race, ethnicity, and age. This variety contributes to different kinds of graffiti styles and locations where they do their work. In California, many of the wall writers are Chicano and African American and participate in gang life. And although they engage in graffiti throughout the state, a considerable amount of this activity occurs in larger cities like Los Angeles, San Diego, and San Francisco, where unique graffiti and street art scenes have developed (Bloch, 2021; Phillips, 1999).

Since one of the goals of graffiti (and street art) is to be seen and to mark territory, then its progression toward clothing is natural and makes sense (Ross, 2016c). Just like train and subway graffiti where the writer can take pride in the fact that their work will be seen throughout a city (known as "going All City") or freight train graffiti, where a writer's work might be seen thoughout a geographic region or nation (known as "going All Country"), the same might be said with the markings on clothing.

In terms of gangs, the graffiti sense of identity can also move from the wall to the body (as in tattoos) and to clothing. Phillips states, "Graffiti and tattooing often overlap in the contexts of their use—people use each medium to position in and group identities in different directions" (1999, p. 137).

There are also different styles of gang graffiti, the most important distinction is between Chicano and African American gang styles. The former has been the subject of intense study, not just by Phillips, but by Sally and Jerry Romofsky, who call gang graffiti "the most interesting, subtle, and aesthetically complex graffiti in this country" (Phillips, 1999, p. 13). Over time, gang graffiti "styles have changed, and competition for space intensified" (Phillips, 1999, p. 120). Another source of design has been Chicano/Cholo gang graffiti style.

# CHICANO GANG GRAFFITI STYLE[5]

Among Chicano/Cholo gangs, one of the most prominent types of graffiti is called "A 'hit-up' or 'placa'" (Bojoroquez, 2019). This "is a simple writing of the gang name, clique name, and the name of the writer and a few of his or her closest friends" (Phillips, 1999, p. 11). According to Phillips

> Chicano gang members represent their neighborhoods in graffiti in a variety of ways and for a variety of reasons. Their graffiti ranges from the most minute writings on the walls and concrete scratching to large than life gigantic images that require the use of ladders and crates of spray paint. These messages have the ability to stand on their own and act for gang members even when they themselves are not around; their public nature makes them an important locus to position self and group at a distance through shorthand symbols. Graffiti are crucial mechanisms for the acts of representing through which gang members intertwine their emotional and political concerns.
>
> (1999, p.117)

Among Chicano/Cholo gangs there are "four interrelated but distinct types of graffiti: hitting up, crossing out, roll calls, and RIPs (memorial graffiti). They correspond roughly to the categories with which Ley and Cybriwsky (1994) designated Philadelphia graffiti: affirmative and aggressive" (Phillips, 1999, p. 118). One of the more prominent types of letter faces is the Old English letter style, where words are printed in Old English (Bojorquez, 2019).[6]

# MURALISM

Another influence on streetwear is the murals in the southern California Mexican American urban landscape. According to Arreola (1984), "Here mural art is not only an artifact that embellishes the barrio landscape but also a vehicle for political and political expressions" (p. 409). He adds, "Chicano mural art emerged in the wake of the La Raza militancy of the 1960s and was concerned with expressions of ethnic identity and political activism" (Arreola, 1984, p. 410). The specific content of murals is influenced by the unique artists who paint these pieces and local historical circumstances. The mural pieces typically feature images of iconic public figures (important in the history of Mexican American political struggles), and depictions of historical events. San Diego, where Tribal got its start, has numerous murals of this type including those located at Chicano Park. According to Rosen and Fisher (2001),

The murals depict images of Mexican pre-Columbian gods, myths and legendary icons, botanical elements, animal imagery, the Mexican colonial experience, revolutionary struggles, cultural and spiritual reaffirmation through the arts, Chicano achievements, identity and bicultural duality as symbolized in the search for the "indigenous self," Mexican and Chicano cultural heroes and heroines [...] and scenes based on contemporary Chicano civil rights history.

(p. 94)[7]

# ANALYZING TRIBAL STREETWEAR

## SOURCES OF INSPIRATION FOR THEIR DESIGNS

Started in 1989 in San Diego, by brothers Bobby and Joey Ruiz, Tribal has become a large multinational clothing brand, with retail stores not only in San Diego, but in Germany, Japan, and the Philippines too. The brothers started by

silk screening T-shirts with designs inspired by tattoos as well as Bobby's experience as a graffiti writer, most of the company's initial imagery was

infused with Mayan and Aztec lines and shapes — a characteristic that was instrumental to the name Tribal.

(Daichendt, 2019)

Over time, capitalizing on both a national and international fascination with southern California culture, Tribal expanded not only the inspirations for their designs, the items upon which they placed them including tank tops, baseball caps, lighters, accessories, surfboards, etc., but its audience and customer base.

Tribal's initial designs borrowed and modified design elements from the southern California (Chicano) graffiti and street art scene in general, and the San Diego graffiti and street art that its founders were initially associated with and exposed to. According to Bobby Ruiz,

> I was into graffiti when I was in the seventh grade. As a high school senior I saw hip-hop, and Chicano Gang styles. I also noticed different hand styles and block line work, and multicolor fills. I started doing some research, including visiting the graffiti yard by the tracks and trains.[8]

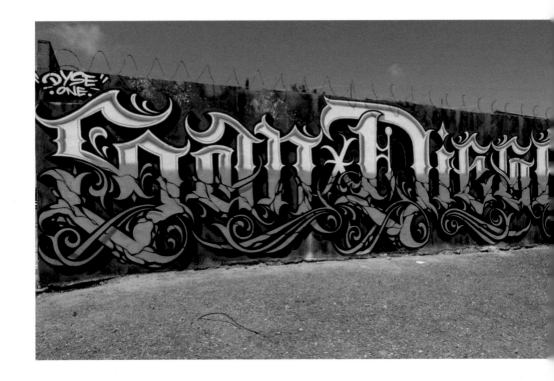

The first location he visited was the Old Town Yard. It was on the tracks as well with a local graffiti writer named Buster (Jesse Ortiz), where he met graffiti writers Bom, Crush, Dyse One, Quasar, Sake, and Zodak. There was also a spot called the Euclid Pits which became one of the most popular places for graffiti writing in San Diego. In 1991, as Tribal expanded, Bobby also curated his first show in which he brought local graffiti artists to the Centro Cultural de la Raza, located in Balboa Park. Later, when he traveled to New York, Ruiz met other graffiti writers such as TATs Crew, who took him to the graffiti hall of fame and spots in the Bronx. In Germany Ruiz would go to train yards with Can 2, then later in Denmark with Bates.

A number of other well-known graffiti writers and street artists have figured prominently in Tribal's designs. These include Brisk, OG Abel, Shepard Fairey, Hasl, Zodak, Mr. Cartoon, OG Abel, Persue, and Risk. Over the years the Tribal brand has provided work for as many as 200 graffiti artists (Pool, 2003).

Also important in the development of Tribal was the integration and ethos of hip-hop, which combined selected elements of graffiti, MCing, DJing, graffiti, and dance (especially B-boying also known as breakdancing), into the Tribal brand.

One of the important aspects of Tribal is a strong T-Star logo (akin to a graffiti writer's tag) which appears to borrow some elements from Sheppard Fairey's Obey giant logo. Tribal has also used visual and symbolic elements from numerous contemporary Chicano cultural practices (like lowriders) and Mayan and Aztec imagery.

Tribal does not just simply borrow the aesthetics and fluidity found in graffiti, muralism, street art, and tattoo art, but they modify them. The company's aesthetics has been affectionately described as having derived from the children's story *Goldilocks and the Three Bears*. In other words, it is not too hard and not too soft.[9] In fact, the San Diego building where Tribal is located includes not only numerous tattoo artists but also a skate shop, music studio, and food purveyors too. This environment has become a laboratory of cross-fertilization of ideas.

Over time, the sources of Tribal's designs have changed as have the ways this company has tried to connect with its customers. Tribal was not only influenced by graffiti writers, street artists, and muralists and their work but also incorporated the aesthetic styles from different sources. Some of the Tribal shirts (e.g., the Jim Ford collection) feature images of lowrider vehicles, including well-maintained cars, trucks, and other vehicles, that use a lot of chrome detailing.[10] Tribal has also borrowed design elements from skater culture too. Ruiz adds, "we brought the lowrider and Chicano-style graffiti culture to the skate and surf communities. All these things combined to establish an open-minded aesthetic that continues to this day" (Daichendt, 2019, para. 3).

According to Ruiz, "We try to keep our hand on the pulse of what is going on. Styles evolve and change, sometimes motivated by competition." This includes changes in scripts, hand and letter styles, and the merging of East Coast and West Coast approaches to graffiti and street art iconography. There was and continues to be a large influence of tattoo flash (the tattoo designs printed onto paper that customers choose from), tribal, Mayan, Aztec, and hieroglyphic designs.

# HOW DOES TRIBAL ATTRACT DIFFERENT ARTISTS FOR THEIR DESIGNS?

In order to remain interesting, and contemporary, the designs that Tribal places on their clothing have changed. Ruiz believes that the quality of the brand is of interest to visual artists like graffiti writers, street artists, graphic designers, photographers, etc. And this has helped to recruit new talent to produce new designs. This has included graffiti artists like Joker, Mr Cartoon, and Risk, in the United States and Daim out of Hamburg. Ruiz indicates that these artists believe that by aligning with Tribal and having their designs on their clothing they could expand their platforms; another way of getting their work seen and getting paid for it. Frequently writers will send their work to Tribal and be part of their ever-expanding network. This approach has been reflected in both the sources for its designs and its customer base has expanded from the local scene to the global one.

# CONCLUSION

Over time depending on a confluence of circumstances the kinds of styles that Tribal has integrated into its clothing have increased and changed. In many respects, this is coterminous with the idea of bricolage, the notion that art evolves and involves integrating new things that are in the environment, especially as their influence and network groups.

Starting out with few guiding principles other than a need and desire to be authentic, to connect with its sources of inspiration and customers, Tribal strived against being stationary or staid in the subject matter and contents they integrated. This has involved borrowing and promoting images from the local graffiti culture and encouraging other domains that it believes have value like tattoo artists and lowrider culture. There is a phenomenal amount of competition in the streetwear clothing industry, and holding on to this approach enabled Tribal not only to survive but also to prosper.

All in all, it appears as if graffiti and street art styles were the foundation for Tribal if not a point of reference from which all other designs flowed. The iconography formed the basis of different colors, lettering, and designs. It enabled the notions of transgression, resistance, and outsider ethos to find a hope in Tribal clothing.

# ACKNOWLEDGMENTS

Special thanks to G. James Daichendt and John F. Lennon for their comments, and Bobby Ruiz for his willingness to be interviewed for this chapter.

# REFERENCES

Aguilar, J. A. (2000, April 25–28). *Chicano street signs: Graffiti as public literacy practice* [Conference paper]. Annual Meeting of the American Educational Research Association, New Orleans, LA, United States.

Alabi, M. (2013, November 26). *When street art meets runway style*. CNN. http://cnn.com/2013/09/07/living/high-fashion-street-art/

Anonymous (n.d.). The history of fashion in graffiti. https://thedailyshine.com/pages/the-history-of-graffiti-in-fashion

Arreola, D. D. (1984). Mexican American exterior murals. *Geographical Review*, 74(4), 409–424.

Banks, A. (2014). The inspirations behind 20 of the most well-known designs in streetwear. *High Snobiety*. https://www.highsnobiety.com/p/inspiration-behind-20-most-important-street-wear-designs/

Bloch, S. (2021). *Going all city*. University of Chicago Press.

Bojórquez, C. C. (2019). Graffiti is art: Any drawn line that speaks about identity, dignity, and unity... That line is art. In A. Jennifer, C. González, O. Chavoya, C. Noriega, & T. Romo (Eds.), *Chicano and Chicana art: A critical anthology* (pp. 117–122). Duke University Press.

Bruzzi, S., & Gibson P. C. (Eds.). (2014). *Fashion cultures revisited: Theories, explorations and analysis*. Routledge.

Cardenas, J. (1999 , August 20). Clothing with a culture. *Los Angeles Times*. https://www.latimes.com/archives/la-xpm-1999-aug-20-cl-1881-story.html

Cesaretti, G. (1975). *Street writers: A guided tour of Chicano graffiti*. Acrobat Books.

Chappell, B. (2010). Custom contestations: Lowriders and urban space. *City & Society*, 22, 25–47.

Chappell, B. (2012). *Lowrider space: Aesthetics and politics of Mexican American custom cars*. University of Texas Press.

Daichendt, G. J. (2014). *Shepard Fairey Inc. Artist/professional/vandal*. Cameron Books.

Daichendt, G. J. (2019, December 1). As it turns 30, San Diego's Tribal streetwear still keeping it real. *San Diego Tribune*. https://www.sandiegouniontribune.com/lifestyle/story/2019-12-01/tribal-streetwear-turns-30-and-represents-san-diego-around-the-world

Ferrell, J. (1993). *Crimes of style: Urban graffiti and the politics of criminality*. Garland Publishers.

Goffman, E. (1959). *Presentation of self in everyday life*. Anchor Books.

Hebdige, D. (1998). *Subculture: The meaning of style*. Routledge.

Hundreds, B. (2011, June 21). 50 greatest streetwear brands of all time. *Complex Magazine*. https://www.complex.com/style/the-greatest-streetwear-brands/original-fake

Hunt, M. B. (1996). *The sociolinguistics of tagging and Chicano gang graffiti (Publication No. 9705114)* [Dissertation, University of Southern California]. ProQuest Dissertations & Theses Global.

Jasman, A. (2020). All to know about Kenny Scharf, the guest artist behind Dior Men fall 2021. *Esquire.* https://www.esquiresg.com/dior-men-fall-2021-kenny-scharf-interview-artist-collaboration-fai-khadra/

Mackanamee, T. (2013, June 13). From urban graffiti runways to feminine graffiti frocks. *Trendsetter.* https://www.trendhunter.com/slideshow/graffitiinspired-fashion

Menendez, E., & Nitschke, A. (2019). Streetwear impact report. https://strategyand.hypebeast.com/streetwear-report.

Miller, J. (1995). Gang style and the meanings of social control. In J. Ferrell, & C. R. Sanders (Eds.), *Cultural criminology* (pp. 213–234). Northeastern University Press.

Phillips, S. A. (1999). *Wallbangin': Graffiti and gangs in LA.* University of Chicago Press.

Pool, R. (2003, October 3). Conference views graffiti's creative side. *Los Angeles Times.* https://www.latimes.com/archives/la-xpm-2003-oct-03-me-art3-story.html

Pulido, A. L., & Roberto 'rigo', R. L. (2017). *San Diego lowriders: A history of cars and cruising.* The History Press.

Romano, P. (2021, February 3). Street art and graffiti on the catwalk. *NSS Magazine.* https://www.nssgclub.com/en/fashion/25064/street-art-graffiti-fashion-runway

Romofsky, J., & Romofsky, S. (1976). *Los Angeles barrio calligraphy.* Dawson's Book Shop.

Rosen, M. D., & Fisher, J. (2001). Chicano Park and the Chicano Park murals: Barrio Logan, city of San Diego, California. *The Public Historian,* 23(4), 91–112.

Ross, J. I. (2016a). Introduction: Sorting it all out. In J. I. Ross (Ed.), *Routledge handbook of graffiti and street art* (pp. 1–10). Routledge.

Ross, J. I. (2016b). Effects of graffiti and street art. In J. I. Ross (Ed.), *Routledge handbook of graffiti and street art* (pp. 389–392). Routledge.

Ross, J. I. (Ed.) (2016c). *Routledge handbook of graffiti and street art.* Routledge.

Ross, J. I., Lennon, J. F., & Kramer, R. (2020). Moving beyond Banksy and Fairey: Interrogating the co-optation and commodification of modern graffiti and street art. *Visual Inquiry,* 9(1–2), 5–23.

Ross, J. I., & Wright, B. S. (2014). "I've got better things to worry about": Police perceptions of graffiti and street art in a large mid-Atlantic city. *Police Quarterly,* 17(2), 176–200.

Sheren, I. N. (2018). The San Diego Chicano movement and the origins of border art. *Journal of Borderlands Studies,* 33(4), 513–527.

Simpson, E. (1980). Chicano street murals. *Journal of Popular Culture,* 13(3), 642–652.

Staff. (2010). Q&A with Tribal Founder Bobby Ruiz: 20 years strong, Ballerstatus.com. https://www.ballerstatus.com/2010/08/05/qa-with-tribal-founder-bobby-ruiz-20-years-strong/

# ENDNOTES

1. For a relatively comprehensive definition of graffiti and street art see, for example, Ross, (2016a).

2. The author recognizes that there are multiple definitions for these interrelated terms, but for sake of convenience has collapsed them under the term styles.

3. Some of the more well-known graffiti writers and street artists such as Mark Ecko, KAWS, and Stash engaged in this activity before they turned to other creative pursuits.

4. E-mail conversation with Jim Daichendt, September 14, 2021.

5. In addition to Phillips (1999) and Bojoroquez (2019), there is a considerable scholarship about Chicano/Cholo gang graffiti. Noticeable work includes work by Busby Hunt (1996) and Aguilar (2000).

6. Also important, but not reviewed is Chicano graffiti writing, some of which overlaps with the work done by members of Chicano/Cholo gangs (Cesaretti, 1975).

7. For additional information connected to murals in this park and their wider implications see, for example, Sheren (2018).

8. Telephone conversation with Bobby Ruiz, Tuesday August 24, 2021. As well as for any further uncited quotes from Ruiz in this chapter.

9. E-mail conversation with Jim Daichendt, September 14, 2021.

10. For an review of lowrider culture see, for example, Chappell (2010; 2012) and Pulido and Reyes (2017).

**Section 2 Figure Credits**

Page 38–39: Tribal headquarters photographed by Bobby Ruiz, Carlos Rivera 63
Page 40: Can 2
Page 43: Bones photographed by Billie the Kid
Page 44: Casper photographed by Willie Toldeo
Page 48–49: Joey Brown photographed by Raspy
Page 58: Gane
Page 60: Dyse One
Page 63: Tribal 59 and Bobby Ruiz
Page 67: Alex Garcia
Page: 68: Herman Plasencia
Page 70–71: Baker
Page 73: Rise Neon
Page 76–77: Fo'Life OG Abel
Page 78: Dyse One

# SECTION 3

## TRIBAL AND ITS TATTOO ROOTS

# RACHEL DAICHENDT

Rachel Daichendt is a philosopher and art historian that teaches at Point Loma Nazarene University in San Diego, CA. Her expertise is on the intersection of architecture and philosophy with a means to create an open dialogue within the context of postmodern aesthetics and visual culture. As part of Rachel's research at the Institute for Doctoral Studies in the Visual Arts, 2025, she engages the philosophical concept of dwelling, concerning how specific structures and art practice can create and inform a poetic atmosphere for lived experience. Daichendt co-hosts the podcast *Two Degrees of Art* and presents internationally on topics ranging from art history pedagogy to philosophical inquiry.

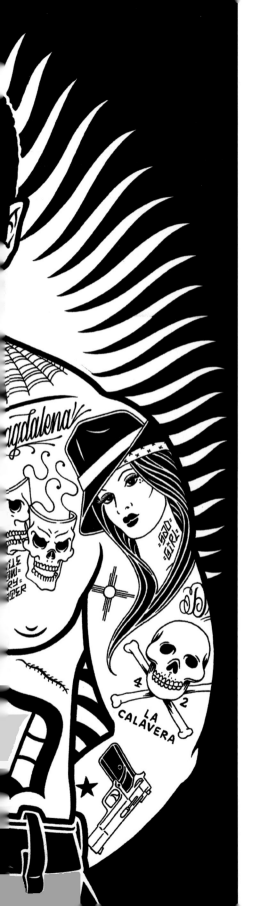

# REPRESENTATION OF WORLD: AN ONTOLOGICAL EXPLORATION OF TATTOOS

## RACHEL DAICHENDT

As an outward sign of an inward representation, tattoos have long been an ontological appropriation of social class, culture, beauty, and marked recognition. With a tattoo shop on most corners and a pastime encompassing many generations, marking the body with ink lends itself to closer inspection. In a majority agreement, as a visual language of the skin (Krutak 2015) tattooing epitomizes a personal identity. Yet, a close philosophical exploration into this tradition helps determine whether the subject, in this consideration the physical body, becomes the object, thus possessing a specific interiority that combines spiritual being with the physical world. Questioning, through tradition and popularity, does tattoo-

ing ultimately reflect a lack of distinction or unique personality, representing instead a conforming to society?

Further relevant to this topic, regardless of inclination, the tattoo captures an existential version of the subject, emphasizing that identity is not separate from the world but woven within it. In a distinctive manner focusing on what philosopher Martin Heidegger considers the "being-there—in the world," the question remains: Can a tattoo capture the essence of the self, or does it have more to do with a representation of the world and our lived daily experience? "We are ourselves an integral part of the world; and our being cannot even be conceived of as other than in a world of *some kind*" (Heidegger, 2010, p. 54). In this case, tattooing and worldly self are the same. It is both a way to have a relationship with the place in which you live and the continual formation of the self.

The term "world" thus sets the tone. An individual is both a part of (ancestrally) and an active participant in their temporal existence in the literal environment we call the world. The philosophical suggestion "world" refers to all things that make up our human reality. In his book *Being and Time*, Heidegger follows the notion of *Dasein* or being-in-the-world, also widely accepted as "being-there." Ultimately pressing upon what is an understanding of the world sensuously and within language, while simultaneously questioning the ontic relevancy by combining the subject and object. Heidegger upsets the traditional understanding of these metaphysical roles. "Dasein is never 'proximally' an entity which is, so to speak, free from Being-in, but which sometimes has the inclination to take up a 'relationship' towards the world" (Heidegger, 2010, p. 54). This relationship of subject/object in traditional terms are separate entities, Heidegger turned this notion upside down, drawing a general conclusion that the subject in the world is one and the same as the object. There is not a separation because the effects of the "world" cannot be extracted from being. Through his interpretative process of *being*, the focus arrives at a relationship with lived experience, fusing an active understanding with a passive one. Does the tattoo become a way of revealing something new or does it uncover a creative spirit that is inherent to *being?* Heidegger's being, or existence, is in experience, so we are illuminating ourselves in it regardless of time and space.

According to Nicholas Thomas in his well-informed book *Body Art*, he considers tattooing "the art form most intimately associated with human experience," linking the self, the senses, the social, and even the political (2014, p. 7). As the "world" and our experiences intertwine, the creation of an individual that

is a collective rather than singular is substantiated. In ancient Egypt female mummies have been unearthed that displayed obvious ink symbols embedded in the outer layers of the fingers. "Although the precise meanings of ancient tattoos may be unclear, it seems evident that they had an array of implications and that women of many different social classes chose to wear them" (Mark 2017). Originally considered to be markings on royal concubines, the detailed and more current research found an extraordinary body that was decorated and most likely a high-status priestess. The world of ancient Egypt even allows for experiences and social status to frame and connect skin markings.

A further historical introduction to a particular culture also helps to engage in a tattoo conversation that interplays between the conscious and unconscious self with the world and cultural significance. Tattoos have been marked on bodies for thousands of years (Lineberry, 2007). Assuming the ink reflects the subject, does a representation of a particular culture or social conformity give the tattoo more or less significance? The Māori, an Indigenous people of New Zealand, is an example of a culture that reflects through tattooing an individual's *whakapapa* (ancestry). Often covering parts of the face as well as the chest and the back, the tattoo was a rite of passage. This *moko* or body art offered a visual language symbolizing rank, prestige, and/or even power amongst a tight-knit group of people using ritual as devotion. The lack of separation between self and world is highlighted here, emphasizing specific information about where the person belongs, a sort of ID card for the tribe.

The imagery displayed on the skin outwardly illustrates an individual as a social subject wanting to connect to an environment that has strong ties to their being. But does it also claim a specific distinctive nature that is inclusive of where you are from and the bloodlines that you share? Or is the sense of community more of a universal display, proving more conformity than individuality? The ample number of tattoo shops offer thousands of images, giving the subject a boundless number of choices. In this respect, is the image a choice of the individual or the tattoo industry? Aesthetic and beauty concerns shift from business to consumer, as the subject explores the concepts of artistic practice and not just assumed technical ability. "All art will be understood more richly if it is understood in cultural, social and historical contexts" (Thomas, 2014, p. 37). Body art, then, proclaims a certain intimate art form, sharing a proliferate celebration in claiming a creative experience with an appreciation of permanent decorative adoration. The image becomes the shared world experience and illustrations are both historical and ever-changing. In this case formal aspects fuse with choices of taste and judgment.

Illustrations vary slightly with a majority of shops offering the traditional renderings of long-standing themes, i.e, American Traditional, black and gray, Japanese, and New School, among others. Generationally these images strike a chord as the person most often chooses an image that is vocationally and/or locationally sound. In honoring most traditional aspects of this ancient and current art form, most present-day shops seek to inform visitors of the strong symbolic value. An example lies in the representation of the swallow. This bird, often rendered in thick black lines, with accents of red and yellow, offers a story that connects time and vocation. Often swallows travel long distances and then return to their original nesting site. This mirrors sailors and was often seen as a reflection of the extreme distance sailors have traveled. The maritime motif embraced nature in a binary way, allowing the individual to exhibit what they do and where they have been. This solidarity in flesh and spirit became noticeable in other popular images, including the anchor, mermaid, shark, and American eagle.

Not to be ignored are the obvious contemporary connections, as the millennial generation has set a separate creative tone for a hyper-traditional industry. "The phenomenological approach assumes that individuals connect on a personal level to things and places as they uncover their real meaning and value" (Heidegger, 2010, p. 62). Google and smartphones have given this generation a newfound outlet and voice. Shifting the attention from tradition to an outspokenness that prefers individuality within unique and personalized renderings. According to The Harris Poll in 2015, nearly half of all millennials have tattoos, compared to just 13 percent of baby boomers (The Harris Poll, 2016). An interesting take on a group of individuals that want to be unique, yet regardless of image the tattoo itself offers conformity.

In pursuing these answers and a more complete understanding of the ontological relationship between the world and culture related to tattoos, it is pertinent to include Tribal Streetwear's role in this dialogue. A term that holds many meanings, a tribe according to *Notes and queries in anthropology* holds specific relevancy as Tribal uses the term The Lower Left as a geographical way to differentiate and highlight the unique section of San Diego, CA. "A tribe may be defined as a politically or socially coherent and autonomous group occupying or claiming a particular territory" (Biebuyck, 1966, p. 501). As a dominant member of the San Diego street culture, Tribal is a group that individuals want to be associated with, from clothing and cars to a much-acclaimed tattoo shop, the brand has created a global significance.

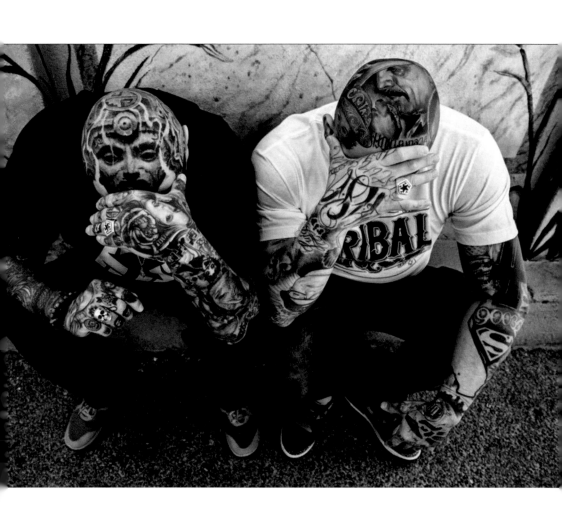

This is apparent in the much repeated and ever-present Tribal logo, formally pleasing it combines five distinctive "T" letters that make out of the outline of a star. The growth and popularity of the brand naturally invite many people to tattoo the logo on themselves. Being a part of a group and inking their representation on a part of the body shows a claim that is reminiscent of the Māori people; a symbol representing devotion. In its traditional context, tattooing most often served to induct the recipient into Indigenous society as a properly enculturated community member (Krutak, 2015). This representational tattooing rings true as both honoring and including yourself within the specific "world," one which is both proudly represented and innately honoring.

The inclusion of ink permanently on the skin also lends itself to considering how the representation of the subject's world considers time. As a temporal being, the everlasting ink sits in the skin, unremovable, reinforcing the fact that regardless of initial inclination there is a forever marking of an object. Can a heart with an arrow through it have the same spiritual meaning as the Māori or Tribal cultural statement? The popularity of tattooing must play a role as the everyday person entering a shop is not referencing an ancient culture but rather, just belonging to this one. This belonging at its core gives the tattoo its importance to the individual. Community, friendship, and alliances are all examples of a temporal belonging with perhaps a more eternal inclination that gives the individual a unique approach to their "world." In many cases, it seems to have sprung up independently as a permanent way to place protective or therapeutic symbols upon the body, then as a means of marking people out into appropriate social, political, or religious groups, or simply as a form of self-expression or fashion statement (Lineberry, 2007).

Ultimately, the ties that bind Heidegger's "world" to the tattooed subject create a connection that is ontologically united. While perhaps being unique in inspiration, the path toward culturally related significance in the tattoo phenomena lies in the inherent being (all of the ways in which we live). "Phenomena are not referential, or an appearance of something in relation. Phenomena must occur so that we can, as beings, have relationships to things in the world and a relationship to, or tacit understanding of, our essential being-ness" (Heidegger, 2010, p. 60). If there is no separation of world and being, the visual representation of the tattoo mirrors this concept, considering perhaps they are in relation to each other and therefore still unique to the individual.

# REFERENCES

Biebuyck, D. P. (1966). On the concept of tribe / SUR LE CONCEPT DE TRIBU. *Civilisations*, 16(4), 500–515. http://www.jstor.org/stable/41231451

Heidegger, M. (2010). *Being and time: A revised edition of the Stambaugh translation* (SUNY Series in Contemporary Continental Philosophy, D. J. Schmidt, contrib., & J. Stambaugh,trans.). State University of New York Press.

Krutak, Lars. (2015). The cultural heritage of tattooing: A brief history. *Tattooed Skin and Health*, 48, 1–5. https://doi.org/10.1159/000369174

Lineberry, C. (2007). Tattoos: The ancient and mysterious history. *Smithsonian Magazine* (pp. 1–6).

Mark, J. J. (2017, January 9). Tattoos in Ancient Egypt. World History Encyclopedia. https://www.worldhistory.org/article/1000/tattoos-in-ancient-egypt/

The Harris Poll®. (2016, February 10). By Larry Shannon-Missal. https://www.prnewswire.com/news-releases/tattoo-takeover-three-in-ten-americans-have-tattoos-and-most-dont-stop-at-just-one-300217862.html

Thomas, N. (2014). *Body art (world of art)* (1st ed.). Thames and Hudson.

Zealand Tattoo. (2020, July 31). Maori tattoo: The definitive guide to Ta Moko. http:// www.zealandtattoo.co.nz/tattoo-styles/maori-tattoo

# EVAN SENN

Evan Senn has contributed to three books on contemporary street art and lectured at a number of prestigious universities in southern California. She is a curator, art critic, and contributing artist to the local southern California art scenes. Formerly the editor-in-chief of *Inland Empire Weekly*, *Culture Magazine*, and assistant editor for *YAY! LA Mag*, along with contributing to a variety of gallery and museum catalogs, and underground zines. Senn holds an M.A. in art history and has contributed as an arts writer for KCET Artbound, OC Art Blog, OC Register, *OCR Magazine*, *Artillery Magazine*, Art and Cake, *Artvoices Magazine*, *Local Arts, Beauty & Wellness Magazine*, Laika, *Wild Magazine*, Unite4:Good, and *E-VOLVED Magazine*.

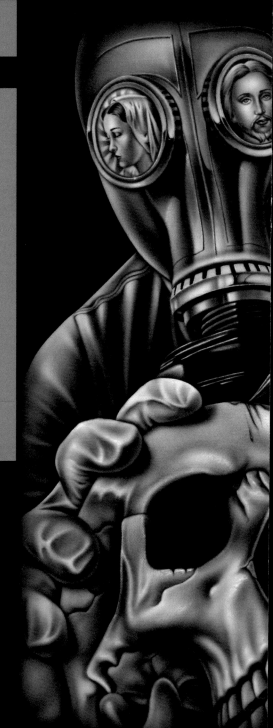

# A BRIEF LOOK AT SOUTHERN CALIFORNIA TATTOO CULTURE AND HISTORY

EVAN SENN

## INTRODUCTION

Although evidence of tattoos and tattoo equip-ment have been found dating back to 10,000 BCE (Gilbert, 2000), many of history's tattoos served a therapeutic purpose over a cultural or emotional one. We have seen simple tattoos show up on stone age figurines, on ancient Egyptian mum-mies, in descriptions of several ancient tribes' practices, as well as on the bodies of warriors and royalty all over the world. In early American history, we have evidence that tattoos were practiced among the early Native American tribes as rites of passage or medical treatments, and even after the continent was colonized, tattoos were used by many races and cultures to treat

specific ailments (Waxman, 2017). Today, however, tattoos are largely utilized as a personal or cultural expression of identity or community.

# HISTORICAL CONTEXT

## MODERN TATTOOING

New York City is considered the birthplace of modern tattooing by most experts, partly because it is where the first professional tattoo artist, Martin Hildebrandt, set up shop in the mid nineteenth century to tattoo Civil War soldiers for identification purposes, and partly because it is where the first electric rotary tattoo machine was invented in 1891, inspired by Thomas Edison's electric pen (Waxman, 2017). However, since these initial developments, tattoo culture has formed several hubs of talent, often located in major metropolitan creative centers. Southern California is particularly unique as an influential tattoo center due to its several famed ports helping to popularize the American Traditional tattoo style among servicemen, its dominant influence in street art, as well as its history with the East Los Angeles Chicano community and culture.

Tattoos had been present in southern California for as long as the navy used the area as a port. Although the roots of American tattoo history can be traced back to Oceanic and Asianic cultures, especially the Japanese, this fascinating art form reached the California shores from the Pacific world. The tradition of those in the navy to have tattoos was propelled through the 1700s when Captain Cook discovered the more decorative tattooed natives of the South Pacific. Cook's sailors were looking for the perfect memento of their journey into foreign lands, and a more creative tattoo than simple identification was the souvenir of choice.

Over time, sailors developed their own visual code for tattoos, obviously inspired by the symbolism used in the tattoos of the South Pacific and the Native American tribes. Symbolizing places they've been, accomplishments and accolades, as well as superstitions and luck, these American sailor tattoos became the foundational images and symbols for the tattoo style later known as the American Traditional style.

According to tattoo historian, Chuck Eldridge from the Tattoo Archive in Winston-Salem, North Carolina, a common pair of hand tattoos seen on sailors, "HOLD" on the knuckles of one hand and "FAST" on the other, was said to help the sailor to better hold the riggings of a ship. A tattoo of a pig on the top of one foot and a rooster on the top of the other was to supposedly protect the sailor

from drowning because both of these animals cannot swim; they would help get the officer to shore quickly. Port and starboard ship lights were often tattooed on the left (port) and right (starboard) side of the body of a sailor, while a tattoo of a rope around the wrist meant the sailor was a deckhand. A very common image of an anchor was acquired if the sailor had sailed the Atlantic Ocean. A full-rigged ship was acquired if the sailor had sailed around Cape Horn. A dragon tattoo could be acquired if the sailor had served on a China station, but a golden dragon was only for sailors who had crossed the International Date Line, while a shellback turtle tattoo was for sailors who had crossed the equator (Eldridge, 2003).

# THE PIKE

The oldest tattoo parlor in California is Bert Grimm's World Famous Tattoo Studio, now known as Outer Limits Tattoo & Piercing, which opened in 1927 but is now run by renowned tattoo artist Kari Barba (since 1983), and contains a small tattoo history museum in the front of the shop.

The shop is located near what used to be known as The Pike, a seaside amusement park area in Long Beach, which dates back to the 1800s. The tattoo shop, thought to originally be called The Professionals opened in 1927 and was purchased by Bert Grimm in 1954. It was one of twelve tattoo shops open during the heyday of The Pike but is the only remaining business from the historic amusement park now. The shop catered to and received much of its business from the sailors stationed nearby at the Long Beach Naval Shipyard, which was shut down in the early 1990s.

Several historic tattooers made their names at The Pike, specializing in American Traditional, as was popular at the time, including Owen Oakley Jensen and his wife Dorothy "Dainty Dotty" Jensen, Charles "Red" Gibbons and his wife Anna Mae Burlingston, aka "Lady Artoria Gibbons," Harry V. Lawson, Frank Martin, Jack Julian, and many others (Outer Limits, 2015).

Grimm was a well-known tattoo artist by the time he bought the historic Pike tattoo shop, having started tattooing in 1912. Early in his career, Grimm worked with carnivals and spent a season with the Buffalo Bill Wild West Show. In his twenties, he made a living as a sideshow tattoo artist; traveling the carnival circuit, and tattooing during the off-season in the arcades along Chicago's South State Street (Outer Limits, 2015). He previously owned and operated tattoo shops in Oregon and St. Louis before deciding to move to Long Beach with his wife to capitalize on the booming tattoo industry in the area. He is considered

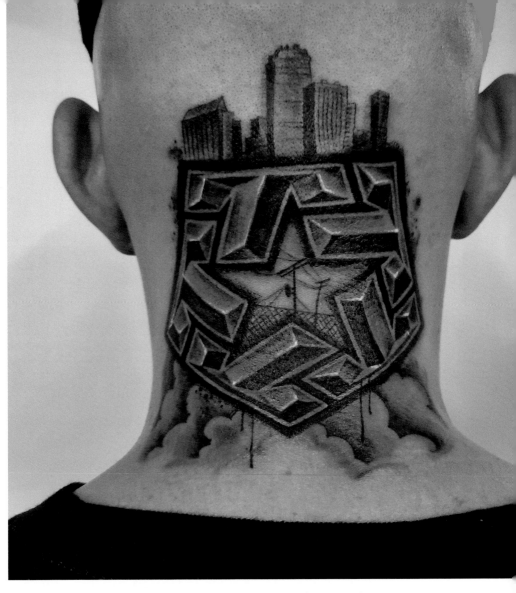

one of the founding fathers of the American Traditional style and was famous
for his large-scale tattoo work including full back pieces, sleeves, and
full-body suits.

Another great artist who got their bearings at The Pike and who helped shape
the southern California style of tattooing early on was "Tahiti Felix," also known
as Felix Lynch, who embraced the Polynesian lifestyle and tattoo style (he also
married a Tahitian woman). He apprenticed at The Pike in Long Beach under
Lawrence Lee "Mac" McKeever in the 1930s and in 1949 he opened up his
own tattoo shop in San Diego, Master Tattoo (Tahiti Felix's Master Tattoo Parlor
& Museum n.d.).

Although not as famous as The Pike in Long Beach, San Diego was another longstanding destination for tattoos due to its large Naval fleet, the nearby Marine Corps base at Camp Pendleton, and Recruit Depot.

## TATTOOS AND WOMEN

It wasn't just sailors and marines getting ink though. In the 2015 exhibition, *Tattooed and tenacious: Inked women in California's history* at the Hayward Area Historical Society, curator Amy Cohen explored and explained the complex and specific history of females getting tattooed in California, and the variety of visual styles that these tattoos represented. According to the exhibition, women in native California tribes such as the Pomo, Miwok, Chukchansi, and Hupa have practiced body tattooing among tribe members and captives since the mid 1800s. Almost every California tribe had a tattooing tradition, often consisting of straight lines of varying thicknesses, dots, or zig-zags, and commonly seen on women's chins or arms. Cohen also included a thorough section on wealthy women and tattoo fads that showed an interesting alternative side of California tattoo history among women, including that of Aimee Crocker, the Sacramento railroad heiress who got many different unique and personalized tattoos throughout her well-traveled life. The exhibition explained that Crocker and other elite California women may have been inspired by Lady Randolph Churchill, mother of Winston Churchill, who sported a snake tattoo on her wrist. Also displayed were heavily inked "tattooed ladies," mainly working-class performers and artists who were covered with permanent body art who made an above-average living as circus sideshow performers starting in the 1880s (Cohen, 2015).

## ADVANCED TECHNOLOGY AND TATTOOING

By the 1910s, tattoo technology had greatly advanced and helped promote more intricate designs in a variety of colors and styles. Subcultural popularity for tattoos continued to grow in California's port cities up through World War I until the reputation for tattoos became more focused within circles of communities like prison inmates and motorcycle gangs, deterring the popularity for high society ink and female clients (Cohen, 2015).

After World War I though, we see tattoos gain momentum in different California populations and in different styles for the first time in large numbers. Up until this point, the American Traditional style reigned as the leading style of tattoo art in California, and in the United States as a whole. But soon, another style

would take hold of southern California's tattoo culture and never let go.

## THE CHICANO TATTOO STYLE

Chicano-style aesthetics in art and design can be seen in one way or another in every aspect of southern California life today, from surf and skate culture to graphic design and fine art, to car culture and tattoos. Because of southern California's history as a destination for many different immigrant communities, as well as its history as a creative destination, several aesthetic movements have blossomed in the region, including Chicano art and Chicano tattoos.

The Chicano tattoo style is often misunderstood by outsiders, lumped into some unassuming category like "jailhouse tattoos," but the rich history and specificity of the Chicano tattoo style are unique, powerful, and thoughtful. Chicano artists, both visual and tattoo artists, have a powerful philosophical and political inclination to express and use culturally significant imagery to get their points across. Often referred to as simply "black and gray" style, Chicano tattoo art utilizes smooth tones of blacks and grays to create the illustrative style it is known for. Rather than the thick black outlines and bright colors of traditional-style tattoos, Chicano tattoos have finer lines and subtle shading and often reference a photo's realistic quality. With roots in simple ballpoint pen and pencil drawings, this style of tattoo work valued the visual mainstays of its history and simply evolved it further.

When Mexican immigration peaked in the 1920s–40s, many Chicano youths fought

against the status quo. In 1943, this finally culminated in the Zoot Suit Riots, sparked by racial tensions of the time, the wartime rationing regulations, and then the death of a young Mexican American man in Los Angeles. It was during this time that the pachuco gang began popularizing cholo graffiti and tattoos among the Chicano youth culture, as they were a prevalent cultural force in Mexican American communities in New Mexico, Texas, and California. Gangs emerged as a means of asserting cultural pride and maintaining control over their communities, and street writing was a way of defining territory. After the Zoot Suit Riots, gang life further evolved alongside street writing and tattoos. Cholo gang members like the pachucos emphasized the creation of a unique Chicano youth community based on street culture (Marin, 2011 cited in Deitch et al., 2011). (Terms like cholo and Chicano are reclaimed activist terms, once used in a derogatory fashion, but transformed into a badge of pride in the 1960s.)

The first pachuco tattoos were of the famous pachuco cross—a simple single-line cross with three lines radiating upward, between the thumb and the index finger. This tattoo was a signifier of gang membership or allegiance. The popularity of simple tattoos spread quickly, and by the 1960s, Chicano tattoos had adopted other imagery as well as non-gang-member clientele. Many of these new tattoo themes included scenes from gang life, skulls, Catholic iconography, beautiful women, clowns, flowers, and lowriders. During this time, uncultured people thought the Chicano art movement was a symbol of criminal activities, but for the southern California Chicano community, these tattoo designs successfully depicted commitment to their culture.

In addition to the popularity of tattoos spreading through Chicano youth cultures, this movement had helped through the rise in popularity of pen and pencil illustrations drawn on bedsheets, handkerchiefs, and pieces of cloth. This art form, called "panos," got its name from the Spanish word panuelo, meaning handkerchief. Prison inmates used to send well-drawn beautiful art pieces on cloth of some kind back home—or even inside the prison—to their families and gangs to express their love, gratitude, care, and secret messages (Khunt, 2019). The style

of illustration was delicate and similar to the detailed and dramatic Catholic art seen in Mexican churches and altars. This underground art form helped Chicano tattoo art—which utilized the same kind of style and imagery—gain momentum in and outside of prisons. With no access to colored inks, prisoners use watered-down black ink to create different varieties of gray, for shadows and depth, eventually earning the descriptor "black and gray" style.

# BLACK AND GRAY

Black and gray style tattoo art today is not just prison related or even Chicano style, but it came out of the unique southern California Chicano style of tattoo-ing. Don Ed Hardy worked in San Diego in the late 1960s and early 1970s, doing Japanese-style tattoos, but later on in his career helped to perpetuate and promote black and gray work and artists in the California tattoo scene. After coming back from Japan in 1973, he moved north to open an appointment-on-ly, custom tattoo shop called Realistic Studio in San Francisco. But at one of the first major tattoo conventions (put on by the National Tattoo Association) in 1977 in Reno, NV, there was a major point of revelation for the tattoo com-munity at large, and specifically the California tattoo community that changed everything.

Artists from all over the world attended this convention, and tattoo legends like Hardy, Good Time Charlie Cartwright, and Jack Rudy all met for the first time. Cartwright and Rudy were well-known in southern California at this time for do-ing the monochromatic single-needle photo-realistic style tattooing with stylis-tic influence from southern California Chicano and Latino street culture. Hardy and other well-known artists at this time like Mike Malone and Bob Roberts were blown away by this newly refined black and gray Chicano style of tattooing. "This was the first kind of counterpart to the Japanese tradition as another way to tattoo. We were very taken with the whole idea of the single needle style and all rushed to learn and develop that" (Hardy, 1996 cited in Gilbert, 2000, p.198). There were previous historic precedents in single-needle styles, like with the early Japanese masters and British pioneer tattooer George Burchett using single needles, but not much in the way of "modern" tattooing for roughly 70 years prior (Hardy, 1996 cited in Gilbert, 2000).

Hardy was so enamored with that style of tattooing that he bought Good Time Charlie's shop in East Los Angeles and had Jack Rudy help him run it, eventually changing the name of the shop to Tattooland.

[Cartwright] and Jack Rudy has been running that shop but Charlie had a religious vision and decided he was going to get out of tattooing, and I bought the shop really to keep it going as a base of expression for that kind of work. I thought it was an incredible and really creative thing that was happening with it. So, Jack managed that shop for me. We eventually had to move the location to a block down the street and we called it "Tattooland."

(Hardy, 1996 cited in Gilbert, 2000: 198)

## AESTHETICS AND SYMBOLISM

Another eventual southern California tattoo legend, Chicano tattoo artist Freddy Negrete got his professional start at Good Time Charlie's Tattooland in 1977. The primarily Mexican American clientele flocked to the shop for the famed fine lines and black and gray shading. Although Negrete learned to tattoo on his own, in and out of prison most of his life, he sent people he had tattooed over to the shop to show off his work until he was able to land a spot at this notorious tattoo shop. "I was like the first Chicano who ever even got a job as a professional tattoo artist" Negrete told *NPR* (Meraji, 2018, para. 9).

In his memoir, *Smile Now, Cry Later: Guns, Gangs, and Tattoos, My Life in Black and Gray*, Negrete wrote about his difficult life and his search for belonging and acceptance in one of Los Angeles County's most notorious Chicano gangs and went into great detail about Los Angeles' unique gang Chicano culture, style, street writing, and the tattoo art. "I displayed my ink with pride—a mix of Aztec, Mexican revolutionary, and cholo imagery. These were our campfire stories, our myths, the marks of our culture. And once marked, you were marked for life" (Negrete et al., 2017, p. 1).

Negrete popularized the "smile now, cry later" tattoos, often accompanied by or symbolized by a clown or comedy and tragedy masks. The phrase comes from a song titled, "Smile Now, Cry Later" by the Chicano band Sunny and the Sunliners (Negrete et al., 2017). This type of tattoo symbolizes the concept of hiding your weaknesses or tears while you're in prison (or performing) and saving your real emotions for when you're home with your family or loved ones. It was very popular among inmates in prison or gang members initially, and then simply adopted by fans of the tattoo style.

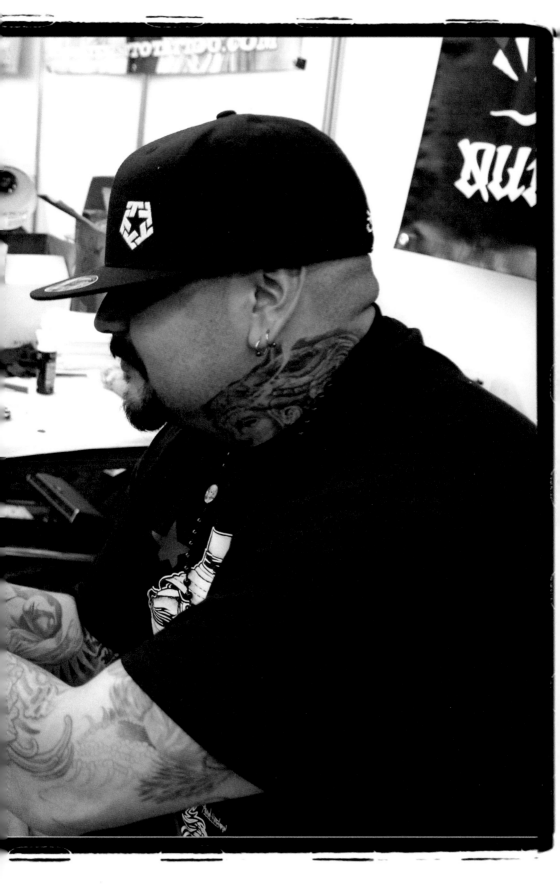

Other popular themes of Chicano-style tattoos include lowrider cars, Bandidas, large Chicano lettering, eagles, and religious iconography—all very important aspects of southern California Chicano culture. In Chicano culture and art, cars can be symbols of economic status, of community, and sometimes gang or crew representation. The lowrider is often depicted as a classic car that is lowered all the way to the ground. Hydraulic suspensions were invented in California, and most people agree that the lowrider culture is unique to the southern California area. The invention of the lowrider type of car and culture is widely accepted to have been pioneered by Mexican Americans in southern California, so a representation of the lowrider in tattoo art is a direct reference to Chicano heritage, innovation, and culture (Arria, 2012). Much of the decorations and custom art on lowriders also reference the Chicano tattoo art style, adopting the fine lines and delicate shading of those same pen and pencil drawings that inmates were creating earlier.

The Bandida tattoo is another common image found in southern California Chicano tattoo art and is often a female icon or a stereotypical beautiful woman. Sometimes she may be adorned with clown paint on her face, a bandana or mask resembling the Zapatistas, or some part of a skull showing through her face. The Bandida is said to symbolize either a woman or women you love or have lost, or simply the beauty of life and love. However, if an aspect of the Zapatista is also included, it may also be symbolic of protest and standing up against injustice. She is often depicted with additional details like dollars, skulls, guns, or flowers, symbolizing the frailty of human life (Choudhary, 2022).

Lettering in Chicano tattoos is often very large in size and either a fancy script-style font or an Old English-style font. As is true for Chicano graffiti, the type of font chosen for Chicano tattoos is very significant to the meaning. Old English-style lettering is often used to convey authority or power in the word, name, or phrase, while the script font is often utilized to convey a more emotional meaning (Deitch et al., 2011). Some script styles used harken back to the swap meet style airbrush art you would be able to see on T-shirts and sneakers at urban southern California swap meets—affordable urban one-stop-shops and pop-ups for fashion and accessories, household items, toys, jewelry, and appliances. This same style of airbrush font can be seen in lowrider art.

The eagle is another common image we see in Chicano tattoos and can symbolize success and freedom or can reference the Aztec symbol for warrior or the centerpiece of the Mexican flag. Of course, one of the most common themes we see in Chicano tattoo art is religious in iconography. Because more than 80

percent of the Mexican population is Catholic and religion is another aspect of culture that is passed down from one generation to the next, it is understandable that so much of the beautiful and symbolic iconography be present in the longstanding visual expression of Chicano tattoo art (Choudhary, 2022).

## CARRYING IT FORWARD

Some of the younger generations of Chicano-style tattooers like Mister Cartoon, aka Mark Machado, are still holding true to the tenets of this historic and culturally significant style. Although he got his start as a street artist, lowrider airbrush artist, and silk screener, Cartoon learned to tattoo from a friend when he was in his twenties, and gained fast notoriety in the 1990s among established musicians like the rap group Cypress Hill, Eminem, Travis Barker, and even Beyonce Knowles. Today, he is not only a world-famous black and gray artist who represents the Chicano tattoo style in a variety of ways to suit his mostly celebrity clients (Norris, 2003) but also has made a name for himself in corporate logo design, branding, and lifestyle marketing. Cartoon's work has helped to bridge the gaps between Chicano tattoo art, street art, and the mainstream marketplace. Two films have even been made about Cartoon's unique life and work with Estevan Oriol, *Lowriders* (2016) and *LA Originals* (2020).

Cartoon utilizes the classic Chicano tattoo art styles in his ink, his graphic design, his streetwear, his street art, and his car art as well. He is a huge supporter of Chicano art and his whole life has been dedicated to staying true to the aesthetic and the culture represented in it. As he explained to *Los Angeles* magazine so eloquently, he just wants to share the beauty of street culture with the world.

> We wanted to take Chicano art as far as we could take it. Show our art to people that weren't part of our culture and didn't have access to it, let them see how we draw and what our style is. We didn't expect to take it to the red carpet in Hollywood or major brand collaborations. One minute we'd be in the housing projects in Watts and East L.A., then we'd be having lunch at Fred Segal. It's hard to cross from one to the other. But the beautiful part that comes out of street culture, which could be connected to violence, poverty, incarceration, is the art form.

> (Moayeri, 2020, para. 10)

Just as the pachucos and zoot suiters used their fashion style in combination with their Chicano tattoos and street writing to firmly express their unique

cultural heritage in the 1940s, the Chicano youth cultures of the 1980s and 1990s established their own fashion-forward ways of representing their culture and community through the implementation of their unique tattoo-dominant aesthetics into their streetwear. Surfers, skaters, graffiti writers, and artists of all kinds and cultures in southern California found self-expression through art, design, and fashion—whether it was in the 1940s or the 1990s. This area seemed to encourage creativity among the youth and still does. Cartoon was one of the most well-known tattoo-forward influencers in southern California in the 1990s, and his choice of fashion, cars, music, and lifestyle—as well as other cultural influencers of this time—became a part of a popular trend and that trend eventually grew to be synonymous with southern California style.

As the cultural curiosity and attraction to southern California Chicano tattoo style grew, the popularity of California streetwear grew in tandem. Big Tiny, a well-respected San Diego-based Chicano tattoo artist and entrepreneur says that in the early 1990s, Tribal Streetwear was a coveted brand that only those in the know could get. "I was tagging when I was real young, around 14 or 15, and just seeing their stuff all over the place," he said.

> You saw it on the Beastie Boys and you saw it on Limp Bizkit—like this stuff you see on MTV. Then, when I was at some of the yards, spray painting, you'd see people rocking T-Stars. But Tribal wasn't in every store. You could only get it in San Diego.

> (Big Tiny, 2022)

Once celebrity culture began embracing brands like Tribal Streetwear, a company that supports and showcases Chicano-style tattoo art and aesthetics, the Chicano style of tattooing catapulted across the globe to infiltrate the tattoo centers of the world. Big Tiny (2022) recalled,

> I'd go to Russia and Japan and all these other countries around the world, and they're looking like Cholos—it has that much influence, because they see the brotherhood that comes with it, the Chicanismo, the tattoos, the low rider culture, and the family.

"Family's a big part of the Chicano culture." The family aspect of Chicano culture translates into the tattoo aesthetic through the strong emotions and relationships depicted, the rarefication of the style, the secret symbolism, and the elegant and unique illustrative realism associated with Chicano-style tattoos.

Companies like Tribal Streetwear also capitalized on the rarefication and unique quality of the Chicano tattoo aesthetics. Tribal's brand has utilized the Chicano illustrative style from the very beginning—but for them, it wasn't a trend. It was representing who they were and what their culture was. Brands like Tribal were monumental in cementing and supporting the southern California tattoo art movement and culture through their influence in mainstream media and with their partnerships and collaborations with tattoo artists, musicians, surfers and skaters, graffiti writers, and cultural influencers since the 1980s.

Big Tiny (2022) explains that Tribal became synonymous with the southern California aesthetic in the 1990s and is maintained today.

> Tribal Streetwear is California, especially Southern California. You have a mixture of everything. You have the surfing, you have the graffiti, you have the tattoos, you have low riding. You have everything. Everything in Southern California—it's just what Tribal is. Tribal is Southern California.

Southern California tattoo culture is still led by the Chicano tattoo style, but a new subsect of the style is gaining momentum in the tattoo mecca of southern California—a more refined black and gray realism and surrealism, still with an undeniable Chicano flare. Artists like Carlos Torres, Alex Garcia, Tony Mancia, Mat Hurtado, and Mikey Carrasco are becoming increasingly more sought after by celebrities and, in turn, are shifting their style. The black and gray realism is expanding to include more classical symbolism and more dramatic illustrative techniques than the original Chicano tattoo style.

## CONCLUSION

Southern California tattoo culture today is vast and has something for every type of person. With roots in American Traditional styles, we still see a lot of artists and shops specializing in that style of work, but in the incredibly popular movement of tattoo culture now, there are more shops and artists utilizing and embracing the black and gray Chicano style in tattoos, design, and fashion. The complex and creative expression involved in the Chicano tattoo style is no longer a secret underground movement for only a select few to be in the know of, but is a celebrated and symbolic style known the world over, for its rich imagery, meaning, and detailed illustrative style.

Additionally, as southern California's diversity has grown exponentially in the last 20–30 years and continues to expand, with that expansion, the preference for more unique and distinctive creative expressions has also grown. Tattoo lov-

ers are seeking out artists and areas that specialize in detailed black and gray work and more specifically, the Chicano style of tattooing. People will travel all over the world for work by specific artists in particular styles now. Tattoos are no longer relegated as symbols of criminal activity, but as wearable pieces of art to be collected and valued in the same way as fine artworks. Not unlike fashion, the art form of tattoos is one of the only forms of artistic expression that can exist in a crossover state between highbrow and lowbrow culture, simultaneously valued as a collected fine artwork by some and dismissed as inconsequential and superficial by others. This unique place for both fashion and tattoos is complicated but fascinating.

Using history as a barometer to hypothesize possible futures for tattoo art and culture, it seems likely that Chicano-style tattoo work and/or black and gray work will exceed past its already impressive aesthetic boundaries and expand or morph into subsections within other cultures and locales. The Latin American and Chicano creative cultures that have become uniquely synonymous with southern California culture will never dissipate entirely from the style, regardless of the growth or evolution of the black and gray aesthetic in tattoos; however, it will only further cement the influence of this local culture into our larger global tattoo history.

# REFERENCES

Arria, M. (2012, October 15). *The cultural significance of lowriders in America*. Vice. https://www.vice.com/en/article/qkkmpw/lowriders

Big Tiny. (2022). Interview by Evan Senn, San Diego, September 23.

Choudary, J. (2022, December 13). *Chicano tattoo: Meaning, cultural references and everything about it*. fixthelife. https://www.fixthelife.com/chicano-tattoo/#Bandida_Tattoo

Cohen, A. (2015). *Tattooed and tenacious: Inked women in California's history*. Hayward Area Historical Society, Hayward, CA, July 9–August 15.

Deitch, J., Gastman, R., & Rose, A. (2011). *Art in the streets* [published on the occasion of the exhibition held at the Museum of Contemporary Art, Los Angeles and the Geffen Contemporary at MOCA, April 17–August 8; Brooklyn Museum, New York, March 30–July 8] (p. 146). Rizzoli.

Eldridge, C. (2003, n.d.). *Sailor tattoos – tattoo archive*. Tattooarchive. https://www.tattooarchive.com/history/sailor_tattoos.php

Gilbert, S. (2000). *Tattoo history* (pp. 197–199). Juno Books.

Khunt, Y. (2019, June 7). *Chicano tattoos: Roots, cultural references – Trending tattoo*. https://www.trendingtattoo.com/chicano-tattoos-roots-cultural-references/

Meraji, S. (2018, April 15). *Black and gray … and brown: A tattoo style's Chicano roots*. NPR. https://www.npr.org/sections/codeswitch/2018/04/15/602169159/black-and-gray-and-brown-a-tattoo-styles-chicano-roots

Moayeri, L. (2020, April 10). *Estevan Oriol and Mister Cartoon, a pair of L.A. originals, tell their story. Los Angeles* magazine. https://www.lamag.com/culturefiles/la-originals-estevan-oriol-mister-cartoon/

Morrow, J. (n.d.). *Chicano tattoos: Roots, cultural references, and artists*. Tattoodo. Retrieved August 14, 2020, from https://www.tattoodo.com/guides/styles/chicano

Negrete, F., Rodriguez, L., & Jones, S. (2017). *Smile now, cry later*. Seven Stories Press.

Norris, M. (2003, January 1). *Mister Cartoon's growing tattoo empire East L.A. artist's work a favorite of top music stars. NPR*. https://www.npr.org/templates/story/story.php?storyId=895768

Outer Limits. (2015). *A brief history of tattoos, colorful characters, & the shop that won't stop.* Retrieved August 15, 2021 from https://www.outerlimitstattoo.com/pike-artists.

Tahiti Felix's Master Tattoo Parlor & Museum (n.d.). History. Retrieved August 15, 2021, from http://www.mastertattoo.com/history.

Waxman, O. (2017, March 1). *See rare images from the early history of tattoos in America. Time*. https://time.com/4645964/tattoo-history/

**Section 3 Figure Credits**

Page 84–85: Photograph of Johnny Quintana
Page 86–87: Mike Giant
Page 91: Michael Jaffe
Page 94: Sal Elias
Page 98: Photograph of Russian fan tattoo courtesy of Tribal Streetwear
Page 100: Photograph of Mister Cartoon in Japan
Page 103–04: Steve Soto photographed by Bobby Ruiz

# SECTION 4

## TRIBALISM AND IDENTITY

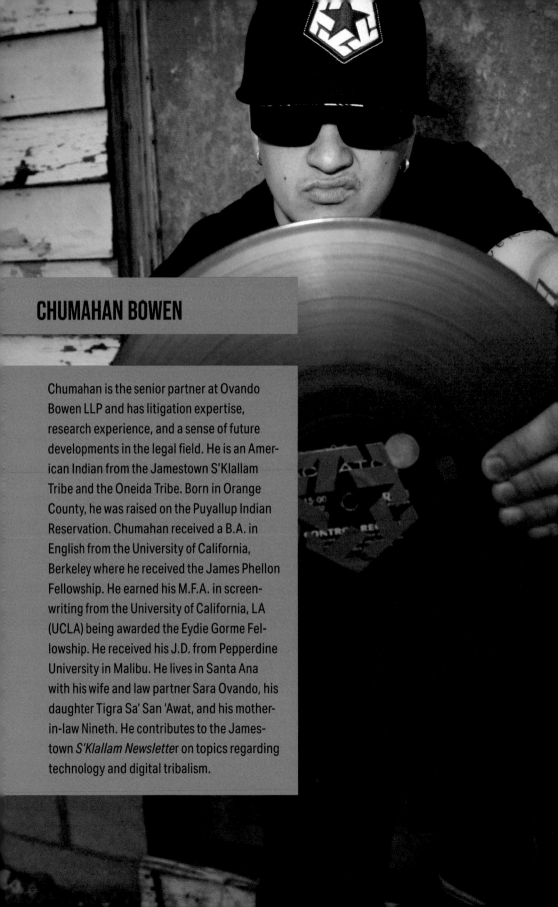

# CHUMAHAN BOWEN

Chumahan is the senior partner at Ovando Bowen LLP and has litigation expertise, research experience, and a sense of future developments in the legal field. He is an American Indian from the Jamestown S'Klallam Tribe and the Oneida Tribe. Born in Orange County, he was raised on the Puyallup Indian Reservation. Chumahan received a B.A. in English from the University of California, Berkeley where he received the James Phellon Fellowship. He earned his M.F.A. in screenwriting from the University of California, LA (UCLA) being awarded the Eydie Gorme Fellowship. He received his J.D. from Pepperdine University in Malibu. He lives in Santa Ana with his wife and law partner Sara Ovando, his daughter Tigra Sa' San 'Awat, and his mother-in-law Nineth. He contributes to the Jamestown *S'Klallam Newsletter* on topics regarding technology and digital tribalism.

# TRIBAL STREETWEAR WILL BE THE FIRST AESTHETIC ETHNICITY FOR THE DIGITAL METAVERSE

## CHUMAHAN BOWEN

Tribal Streetwear is more than a clothing brand—it is a brand-new identity classification; it is a new manifestation of the "ethnicity" concept. There is a shared language, a shared culture, a shared set of values, and a shared aesthetic. It is informed in part by the history of colonialism as much as it is a living American company named after a human social group that the dominant culture *currently* oppresses. Yet "race" is not the sole entry or a bar into Tribal Streetwear. Many pass through the gates by their shared affinity for the Tribal Streetwear aesthetic. Many pass through the gate by their affinity for its spirit, or values. Thus, Tribal Streetwear is accessible to anyone—anywhere. This is true for a brand that is synonymous with southern California and has many global adherents too. This may be the secret to Tribal Streetwear's longevity in a business sector famous for short-lived brands.

The word "tribal" is the first thing I see in Tribal Streetwear. Raised on the Puyallup Indian Reservation and fighting my way

through Chief Leschi Elementary, *tribal* was everywhere: road signs, paper, ti-
tles, administrative buildings, markets, and so forth. Once I left the reservation,
the word made itself known in new forms. Tattoo styles, the Jewish faith, the
current political climate, and other groups claimed ownership of the word. This
is part of its power—the word organizes people into groups.

I suppose my American Indian experience is one reason I was asked to examine
Tribal Streetwear and its relationship to a powerful American-turned-global
phenomenon known in fashion as *streetwear*. What I bring to this discussion
is some observations about how people will group together in the future. The
unrelenting questions of my life have always been, "What is a Tribe? What is an
American? Who do I belong to?" Tribal Streetwear's longevity and decades-long
success can be attributed to the fact that it offers a model of how to answer
these questions, without getting stuck in the past through rigid attachments
to old social constructs that no longer serve a modern audience. Tribal Street-
wear's experience offers lessons for the future of identification—especially as
we enter the digital metaverse, or the "singularity."

It is extremely important to trace the word "tribal" to understand what it meant
in the context of when Bobby Ruiz (founder of Tribal Streetwear) and his brother
Joey created the name of the brand. Following the word's evolution—especially
in the American context—will give shape to its transformation into the current
global community and brand that Tribal Streetwear has become. These obser-
vations reveal that the brand itself is a distinct social group in a long continuum
of people identifying with each other. It also created a new modern culture
empowering people to transcend antiquated social categories.

The American Indians (another label I prefer but is not part of this discussion)
are generally organized in Tribes. Before the colonization and nearly 200-year
American war against the Indians, however, the Indians did not think of them-
selves as Tribal, because the word was foreign to them. One of the significant
tragedies of colonization is the loss of social constructs and social groups be-
fore Capitalism became the norm. The term "tribe" dates back to Ancient Rome
as a bland catchall for a voting group.[1] Perhaps *district* would be an appropriate
synonym. When Big Money and Big Government stole land from the American
Indians, "tribe" took on not only darker undertones but also notes of strength—
such as resistance.[2] It meant people who rejected joining the dominant culture.[3]
Sometimes Americans feared for their safety in face of this resistance to join.
Yet Americans *also* respected it, for resistance to power is an American ethos.
Americans worship the Founding Fathers' rebellion against Britain.

Bobby and Joey Ruiz tapped right into this ambiguity by naming their company Tribal Streetwear. Their Chicano Studies classes and discussions about Aztec and Mayan history inspired the brothers to name their streetwear company Tribal. The word instantly evokes the United States' brutal history. Foreign disease, warfare, poverty, rape, cultural oppression, and drugs decimated the American Indians. We were rounded up and put in ghettos that morphed into the political landscapes known as Reservations. These were modern constructs fought for by the Indians that had powers akin to a state with a federally recognized sovereign status. To oversimplify, the legal and illegal Indian Tribal resistance embraced the modern global construct of nations to create and exert powers uniquely Indian. While historical and cultural preservation is important, it is also important to see how Indians adopted the federal system and forged a new space for themselves. This history is the *sine qua non* of the US identity, especially as differentiated from Europe. Without it, there would be no United States.

Tribal carries something that survives the destruction of familiar life or usual institutions, which is where Tribal Streetwear aims. Like the American Indians, despite the whipsaw of catastrophic changes, something Tribal remains and orients us in a foreign homeland.[4] Let me put it this way: because I am a Tribal, the housing crisis was not shocking or frightening. Big Money stealing your home through scams or broken promises is not surprising to an American Indian. The American Indian also knows that the loss of a home is not a loss of culture or power. The Jewish faith also exemplifies this human dimension.[5] Tribal organization always offers hope. Some social theorists see Tribal as organizing Americans in a more effective future way.[6] The often quoted—and seldom understood—Marshall McLuhan predicted that electronic media would revive the Tribal societies destroyed by the written word.[7] Web 3.0's and the Metaverse's promise might make this prediction come true.

Tribal in Tribal Streetwear conveys an inherent tension. While the United States does not exist without Indians, along with other marginalized people, the United States does not treat Indians like founding patricians. The mainstream's owed respect is instead paid through a shallow esteem in the form of obligatory, superficial sympathy for past crimes. This creates a fetishization of American Indian spiritual practices, like ubiquitous New Age shops prevalent in southern California. I was introduced to a shaman who obtained his American Indian shamanism certificate from Santa Monica Community College and belonged to no tribe. The fact that the tribes of the dominant culture marginalize Indian Tribes already baked into the dominant culture's own identity—gives the tribal

element an outside and inside status. This is the key to beginning to understand group identity and formation offered by the signifier *Tribe*.

Streetwear experiences a similar dual-existence wherein the marginalized group, let us say the Chicanos in San Diego, create their own aesthetic through graffiti, lowriders, B-boys, music, and fashion. This is because Chicanos were traditionally marginalized by the dominant culture. They had to make their own. Once Tribal Streetwear created an economically viable mode, a new problem arose. Elite fashion houses wanting to cash in attempted to mimic the street-wear appeal from hoodies, T-shirts, and shoes to marketing. Just like the Santa Monica New Ager's attempt to mimic Indians, the elite fashion houses copied streetwear without actually living in street culture. What is more American than an established order legitimizing itself by normalizing rebellion against some other established order?

Tribal Streetwear keys off of that inscribed ambivalence. Graffiti violates official property laws. Corporations gobble up underfunded public spaces to public art. Tribal Streetwear's graffiti-writing allies defy old notions of art and privilege. But how does rebel art survive long after Big Money deletes its work? Lowrider culture imbeds Chicano art and ethos by customizing cars beyond automakers' imaginations. When the so-called legitimizing art circles like museums denied Chicanos access, Chicanos made their cars their art pieces. We must ask our-selves how will a car culture's art and ethos survive when cars die out? Imagine Amazon's artificial intelligence-driven unowned vehicles filling the city's skies. A culture's social power is another problem. Gentrification displaces Chicano families, creating an urgent need for cultural survival innovations. The lopsided economy/capital funding gentrification creates a crucial need for new forms of social power to counteract it. Tribal Streetwear's invocation of Indian Tribes serves the purpose of new cultural power and growth. The American Indians, through tribal affiliation, survived the great upheavals European contact brought. Current tribes show how a culture can persevere to find its next em-bodiment in future landscapes. One is by unifying in a bond less than national, but more than family, and embracing modern structures to create cultural forms more modern than the dominant culture's forms.

This is tribal's currency. As a category, it retains an undefinable "X" factor. Malcolm X's use of the "X" best exemplifies this. It stands in for the unknown, lost African name, and ultimately takes on its own meaning. This undefinable element can contain everything the Dominant Culture excludes. Like tribal, Streetwear also contains an unknown factor.

Streetwear has always been hard to define (RebelsMarket, 2023). It is Californian. Starts with punk, hip-hop, new wave, and heavy metal cultures—music. A constant motif of do-it-yourself runs through the surf and skate culture as well. Long before the so-called gatekeepers were removed by digital technology, the creators were already trying to bypass the gatekeepers. Bobby Hundreds defines streetwear as modern clothes connected somewhere between sportswear and military style that touches an array of subcultures (Hundreds, 2011). Bobby Hundreds pinpoints Stussy as the true father of streetwear. He boils it down to T-shirts and exclusivity. Sometimes Streetwear is seen as a fashion trend that relies on elements outside of fashion (Yotka, 2019). Some argue that Streetwear is born from a reaction to all the traumas running the gamut from poverty to drug abuse to racism to systematic forms of discrimination (Stein, 2020, p. 11).

Like the label tribal, streetwear's characteristic trait is its appeal to a spectrum of cultures or groups excluded from the dominant culture. Streetwear tends to communicate empowerment to the groups traditionally oppressed by elites in politics, business, and property. Some argue that streetwear flips the script between commodities and the consumer. It's been observed that streetwear is a way for people to use commodities to create their own culture—rather than allowing the commodities to use them (Stein, 2020, p. 29). Customizing sneakers to reflect a subculture demonstrates that streetwear reverses the power relation between consumer and commodity. Instead of passively wearing what a factory pumped out for mass consumption, an individual actively transforms it into something reflecting his, her, or their own cultural identity.

However, we must be careful to see that transformation can go both ways. While streetwear changes the commodity, the commodity can transform the culture as well. As an American Indian, I have seen this firsthand. The first reaction is to try to keep the commodity from affecting one's culture. In my experience, however, this is unskillful and perhaps a faster slide into cultural extinction. The American Indians grabbed hold of many commodities—the horse for instance—made it their own and moved forward—*without* getting stuck by trying to preserve the "old ways." This is not a uniquely Indian thing. You see this everywhere. Even the dominant culture's desire for the "golden age" is a fallacy. The true source of eternal existence is to create something more modern, like streetwear made with T-shirts, hip-hop made with turntables, and graffiti writers made with walls. This is how culture flourishes.

The ambiguity between who controls whom between consumer and commodity in streetwear is a good place to discuss Graham Harman's exquisite book, *Objectoriented ontology in immaterialism* (*Theory Redux*). Harman states that

all objects (consumers, sneakers) exist before their relations or effects (Harman, 2018, p. 42). If that was not the case, nothing new or different could occur, because there would be no unrevealed potential to give rise to the change (Harman, 2018, p. 42). Thus, the T-shirt had the potential to bear tribal and the infamous T-Star logo before Bobby and Joey Ruiz sold T-shirts at swap meets. The new object here would be Tribal Streetwear which, as Harman points out, is a synecdoche (2018, p. 42). Tribal Streetwear is a part (the company) of the new compound object (Bobby Ruiz, Tribal's global supporters, fashion, San Diego, Chicano, and everything making up Tribal Streetwear) that the new object Tribal Streetwear actually is. Harman argues viewing Tribal Streetwear in this way does more justice to these new objects (2018, p. 42). The symbiosis worth examining is when relationships become irreversible (Harman, 2018, p. 47).

In Tribal Streetwear's case, a symbiotic point of irreversibility would be the shows that Bobby Ruiz curates. In 1981, the ASR (Action Sports Retailer Trade Expo) was a San Diego-centered traditional trade show focusing on surf, skate, footwear, style, and youth culture products. Major established surf brands like Billabong presented their products to massive retailers. Tribal Streetwear and friends (Third Rail—Risk's company) had to exist at 432F. 432F was a sort of off-Broadway version of the ASR Tradeshow. Bobby Ruiz created the cultural phenomenon that Tribal Streetwear symbolizes by inviting graffiti writers, B-boys, and DJs to the smaller show. Word got around, and ASR invited Bobby Ruiz and the company to participate in ASR, thereby making ASR more relevant to youth culture. The change from traditional retailers and clothing compa-nies controlling the "commercial space" of a trade by inviting Tribal Street-wear to bring culture to that space reflects the changing dynamic between producers and middlemen. This shows curation growing as an important skill for businesses—not just museums. This reflects the changing marketing approach from traditional information and attention-grabbing to creating a brand that is a *lifestyle*. Tribal Streetwear took the curation (curating before it was a commonly used word like it today) of the culture internationally.

This was over three decades ago. Now, Bobby Ruiz still curates large shows that have become cultural and artistically meaningful events—and ASR has become extinct. This is Harman's symbiosis. It's not that Tribal streetwear merged with ASR, but the *relations* provided by a traditional trade show shrunk irreversibly into a component of the whole compound object Tribal Streetwear. Tribal Streetwear curates cultural events that communicate far more than next season's goods. It curates what is culturally relevant at that moment, exhibiting streetwear culture far beyond the conventional boundaries of traditional retail tradeshows and the limitations of classic streetwear. Tribal Streetwear reveals

that the fourth wall separating retail tradeshows, from pop or contemporary culture, is gone. Some argue that culture and pop culture have finally merged into the same thing.[8] Digital technology eliminated gatekeepers. Traditional retail monoliths setting trends for pop culture gave way to participants exhibiting their culture, with businesses invited to participate. Tribal Streetwear exhibits some of the dynamics once exclusively belonging to fine art galleries. It can be argued that Tribal Streetwear has become a guardian of the culture it reflects, especially in an age of dwindling support for art and culture in public education.

Tribal Streetwear's pop-up art installations are more than just the cross between cultural events and tradeshows. While the consumers-turned-business professionals and the business professionals-turned-consumers mix at these diverse events, Tribal Streetwear becomes something akin to a frame around a certain time and place. This is a much more direct way of capturing art emblematic of a community's vision, real life, along with teaching members of the community what other members are up to. Tribal Streetwear is also a mode of communication between members of a particular culture.

Tribal Streetwear found another way to curate culture. It takes forbidden civic art and puts it on clothing. Tribal is one of the few that recognizes that the person's body in the city is also a civic space. When someone wears a Tribal design created by a graffiti writer, that person represents a civic space. Every human in the city that is in public is a public space. The body occupies the civic space and merges with it for that moment. Thus, the active choice to wear graffiti or tattoo art is an act of resistance and tribalism. In a T-shirt, the same forbidden art wiped off a bank's outside walls will be allowed inside the bank worn by someone who belongs, identifies with, or appreciates that forbidden art. Fashion is another place where the art and aesthetics representing a specific culture in resistance could be kept alive to grow and flourish.

This is where Tribal Streetwear excels. As a clothing brand, Tribal Streetwear entered the culture when brands began to think of themselves as representing lifestyles. The distance between lifestyle brands and social movement may not be as far apart as one may think. Traditional marketing gave way to the hegemonic strategy of evocative storytelling, crafting a narrative, as the way to sell a product. Books like *Story brand* by Donald Miller, or the billionaire reality "press" releases create lasting relationships with consumers. Elon Musk (Grose, 2017) said recently, "But at some future point, work itself may no longer be an option. 'There is every reason to believe,' Bliss says, 'that machines will eventually do all the things humans now do. There are no barriers to machine intelligence.'" If automation destroys the need for business to hire people then

we will no longer receive an income—especially disposable income. Without disposable income then consumer culture as we know it will dry up completely.

The answer from Stockton, CA all the way to Elon Musk is a universal basic income, "While unveiling Optimus in August, Musk said he believes that a universal basic income will eventually be needed when the rise of robotics and automation renders physical work a choice" (Knutson, 2022, bullet point 3). That is, pay everyone *something*—whether they work or not. Cryptocurrencies, the rise of the digital metaverse, video games, the pandemic, digital voting systems, and the collapse of the traditional political system shows, as Slovoj Zizek has repeated *ad nauseum*, that we are at the end times of the old ways of business and life. An evolution is upon us, giving way to a new dimension that Zizek often advises we embrace, instead of reverting to some artificial golden era. Of course, who could better understand this than the original people within streetwear? This is a marginalized group who had to create their own aesthetic from what was available to them—and take ownership of it. They were the disruptors *before* the tech disruptors.

Tribal Streetwear maintains a southern Californian Chicano aesthetic, yet race isn't a mandatory part of membership. A simple appreciation of the spirit, aesthetic, or lifestyle is enough. Admission is participation, either in the lifestyle, artistically, or financially. The old days of commercial trade undermined the art, or resistance, but Tribal Streetwear has shown it's actually the opposite. Streetwear's change in emphasis from a trade show to an artistic curation as the participatory focal point by people from and to that culture is a more radical modern form of social cohesion than its predecessors. Instead of companies servicing cultures with products, cultures produce art that is financially supported by the business branch of that culture. This quasi-private cultural entity grants the public access to art within their community, while the barriers to public art today are greater than ever. In the increasing world of privatization, Tribal Streetwear illustrates how to manage cultural curation alongside this new private world, demonstrating for the community what entities like Tribal Streetwear can really achieve. Tribal Streetwear's legacy shows address these issues by not only showing the people's art and holding these shows in more accessible locations, such as outside but by allowing people to bypass official channels and fund the art directly. And as it has been described previously by Grant McCracken in *Transformations*, people are co-creating the art with these streetwear companies. Thus a "company" is no longer just a business entity but a mini-civilization—or a *Tribe*. Thus, it is not that Tribal Streetwear is a business or a government, but something more radical: an identity based on *chosen*, shared appreciation for the aesthetic that Tribal Streetwear really is.[9]

An aesthetic is also a difficult category to define outright. German philosopher Alexander Baumgarten (1714–62) originally used the word as a category for studying what is sensed and imagined and what is experienced. Although common definitions focus on beauty, I adopt the definition that it is interaction with, experience of, and production of art that invokes intense feelings.[10] With a specific community's art and ethos privileged over a race classification, one can see the potential of an authentic post-racial social category.

In order to orient ourselves toward this idea that what was once considered a streetwear brand could evolve into a new kind of group, who identify along an intense feeling created by a particular aesthetic, we should look at some traditional race categories. For instance, you may notice that in medical or quasi-official surveys, race classifications also contain something called an ethnicity. Why wouldn't there just be another race category for whatever the ethnic category is? Race is defined as groups based on physical traits commonly attributed to people with shared ancestry in most dictionaries. Ethnicity, on the other hand, is a collection of shared cultures, languages, practices, and beliefs.[11] Both contain elements of culture and tradition. Both contain the traditional artificial constructs associated with a shared genetic history. Both are also foisted onto each member without their choice. They passively enter into their race or ethnicity and actively wrestle with it after. The main difference seems to be the emphasis on the shared genetic component. Race puts the so-called shared genetic heritage as a primary feature, while ethnicity contains an element, but prioritizes culture above it. But what if in the near future, a person can *choose* to belong to a group, without race entering the equation? Pragmatists will say that in the real world this is virtually impossible in the United States. Yet in a virtual world, this might really be possible. Let us not forget that what we experience as real oppression or real racism is absolutely based on a totally artificial race category created by the oppressive class. That new economic system of colonialism and capitalism is a "virtual" reality. It only exists to the extent we are forced to participate in it. However, as the universal basic income and digital metaverse come into being, we should remember our true heritage: that an artificial social construct can become reality, and the sooner you grab hold of it, and make it even more radically modern, the more power you will have. Tribal Streetwear, through privileging art and culture over race-based classifications, and using business to support the movement, paves the future existence of streetwear.

Now we can see a continuum unfolding about collectivizing ourselves. Race, tribes, ethnicities, businesses, streetwear, and aesthetics exist on a spectrum of social grouping with varying collective powers. They all want to continue

to exist and be relevant. Tribal Streetwear exists closer to the front of these developments. Traditional business is losing its social relevance as Musk and others intuited. This is in part because an increasingly automated industry will displace workers. Also, businesses turn more and more to a system of "rents" through subscriptions instead of actual ownership like what has happened in the music industry. When manufacturing goods no longer supports an economy, what then will the economy be? This is a very difficult reality to conceive because we have been in a consumerist economy for quite a while. But if jobs disappear and everyone has a universal income, as Musk predicts, what will we buy? Perhaps we will buy identities and participation in *tribes,* in Tribal Streetwear.

This is something that appears to be happening in very simplified forms in gaming platforms like Fortnite or Roblocks. As the digital metaverse becomes more and more accessible, perhaps membership in a chosen *tribe* will be the engine driving the economy. In his book, *The metaverse: And how it will revolutionize everything*, Matthew Ball (2022, p. 29) defines metaverse as:

> [a] massively scaled and interoperable network of real-time rendered 3D virtual worlds that can be experienced synchronously and persistently by an effectively unlimited number of users with an individual sense of presence, and with continuity of data, such as identity, history, entitlements, objects, communications, and payments.

At some point, an alternate reality or universe will be an immersive three-dimensional world built with digital art. It's not hard to imagine that this is where future generations will play and live. In this created world, a citizen's chosen aesthetic is not forced to be tied to the natural world in real life. This opens vast new possibilities for self-creation.

To recreate yourself is the American fantasy and the created-reality metaverse presents a world where that self-recreation can be fully realized. This is why Tribal Streetwear's experience is helpful to point the way to how this digital world will operate. Tribal Streetwear's decades-long experience curating an aesthetic that transcends the traditional boundaries between identity, art, sports, and community gives it an edge in providing us in the coming metaverse with a sense of tribalism based on aesthetics. This "vibe" is akin to a shared culture, language, practice, and belief. Tribal Streetwear's aesthetic shows a new way to identify—a new ethnicity. Thus, the aesthetic one chooses becomes an ethnicity through choice, not birth. This is how, if not already, metaverse people will be able to identify and form cultures digitally. This metaverse ethnic form

will transcend the biological based theories of belonging that we have not been able to shed in real life. You can belong by choice with something more than family and less than national—you can be Tribal by being loyal to an aesthetic.

# REFERENCES

Ball, M. (2022). *The metaverse: And how it will revolutionize everything*. Liveright

Flanagin, A., Frey, T., Christiansen, S. L., & Bauchner, H. (2021). The reporting of race and ethnicity in medical and science journals. *JAMA*, 325(11), 1049. http://doi.org./10.1001/jama.2021.2104

Grose, T. K. (2017). Replaced by machines. *ASEE Prism*, 26(7), 30–33. https://www.jstor.org/stable/44160964

Harman, G. (2018). *Object-oriented ontology: A new Theory of everything*. Penguin.

Hundreds, B. (2011, June 21). 50 *greatest streetwear brands of all time*. https://www.complex.com/style/the-greatest-streetwear-brands/

Knutson, J. (2022, January 27). *Elon Musk says Tesla is prioritizing development of a robot that can perform human tasks*. https://www.axios.com/2022/01/27/musk-telsa-prioritizing-robot-development

McCracken, G. (2008). *Transformations: Identity construction in contemporary culture*. Indiana University Press.

Mishan, L. (2020, April 13). What is a tribe? *New York Times*. https://www.nytimes.com/interactive/2020/04/13/t-magazine/tribe-meaning.html

Oxford Learners Dictionaries. (n.d.). Aesthetics. In *Oxfordlearnersdictionaries.com*. Retrieved July 31, 2023, from https://www.oxfordlearnersdictionaries.com/definition/english/aesthetic_1.

RebelsMarket. (2023, March 17). The origins of streetwear: What is it and how do I wear it? https://www.rebelsmarket.com/blog/posts/the-origins-of-streetwear-what-is-it-and-how-do-i-wear-it

Yotka, Steff. (2019, January 11). Think streetwear is a new phenomenon? Meet Luca Benini who started the hype 30 years ago. *Vogue*. https://www.vogue.com/article/slam-jam-luca-benini-interview-pitti-uomo

Žižek, S. (2018). *Like a thief in broad daylight*. Penguin.

# ENDNOTES

1. Etymologically, "tribe" is fairly neutral, from the Latin tribus, an administrative category designating a voting unit: that is, a body of people endowed with a degree of political power. It does not presuppose an opposition, like the Japanese dichotomy of uchi-soto, which marks inside and outside, the familiar and the unknown, us and them—each group explicitly defined by what it is not.

(Mishan, 2020, para. 9)

2. But after Europeans began to explore other regions in the fifteenth century, the word "tribe" took on the shadow of colonialism, as a label reserved for non-western peoples who were seen to represent an earlier and implicitly inferior state of social evolution.

(Mishan, 2020, para. 10).

3. Taken from the article in 1975 showing how the word became shaded with derogatory meaning.

4. At the same time, the erosion of local institutions and neighborhood life has left a void: Some of us fear we no longer have a place to call home, in the deepest sense of the word, a place that is ours and can never be taken from us. In "Idols of the tribe: Group identity and political change" (1975), the American political scientist Harold R. Isaacs likened this alienation to the literal and spiritual displacement of immigrants "transported across great physical and cultural distances"; group identity is "the ark they carry with them, the temple of whatever rules one's forebears lived by [...] whatever form of creed or belief in a given set of answers to the unanswerables." To be part of a tribe is at once a refuge and a declaration of faith. It is to be anchored, to be certain that we have a role in the world.

(Mishan, 2020, para. 7)

5. A clan is related by blood, a generation by age, a faction by politics, a sect by religion, and a cabal by conspiracy. A clique doesn't scale beyond the intimacy of friends (and enemies), and a gang has come to be deployed almost exclusively in matters of youth and crime. To call a group a subculture presumptively shunts it to the margins. There is no English correlative to the Chinese suffix zu, which applies to both "clan," zongzu, and "ethnic group," minzu, and has been recently adapted as latter-day ethnographic slang, delineating the likes of yi zu, the ant tribe, college graduates from the provinces who move to the cities and wind up toiling at poverty level, and ken lao zu, the bite-the-old-folks cohort, young people who do no work and leech off their parents. Still, these are nicknames imposed by observers, not voluntarily chosen identities or loyalties.

(Mishan, 2020, para. 8)

6. It's a newly urgent notion in the West today, and to focus only on the clashes between partisans in the political sphere is to ignore both the multiplicity of tribes and how they bring vigor to public life. The strength of a culture lies not in its promotion of a single way of being but in its ability to sustain a diversity of viewpoints. How else are ideas generated but through exchange and debate, polyphony rather than a single voice? Among the groups celebrated in the pages that follow, borders are fluid; these are not hermetic bubbles but ever-expanding spheres.

(Mishan, 2020, para. 11)

7. The 20th-century Canadian media theorist Marshall McLuhan attributed the decay of tribal culture to the overriding of oral tradition by a codified, written language, a process accelerated by the 15th-century invention of the printing press. He saw this as a corruption of our original unmediated sensual relationship to the world of things and to each other. Once we no longer needed to communicate face-to-face, to connect the message to the messenger, we grew estranged. McLuhan also predicted—in a 1969 interview, before the dawn of the internet—that electronic media would revive tribalism by creating a simultaneity of experience, bringing back the prelapsarian immediacy of a long-lost village. In this ceaseless flow of data, there's a risk of a tribe becoming no more than a brand, its members' identities reduced to the products they buy—swirly-hued bath bombs, say, or catchphrases memorialized in neon scribble signs—choices that can easily be monetized and exploited as part of a capitalist system. Marketers speak of "consumer tribes" and corporate leaders are exhorted to instill in their employees a tribal culture, leveraging loyalty and a sense of mission for greater production and profits.

(Mishan, 2020, para. 14)

8. Grant McCracken (2008) in his book *Transformations* saw that consumers were becoming co-creators (L84). People want something more active (L84). While Grant McCracken is talking about entertainment, this appears to be the case in clothing—especially streetwear (L84). Pop culture has finally become culture (L100). Culture has become something to make, engage in, help construct, and then consume (L100). Technology created mass-accessible tools and information for people who were kept out of cultural production and curation to step beyond old gatekeepers to manufacture the culture and its relics themselves (L100).

9. "The way to strike back at neo-colonialism is not to resist it on behalf of their traditional culture but to reinvent a more radical modernity" (Zizek, 2018, p. 134).

10. *The Oxford English Dictionary* defines "aesthetics" as focused on beauty, valuing beauty deriving pleasure from beauty. According to the authors "empirical aesthetics" is the scientific study of the perception and evaluation of art with a close relation to neuroscience. Of course, the definition of "aesthetics" is unstable here. I like Anjan Chatterjee's definition, "The term aesthetics is used broadly to encompass the perception, production and response to art, as well as interaction with objects and scenes that evoke an intense feeling, often of pleasure." This is enough to give us a handle on the concept of Aesthetics; it has something to do with art, perception, and an intense feeling. What if the "Intense Feeling" becomes privileged with the Tribal Streetwear such that it becomes a focal point of identity. If it becomes a focal point of identity, the lifestyle aspect of the brand can become "a culture." If the culture is based on an aesthetic it seems entirely plausible that this culture would soon have.

11. But the American Sociological Association defines "ethnicity" as a "shared culture, such as language, ancestry, practices, and beliefs." (Flanagin et al., 2021, para. 6), 1049.

# MONIQUE CHARLES

Dr Monique Charles is assistant professor of sociology at Chapman University. She developed a research method to analyze music for social science and cultural studies (Musicological Discourse Analysis – MDA) and a theory on Black music and spirituality in live performance/clubbing spaces (Amun-Rave Theory). She is on the editorial board of the *Global Hip Hop Studies Journal*, and has been on the London Borough of Culture Board (Brent 2020). She is on the British Library's Black British Music exhibition advisory board for their 2024 national exhibition. She is the creator, curator, and editor of *Black music in britain in the 21st century* (Liverpool University Press, 2023). She is a sound healer (tuning forks, voice, and cardology). Her website is available at: https://drmoniquecharles.com/.

.KINSEY-1998

# A TRIBE LAUD WEST[1]: HIP-HOP AND ITS INFLUENCE ON TRIBAL GEAR AND A NEW CHICANO GENERATION

MONIQUE CHARLES

## CALIFORNIA LOVE?[2]

When examining the history of Mexican Americans in southern California (SoCal), the structures of race and class, specifically redlining, positioned them as outsiders. Marginalization often positioned them in poorer parts of cities, barrios—Spanish quarters. The historic bias of housing along racial lines meant that people of

color were concentrated in poorer areas, but within these spaces, race and ethnicity were relatively homogenized, i.e., ghettos—African American, barrios Mexican American. Mexican Americans experienced this when they migrated to Los Angeles (LA) for work and were confined to East LA and particular neighborhoods in Compton. The focus on LA here (rather than San Diego) is primarily to acknowledge Compton, the neighborhood credited as the first site of West Coast hip-hop with its distinctive sound, sensibility, and outlook and thus subculture that influenced both ideology and style amongst a generation youth across the region[3] and eventually the world. The Mexican American presence in Compton, LA also highlights that despite nuances in how racism affected both groups, both African American (Black) and Mexican Americans (Brown) lived in close proximity and therefore experienced similar social conditions and cultural exposure to the genre. Additionally, it highlights the significance of mural culture (with LA being a mural capital in the US Bloch, 2016) in LA and the diverse and active graffiti artists in the area.

"Subcultures represent 'noise' (as opposed to sound): interference in the orderly sequence which leads from real events and phenomena to their representation in media" (Hebdige, 1979, p. 90).

With each new subculture, "interference" to dominant culture is present visually, aurally, and spatially. Hip-hop's arrival to the West Coast made it possible for Black and Brown youth, particularly males, to express themselves through a new medium that resonated with their lived reality (Pulido, 2009) beyond the imposed confines (such as redlining) of space and movement. Hip-hop provided a mechanism through which cultural exchange (i.e., interracial—Black/Brown)

could take place, as each group could connect to it and therefore each other through familiar vantage points (Baker-Kimmons & McFarland, 2011). (This does not negate the ongoing antagonistic and hostile relations between these groups however—see Mock, 2007.) Through hip-hop, "interference" and taking up space manifests as moving through it as loudly and as visibly as possible representing oneself viscerally. To illustrate this point, one can posit that, through government orchestration, Black and Brown groups were confined to particular spaces. Compounding this, on the West Coast, the primary mode of transportation is the car, further limiting options available to facilitate movement. Barrios and ghettos that are already constructed externally were particularly vulnerable to government town planning with regard to infrastructure and transportation routes (freeway building) between the 1950s and 1970s (Stromberg, 2016). Town planning and automobile ownership were/are instrumental in how freely people move through space. Additionally, the make of the car is an indication of class and status. The historical–cultural context of marginalization, spatial precarity, and movement limitations, orchestrated and enforced by the government, operate alongside the necessity and desirability of the car.

In the same oppressive historical–cultural context, Mexican Americans took (and continue to take) pride in their heritage and culture (taking a more political edge since the 1960s Chicano movement) when identifying as "Chicano," incorporating Aztec heritage, traditional or ancestral practices. Mexican American or Brown pride has historically included distinctive dress and style as visceral "interference." Connecting Brown pride with space, style, and

movement to become viscerally visible and audible, "interference" can present as immaculate cars moving through available space flamboyantly, drawing as much attention as possible for example.

Visibility in the context of marginalization, spatial precarity, and movement limitation becomes stylish dress, *placas* ("wall writings") (Bloch, 2016, p. 453), murals, and Cholo graffiti/fonts (pioneered by Chaz Borjorquez—see streetwriters.com) as well as the aforementioned low-riding cars in the barrio (Chappell, 2010). These "interferences" include visible signs of heritage and cultural practice. "Interference" fits into SoCal, particularly LA, which has a strong history of counterculture amongst its youth over the generations (Cox, 2017). Counterculture has been integral to LA, often articulated through music and style by youth and musicians; jazz in the 1930s, Beach Boys and funk in the 1960s, punks in the 1970s/80s, and hip-hop in the 1980s (Cox, 2017). Music scenes and vernacular street fashion were and remain deeply connected and intertwined with LA counterculture. More specifically, in the context of Tribal, Chicano's longstanding differing practices (that take up visual and aural space), in conjunction with hip-hop, syncretize and become connected to a specific modern street "Cholo" style and identity, different from those gone before.

It should be noted that despite the general counterculture of SoCal in the late 1980s, at the time of Tribal's birth, the laid-back attitude of generation X (1965–80),[4] which included apathy and disillusion with the political and economic climate (that "grungy" college educated/tech savvy white American generation Xers experienced under Reagan's neo-liberalism and neo-conservatism), was vastly different to Black and Brown youth in major cities across the United States. Black and Brown people were marginalized on grounds of race, which was exacerbated by police brutality, neighborhoods flooded with drugs (Love, 2016) and weapons, horizontal violence (see Fanon, 2001) (both inter and intraracial) through gang activity, criminalization, and mass incarceration in LA (Streets of Compton, 2016). Mass incarceration itself was so prevalent that it influenced subcultural practices in LA ghettos and barrios. These factors further exacerbated the precarity of moving through space within barrio, ghetto, and beyond it.

Tribal as a brand is embedded in modern countercultural Cholo identity-affirming practices, many of which emerged before hip-hop arrived on the West Coast. Significantly, however, "Hip-hop has always embodied diversity and versatility, and it would be difficult to identify another musical genre that has enjoyed comparable adaptation and local interpretation in communities around the world" (Reznowski, 2014, pp. 86–87). In conjunction with hip-hop, Tribal's SoCal location and heritage specificity for a new era were made possible.

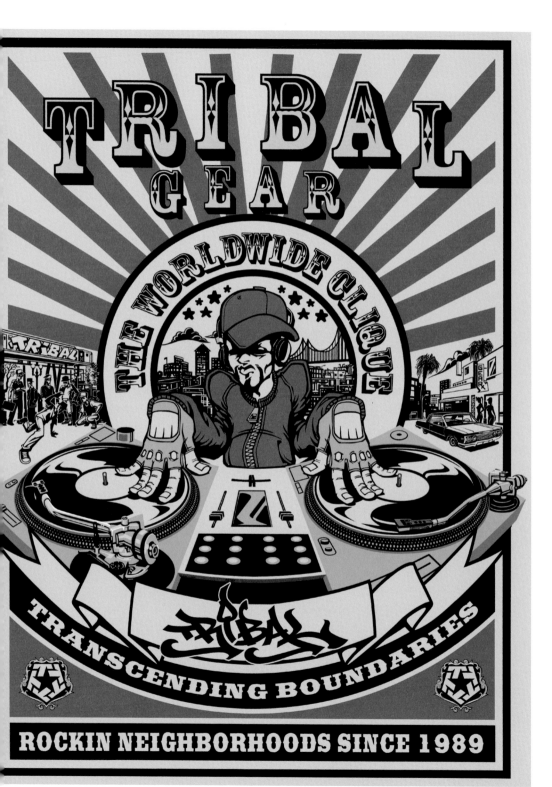

# ESE MEETS WEST

Hip-hop was formed in the late 1970s on the East Coast in the Bronx, NY (Rose, 1994, etc.). Lyrically, it spoke to (amongst other things) lived realities, oppression, and critiquing the authorities under (and in the aftermath of) the Reagan administration. Hip-hop culture's flexibility results from its ethos or "cultural approach," i.e., the inclusion of *elements*: DJing, MCing, The Knowledge, Graffiti, and Breakdancing (George, 1999). Each element remained stable due to its fluid and tangible connection to and collaboration between cultural producers within and across elements. As the genre grew in the 1980s and more African Americans gained mainstream recognition in the scene speaking to African American issues, it was overtly acknowledged as a Black musical form. Many sources reference the obvious African American contribution to hip-hop, rooted in African and African diasporic traditions, sonic signatures and practices (i.e., orality, group participation, call and response, syncopation [Gilroy, 1993; Perkinson, 2005], and prioritization of rhythm [Rose, 1994]). However, it should be noted that there are Latin elements (particularly from Puerto Ricans) integral in the creation of hip-hop music and culture; these include sonics (the use of instrumental records, e.g., salsa) and participation across all elements and Wild Style graffiti font in particular (Wild Style, 1983). From its inception, hip-hop demonstrated (a) an ability to speak to social issues; (b) its openness to incorporate different practices (i.e., elements) into its cultural whole; and (c) its possibility to become a mechanism, for cross-cultural communication between marginalized groups, even before its arrival, reinterpretation, and finding a new location and time-specific sound and v oice on the West Coast.

By the late 1980s, important sensibilities in hip-hop ideology included social critique, articulating gendered, raced, and classed experiences and connections to the street, racial pride, and authenticity through artists such as Public Enemy and KRS One. Therefore, it is no surprise that hip-hop had "translatability" and resonated with both African Americans and Mexican Americans that experienced criminalization, marginalization, gang-related horizontal violence, police brutality, and mass incarceration in SoCal (Streets of Compton, 2016). West Coast Gangsta Rap, emerging in the late 1980s and early 1990s, connected their own important sensibilities of social critique, i.e., in line with hip-hop ideology, masculinities (Baker-Kimmons & McFarland, 2011; Lebron, 2011; McFarland, 2003) referencing criminality, gangs, nihilism, and prison culture to create a new sonic footprint timestamp (SFT—see Charles, 2018) within hip-hop upon its arrival and reinterpretation on the West Coast.

# THE FABRIC[5] OF HIP-HOP

With East Coast hip-hop came a variety of styles of dress. Dapper Dan rein-terpreted high-end designer labels and prints for rappers (and drug dealers) in the 1980s (The Remix, 2019), April Walker started Walker Wear streetwear worn by rappers in 1987 (Hip Hop Education, n.d.), and Karl Kani developed his urbanwear in 1989 (Karl Kani, n.d.). These designers spoke to East Coast African American youth's hip-hop's then ideology and sensibilities, i.e., desires for authenticity (street) and exclusivity (designer goods) through style. Unlike East Coast's hip-hop's penchant for designer labels, SoCal youth of the late 1980s, particularly Mexican American and African American youth turned against them, opting to wear, khakis, all-black clothing with logos of their local sports teams, and "snapback hats" such as LA raiders, LA Kings, or Converse (Cox, 2017). By the late 1980s, clothing colors and bandanas already held sig-nificance; further compounding how one moves through space safely (Express, 2012), e.g., Crips and Bloods gangs adopted the colors blue and red as signals of affiliation (Streets of Compton, 2016).

"People tend to see themselves through the lens of hip-hop, identifying elements of their own cultural experience within the genre. Kitwana explains, 'Young people worldwide gravitate to hip-hop and adapt it to their local needs' (2006, p. 10)" (cited in Reznowski 2014, p. 87).

Hip-hop's *ethos and "cultural approach,"* i.e., the ability to provide space, through different but connected "elements" (and practices), enabled it to be a unifying vehicle for differing but interlinked SoCal-specific cultural practic-es and messages. It helped articulate and express the realities of new youth culture through one lens or prism. In California, Cross Colors founded in 1989 spoke to hip-hop and African American youth culture. The Tribal lifestyle brand, founded in 1989, harnessed hip-hop into a specific aesthetic and identity for young Mexican Americans; acknowledging and showcasing the pre-existing cultural practices, interests, aesthetics, and styles of significance alongside articulating Brown pride.

Famous early West Coast rappers/groups were both African American and Mexican American, including Ice-T and NWA, Kid Frost, and Cypress Hill. For Mexican Americans, hip-hop became a space to address social issues, articu-late their identity, critique society/authority, and express a nationalistic Brown pride (Delgado, 1998; Pulido, 2009). Artists like Kid Frost and songs such as Chicano 2 Da Bone contain lyrics that "invite Mexican Americans to perceive the artists as nationalists and to identify with the sentiments expressed" (Del-

gado, 1998, p. 103). Despite the social context, lyrics focus less on nihilism but rested heavily on Mexican pride and self-education as a resource to navigate oppressive forces (Delgado, 1998, p. 107).

# BODI POPPIN'

Mexican Americans developed a "Cholo" style connected to the barrio, over time. Cholo, a term whose meaning has changed over time [to refer to an Aztec god with a dog's head, to a slur against people of mixed Spanish and Amerindian heritage (Cox, 2017, p. 44)] has at least since the 1990s become "*slang term associated with nonconformist Mexican-American youngsters*" (Laboy, 1998, original emphasis) that have used style to articulate their countercultural standpoint and pride. Stylistically, through dress, the aesthetic has always included oversized clothes—connected to both flamboyancy through excessive use of fabric and tailoring (Cox, 2017), and/or utility through "hand-me-down" clothes (see High Snobriety, n.d.) and functional inexpensive workwear. Examples include Pacchino's inspired by the oversized zoot suit of the 1940s, white vests under oversized Pendleton (flannel) shirts, baggy Dickies chinos (Cox, 2017, p. 45; High Snobriety, n.d.), and khakis. Gang affiliation, criminalization, and incarceration of youth also connect oversized clothes and "sag" fits of the clothing worn in prison (because of the elimination of shoelaces and belts). Some of these distinctive subcultural styles of dress have extended beyond the Mexican American community and back into hip-hop and youth culture more broadly.

Additionally, hip-hop's *ethos and cultural approach* of including "elements," to form a cohesive yet flexible hip-hop culture, is the same approach Tribal brings to its lifestyle brand. Hip-hop is flexible enough to congeal or stabilize pre-existing Mexican American cultural practices and interests into a new and contemporary Mexican American SoCal identity. Tribal is clothing, documentaries, festivals, graffiti crews, etc. With hip-hop, Tribal is able to synthesize Wild Style graffiti, Olde English Gothic and Cholo font, Mexican heritage and tradition, cars, skate culture, Christian and traditional religious belief and style, all of which existed before hip-hop's arrival on the West Coast. The founder Bobby Ruiz with brother Joey and friend Carl Arellano were already actively involved in practices that spoke to a SoCal Chicano identity (see Tribal.com) and hip-hop culture. Through the cohesive yet flexible ethos and "cultural approach" of Tribal (which mirrored the cultural approach of hip-hop), space for a new, modern, stable all-encompassing Cholo aesthetic was created (in conjunction with hip hop). Hip-hop itself was (and remains) flexible enough to include practices central to Tribal AND other musical genres (sonic signatures and norms)

prevalent on the West Coast such as funk (for the West Coast hip-hop sound), (hardcore) punk, and grunge (both contributing to the nu metal/rap metal sound),[6] in order to increase visibility, sonic dominance (see Goodman, 2010), and articulate modern Chicanismo.

Fundamentally, what is argued here is the hip-hop *ethos and cultural approach* was included in all elements and replicated by Tribal and in doing so, with hip-hop music and culture as a channel, brought forth a way to manifest a new space for a modern Chicano—Cholo identity that considered heritage, practice, and lifestyle in a new holistic way. Tribal successfully harnessed all these facets or elements in their brand, and in doing so created a multidimensional brand.

"All aspects of culture possess a semiotic value" (Hebdige, 1979, p. 13).

With regard to specific markers and iconography in hip-hop culture and Mexican Americanness, markings on the body and tattoos are direct nods to ethnic traditions, cultural norms of adornment, pride, religious belief, and hip-hop culture. The articulation of pride is important in expressing Chicanismo, as is the focus on remembering and paying homage to an ideological past, the Chicano movement, and Mexican and Aztec heritage (which connect to Chicano rap lyrics). Visually this includes Cholo inflected gothic "Olde English" style fonts and skulls (connected to Day of the Dead tradition). Distinctive make-up and hair, bold heavily defined eyebrows, lips, and eyes as well as gold hip-hop inspired "door knocker" bamboo earrings contribute to the style for women (Cox, 2017). Bold lines, whether permanent (tattoos) or temporary (makeup) on the body, are central in adornment and take up visceral space, but the modern Cholo style now connotes a musical subcultural twist having extended back into wider hip-hop culture. Articulation of pride through bold markings and lines is essential to examine because of the consistent themes of visibility and taking up space and the dialogical exchange between iconography and music in Chicano culture and practice, as well as hip-hop culture's connection to graffiti visibly through lines and logos in fashion and the dancing/moving body.

West Coast car culture expands modern Cholo style to include movement through public space, beyond the body, to become a visual (and sonic) feast—taken up by immaculate cars, extravagant and meticulously crafted customized cars, i.e., lowriders, classic cars. Tribal festivals (at historic sites such as Chicano Park San Diego) incorporate this; the iconography of the car and car culture specific to the West Coast is represented in clothing—on the casual, oversized T-shirt (and other streetwear items). Logos, calligraphy, fonts, and designs are found on clothes, cars, streets, and skin.

"As public spaces, parks carry higher value by reflecting the community's abiding need for belonging. Art interventions enhance beyond the obvious aesthetics; they contribute to a community sense of mental and emotional wellbeing" (Diaz, 2020, para. 16).

The pride that is shared lyrically through hip-hop, with ancestral and ethnic references are present in clothing with both ethnic and hip-hop signifiers and iconography. Style reflects the SoCal environment. The presence of murals (particularly what LA is known for) along freeways and canals is reinterpreted through hip-hop (Bloch, 2016). Clothing design aesthetics are seen (or worn) at skate parks in day-to-day activities in the barrio, with design and fonts replicated on walls, surfaces, and skin. Tribal clothing and lifestyle allow for the simultaneous embodiment of space, scene, practice, culture, and heritage that are made possible through designs inspired by taggers, graffiti, and tattoo artists or gang members marking out territories, reclaiming space, and adorning bodies.

# TRIBAL—M.W.A.[7]

Multiple clothing, cuts, and designs on Tribal Streetwear are clearly connected to these sensibilities—social realism, expressing authenticity, and heritage enabling the replication of space and visual "interference" through music and style.

Tribal, the name itself is obvious. It embodies all of it. It acknowledges a collective—a connection to a group through heritage, Brown pride, a modern Chicano identity and ideology that references, raps, and replicates iconography of the past to claim the present and create the future. Tribal in conjunction with hip-hop has become the prism/crucible to manifest and solidify a unique identity and modern "Cholo style" that all syncretic *elements that inform Tribal's ethos and cultural approach can smoothly exist inside.*[8] Together, through hip-hop and Tribal, the modern Cholo has become such a distinctive and recognizable identity that expanded into a permanent aesthetic and approach in hip-hop culture more broadly. It has become brandable in the process. It is understood, aspired to, and recognized worldwide. Tribal, with hip-hop, becomes a new frame with which young people, Mexican American or not, can begin to explore and give voice to their own identities, practices, and subcultures in flexible ways.

# REFERENCES

2Pac, Roger and Dr. Dre ([1995] 1998), "California Love", *Greatest Hits*, https://open.spotify.com/track/3ia3dJETSOIIPsv3LJkE35?si=e82c1e6a43674c93. Accessed 5 October 2023.

Ágq, R. (2007). Migration, ethnicity, and interactions between the United States and Hispanic Caribbean popular culture. *Latin American Perspectives*, *34*(1), 83–93. http://doi.org/10.1177/0094582X06296339

Ahearn, C. (Director). (1983). *Wild Style* [Film]. Wild Style Productions, Inc. https://www.youtube.com/watch?v=CIIEC2V88hc

Anon. (n.d.). April Walker. Retrieved May 31, 2023, from https://walkerwear.com/pages/about-us

Anon. (2012, May 22). Will.i.am credits crazy clothes with saving him from gang life. *The Express*. https://www.express.co.uk/celebrity-news/321723/will-i-am-credits-crazy-clothes-with-saving-him-from-gang-life

Baker-Kimmons, L., & McFarland, P. (2011). The rap on Chicano and Black masculinity: A content analysis of gender images in rap lyrics. *Race, Gender & Class*, *18*(1/2), 331–344. http://www.jstor.org/stable/23884882

Balasandiran, T. (2019). Hispanic heritage month: The Latin influence on hip hop. *Ketchum*. https://www.ketchum.com/hispanic-heritage-month-the-latin-influence-on-hip-hop/

Bloch, S. (2016). Why do graffiti writers write on murals? The birth, life, and slow death of freeway murals in Los Angeles. *International Journal of Urban Regional*, *40*, 451–471. https://doi.org/10.1111/1468-2427.12345

Cesaretti, G. (2021, January 1). *A guided tour of Chicano graffiti*. Street Writers. https://streetwriters.com/

Chappell, B. (2010). Custom contestations: Lowriders and urban space. *City & Society*, *22*, 25–47. https://doi-org.ezproxy.uwl.ac.uk/10.1111/j.1548-744X.2010.01029.x

Charles, M. (2018). MDA as a research method of generic musical analysis for the social sciences: Sifting through grime (music) as an SFT case study. *International Journal of Qualitative Methods*, *17*(1), 1–11. https://doi.org/10.1177/1609406918797021

Chicano Park. (n.d.). *National landmark local treasure*. Retrieved May 31, 2023, from https://www.sandiego.org/articles/parks-gardens/chicano-park.aspx

Cortes, L., & Khalid, F. (2019). The remix: Hip hop X fashion. *Oddball tribeca film*. http://websites.umich.edu/~ac213/student_projects06/tylaxe/justifying.html

Cox, C. (2017). *The world atlas of street fashion*. Mitchel Beazley.

*Cross Colors* (n.d.). Retrieved May 31, 2023, from https://crosscolours.com/pages/cross-colours-history

Daichendt, G. J. (2019). As it turns 30, San Diego's Tribal Streatweal still keeping it real. *The San Diego Union-Tribune*. https://www.sandiegouniontribune.com/lifestyle/story/2019-12-01/tribal-streetwear-turns-30-and-represents-san-diego-around-the-world

Diaz, E. (2020, April 28). Fifty years ago, fed up with the city's neglect, a San Diego community rose up to vreae Chicano Park. *Smithsonian Magazine*. https://www.smithsonianmag.com/smithsonian-institution/fifty-years-ago-fed-citys-neglect-san-diego-community-rose-create-chicano-park-180974764/

Delgado. (1998). Chicano ideology revisited: Rap music and the (re)articulation of Chicanismo. *Western Journal of Communication*, *62*(2), Spring, 95–113.

Dike, J. (2016 , October 19). Why you've never heard of the most popular font in streetwear history.

*HypeBeast*. https://hypebeast.com/2016/10/life-of-pablo-font-streetwear-deeper-history

Estiler, K. (2018, May 7). Beyond the street gathers leading international artists for monumental exhibition. *HypeBeast*. https://hypebeast.com/2018/5/beyond-the-streets-festival-2018-recap

Fanon, F. (2001). *The wretched of the earth* (Reprint ed.). Penguin Classics.

Foley, G. (2020, n.d.). The trends & brands that defined '90s hip-hop fashion. *HighSnobriety Online*. https://www.highsnobiety.com/p/90s-hip-hop-fashion/

Ford, M. (Director). (2016). *Streets of Compton* [Film]. Entertainment One.

Gamboa, S., McCausland, B., Lederman, J., & Popken, B. (2021, June 18). Bulldozed and bisected: Highway construction built a legacy of inequality. *NBC News*. https://www.nbcnews.com/specials/america-highways-inequality/

Gastman, R. (n.d.). *Art in the streets.* Retrieved July 31, 2023, from http://www.rogergastman.com/art-in-the-streets

George, N. (1999). *Hip hop America*. Penguin.

Gilroy, P. (1993). *The Black Atlantic: Modernity and double-consciousness*. Verso.

Goh, G. (2012, July 11). Acclaim magazine: Chas Bojorques—Godfather of Cholo style letters video. *Hyper Beast*. https://hypebeast.com/2012/7/acclaim-magazine-chaz-bojorquez-godfather-of-cholo-style-letters-video

Goodman, S. (2010). *Sonic warfare: Sound, affect, and the ecology of fear*. Massachusetts Institute of Technology Press.

Gray, F. G. (Director) (2015). *Staight outta compton* [Film]. Legendary pictures. New Line Cinema.

Hebdige, D. (1979). *Subculture: The meaning of style*. Routledge.

Hip Hop Education. (n.d.). April Walker is fresh, bold and so def. *Hip hop education*. https://hiphopeducation.com/women-in-hip-hop/april-walker-is-fresh-bold-and-so-def/

Karl Kani. (n.d.). About. Retrieved May 31, 2023, from https://www.karlkani.com/pages/about-us

Laboy, J. (1998, April 8). Clothiers bring the barrio to Japanese teen rebels. *Wall Street Journal*. https://www.wsj.com/articles/SB891971121767579000

Lebrón, M. (2011). Chicano rap: Gender and violence in the post-industrial barrio. *Latino Studies*, 9(2–3), 351–353. http://dx.doi.org.ezproxy.uwl.ac.uk/10.1057/lst.2011.28

Love, D. (2016, March 23). Nixon adviser said the 'War on Drugs' was a manufactured lie designed to target and disrupt the black community. *Altanta BlackStar Online*. https://atlantablackstar.com/2016/03/23/nixon-adviser-said-the-war-on-drugs-was-a-manufactured-lie-designed-to-target-and-disrupt-the-black-community/

McFarland, P. (2003). Challenging the contradictions of chicanismo in Chicano rap music and male culture. *Race, Gender & Class*, 10(4), 92–107. http://www.jstor.org/stable/41675103

McFarland, P. (2006). Chicano rap roots: Black-Brown cultural exchange and the making of a genre. *Callaloo*, 29(3), 939–955. http://www.jstor.org/stable/4488380

Mendoza, V. (2000). Video review of Chicano!: History of the Mexican American civil rights movement. *The Journal of MultiMedia History, 3*. https://www.albany.edu/jmmh/vol3/chicano/chicano.html

Miller, J. (2018, February 21). Roads to nowhere: How infrastructure built on American inequality. *Guardian online*. https://www.theguardian.com/cities/2018/feb/21/roads-nowhere-infrastructure-american-inequality

Mock, B. (2007, January 16). Latino gang members in southern California are terrorizing and killing Blacks. *Intelligence Report*, Winter, https://www.splcenter.org/fighting-hate/intelligence-report/2007/latino-gang-members-southern-california-are-terrorizing-and-killing-blacks

Oriol, E. (Director). (2020). *LA originals* [Film]. Underground Contenidos.

Perkinson, J. (2005). *Shamanism, racism, and hip hop culture: Essays of White supremacy and Black subversion (Black religion/womanist thought/social justice)*. Palgrave Macmillan.

Pulido, I. (2009). "Music fit for us minorities": Latinas/os' use of hip hop as pedagogy and interpretive framework to negotiate and challenge racism. *Equity & Excellence in Education*, *42*(1), 67–85, https://doi.org/10.1080/10665680802631253

Reznowski, G. (2014). *Hip-hop mundaii: Latino voices, global hop-hop, and the Academy* [Conference presentation]. Fifty-Seventh Annual Meeting of the Seminar on the Acquisition of Latin American Library Materials, Port-of-Spain, Trinidad. https://research.wsulibs.wsu.edu:8443/xmlui/handle/2376/5371?show=full http://hdl.handle.net/2376/5371

Rose, T. (1994). *Black noise: Rap music and Black culture in contemporary America*. Wesleyan University Press.

Stromberg (2016, May 11). Highways gutted American cities. So why did they build them? *Vox*. https://www.vox.com/2015/5/14/8605917/highways-interstate-cities-history

Sullivan, A. (2021, May 25). U.S. freeways flattened Black neighborhoods nationwide. *Reuters*. https://www.reuters.com/world/us/us-freeways-flattened-black-neighborhoods-nationwide-2021-05-25/

Tribal Streetwear (2021, January 1). *Tribal: Tribal Streetwear since 1989: Tribal gear*. https://www.tribalgear.com/global/

UNIVERSAL HIP HOP TV. ([1982] 2019, January 27). *Wild style* [Video]. Ahearn C. First run features. YouTube. https://www.youtube.com/watch?v=GaXMfwOIJOo

# ENDNOTES

1. Rhymes with Hip Hop group A Tribe Called Quest, whilst actually meaning praise of a 'tribe' (i.e. Tribal) from the west (coast).

2. Title of of a 2Pac, Roger and Dr. Dre song by the same (see 2Pac, Roger and Dr. Dre [(1995) 1998]).

3. Since the late 1980s.

4. Kitwana (2006) calls 1964–84 the hip-hop generation.

5. Mexicans With Attitude. See https://open.spotify.com/artist/1ViUSoYpsi8Zh9KGYA-huZg?si=opP1_rOaSBSPos4URIxmWg

6. And subcultural practices related to these.

7. Mexicans With Attitude. See https://open.spotify.com/artist/1ViUSoYpsi8Zh9KGYA-huZg?si=opP1_rOaSBSPos4URIxmWg

8. In a similar way hip-hop allowed for multiple "elements" to co-exist as part of hip-hop's ethos and cultural approach with regard to syncretic practices.

**Section 4 Figure Credits**

Page 112–13: Craig Stecyk
Page 114: DJ Slynkee photographed by Bobby Ruiz
Page 117: Shepard Fairey
Page 129: Huit
Page 130–31: Dave Kinsey
Page 132–33: Scott Herskovitz
Page 135: Pres ONe

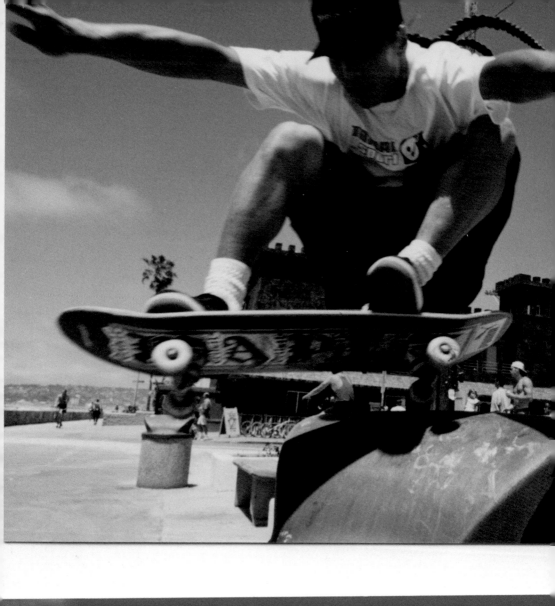
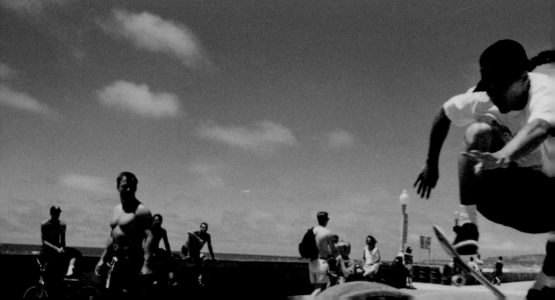

# SECTION 5

## SURF AND SKATE

# BEN CATER

Ben Cater serves as the associate dean of General Education and the Director of the Honors Program at Point Loma Nazarene University. He possesses an M.A. and Ph.D. in US history and has written widely on diverse topics, including public health and medicine, religion, surfing, and the American West. His publications have garnered several awards, such as the Editor's Choice and the Dale L. Morgan prizes from the *Utah Historical Quarterly*. A common theme throughout his scholarship is human flourishing—what it means and how it's achieved over time and place. An avid surfer of more than 30 years, Cater teaches surf history and culture that presents wave riding as a medium for studying human hopes, dreams, and fears. He often paddles out with students and is currently writing a series of essays that emphasize the sacramental nature of surfing.

# SURFING TOGETHER, SURFING ALONE: SURF TRIBES AND TRIBALISM IN SOUTHERN CALIFORNIA DURING THE TWENTIETH CENTURY

## BEN CATER

On Sunday, April 14, 2019, the annual "Gathering of the Tribes" wrapped up at San Onofre State Beach. Sponsored by surf tribes, or clubs, from San Diego to Santa Barbara, the event gathered clubs for three days of competition and camaraderie. Doheny Surfing Association president Mark Gales observed that "everyone had a lot of fun" (Connelly, 2019, para. 3), riding waves, talking story, consuming Costco pallets of beer and brats, and undoubtedly, earning bragging rights for the winning club. Gales wasn't all smiles, though. He lamented the weak turnout compared to previous years. Twenty-two

clubs had shown up, but the Doheny crew totaled 40 members compared to the 1980s average of 200. Other clubs reported similar shrinkage, adding that recruiting members and corporate sponsors was a "constant strain" (Connelly, 2019, para. 20). Would the tribes reassemble next year? Gales couldn't say for sure. While clubs have made a significant impact on the sport, their popularity has risen and fallen over the years, paralleling their shift in purpose. They've preserved wave riding as a shared cultural pastime uniting diverse communities and groups, but also encouraged competitive individualism, cliquishness, racial, gendered, and ethnic insularity. They've supported surfing's mainstream commercial appeal, as well as core commitment to the sport, an anti-social and countercultural ethos, cultural diversity and political activism. In many ways, surf tribes and tribalism have highlighted key ironies and tensions in surfing and surf culture, their historical evolution, and broader historical and sociological trends of the twentieth century.

The first surf clubs appeared in Hawai'i during the early 1900s and set a precedent for those in southern California. The Outrigger Canoe and Surfboard Club was founded in Waikiki in 1908 by Alexander Hume Ford, an orphaned son of wealthy South Carolinian planters. Hume's intentions for the club were for reviving, preserving, and "'developing the great sport of surfing in Hawaii'" (Warshaw, 2005), the former having declined since New England missionaries—the overly narrow sort—discouraged it in the mid nineteenth century. A pastime traditionally done by men, women, and children in the buff, surfing made biblical sexual ethics difficult to embrace or enforce and contributed allegedly to high rates of venereal disease. As winds and tides determined when to surf, the sport undermined standardized work and school schedules, vital to modern society. Composed of men dawning shorts and tank tops, the Outrigger also defended surfing from the nascent hotel-industrial complex. After US annexation in 1898, American businesses acquired about 90 percent of Hawaiian lands, and hotels began limiting beachfronts to paying guests. Common surf breaks be damned, Ford believed, a clubhouse by and for surfers would protect the sport's survival in the immediate future.

Over time, idealism waned and the Outrigger became a surf-inspired social club. Two-dozen everyday surfers filled the roster, but most members were foreign-born haloes, wealthy and interested less in accessing waves and more in seeing and being seen, and brokering deals over brunch. Located next to the Beaux-Arts style Moana Hotel, the club belonged to a post-missionary wave of migrants who embraced pseudo-scientific ideas about humanity, society, and especially, racial and ethnic differences. Racialist thinking placed human groups of shared physical traits on a hierarchy of superior to inferior, and club

members, while observing natives' supposedly natural talent in the surf, tried to demonstrate their ability too. Jack London, author of the popular *Call of the Wild* (1903) and a friend of Ford, insisted on the supremacy of the Teutonic race but was insecure about his own surfing acumen. Before heading into the surf, he reminded himself, "'You are a man, and what that Kanaka can do, you can do yourself'" (Warshaw, 2010, p. 44). At the Outrigger, modern notions of racial difference didn't materialize into formal Jim Crowe policies, but ethnic Hawaiians caught a whiff of the White bougie tribalism and never joined in substantial numbers.

In stark contrast, the Hui Nalu Club ("Club of the Waves") was founded in 1911 through the shared efforts of Hawaiian Olympic gold medal swimmer and international surfing ambassador Duke Kahanamoku, *hapa* ("mixed-blood") Knute Cottrell, and Ken Winter. Duke's five brothers, Edward "Dude" Miller, California surfing pioneer Tom Blake, and at least two women were also part of the crew. Although socially inclusive, the Hui was exclusive in its own way. Membership was based on election and surfing chops; merely owning a board didn't cut it; you had to hold your own. Kooks, or beginners, need not apply. Members paid $1.00 annual dues, hung out under the hau tree at the Moana Hotel, and used the downstairs bathroom to change clothes. Resentment toward the Outrigger was apparent, though not deep-seated, and rooted in the club's snootiness and pretensions to superiority. From the hau tree, Hume and his gang could be seen mingling in their linen blazers and long skirts in their open-air pavilion, while the Hui crew cruised on the sand bare chested and in cut-off pants, playing ukes and guitars, talking story, singing their club song, cracking jokes, napping, or nursing a hangover. For these "Beachboys" labor wasn't a high priority, although a few worked with hotels that recommended their services to tourists. Earning modest wages and occasionally generous tips, they served as catch-all lifeguards, tourist guides, surfing, fishing, diving, and canoeing instructors, board builders, musicians, serenaders, party chaperones, and not infrequently, gigolos. Surf historian Matt Warshaw writes, the Beachboys' "sexed-up, easy-going, empty-pocket deviancy" meshed with the sport to produce what would later be called "the surfing lifestyle" (Warshaw, 2010, p. 53).

By the 1930s, surfing and surf clubs were growing in popularity. Waikiki remained the epicenter of the sport, but southern California was quickly catching up. The region's cool but not cold water was key factor. So were the seasonal abundance of waves, the Great Depression, and the New Deal. Surfing could be done cheaply since boards were shared; all you needed were a pair of cut-offs. The ocean provided fish and shellfish and an escape from life's daily worries. Therapeutic exercise and psychic hope in the anticipation of more waves

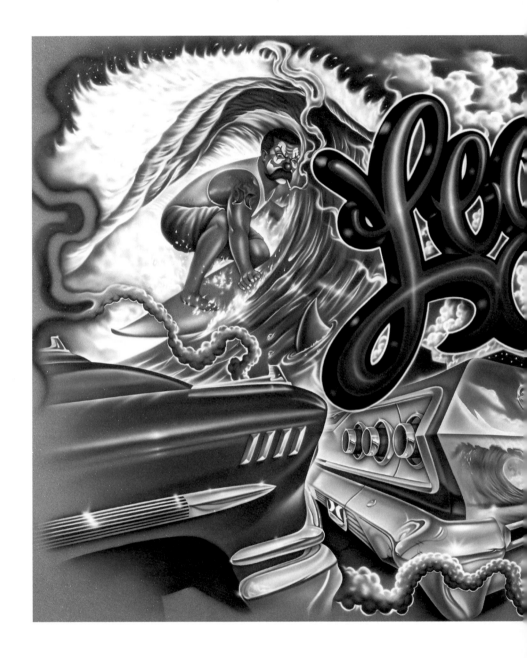

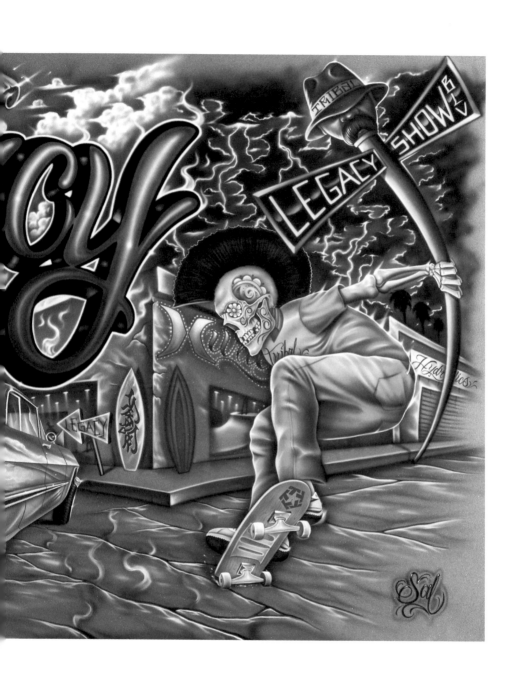

provided physical and emotional solace. As organizational structures, clubs inspired confidence in the state's few hundred surfers who seemed peculiar—unambitious, eccentric, or socially awkward. The best-known and organized club, the Palos Verdes Surf Club, met every Wednesday in the back room of President John "Doc" Ball's dentist office. Members, all from the South Bay, arrived at 7 p.m. dressed in suits and ties, per club policy, and then "seated in a semicircle facing the official table, [with] officers on the right according to rank, [and] three burning candles set in the abalone shell on the president's table" (Warshaw, 2014). Business began. Officers read minutes and approved the reports before planning events—socials, fundraisers, and banquets. Per their initiation pledge, members were expected to conduct themselves socially "in a manner becoming a Club member and a gentleman, so help me God" (Warshaw, 2010, p. 76). Surfers needed to be straight-arrow citizens to be in good standing with the club.

But the Palos Verdes crew knew how to cut loose. Boozing, horseplay, and Benny Goodman on the radio could be observed after meetings adjourned. Members gathered on weekends to surf Redondo, Venice, Hermosa, or Malibu, and sometimes further afield in Long Beach or San Onofre. Surf territoriality didn't exist, nor did the expectation of one surfer per wave. Surfboards were heavy and hard to turn, made of redwood and lacking fins, and thus encouraged surfers to ride together in straight lines to the shore. The Palos Verdes tribe might run into the San Onofre Surfing Club at its eponymous beach and be stoked to share the beach. Their relationship was casual, not competitive. Members exchanged phone numbers and information about surf spots, surfboards, and fin designs. Comradery amongst clubs like these strengthened the incipient surf community.

After the bombing of Pearl Harbor in December 1941, the military limited public access to San Onofre beach. Local surfers struck a deal allowing members of the San Onofre Surf Club to access it anytime. Members appreciated San Onofre for its long Waikiki-esque waves. Some surfers owned their gear but most didn't, so the club usually pooled resources to purchase and deliver supplies, mainly balsawood in Los Angeles leftover from building airplanes. Once in their possession, clubbers divided the work of crafting boards with hand planers, adze, and sandpaper. Finished, the club would lean their boards against hastily built palapas on the beach, admiring their work. Gathered around a campfire with girlfriends, wives, and kids, decked out in Aloha shirts and coconut frond hats, the San Onofre bunch often made seafood stew out of freshly caught abalone, halibut, and bass and pass it around to all-comers, while strumming guitars and ukes to "Little Grass Shack" and other beachboy standards. The beach

served as their common meetinghouse, and gatherings lacked the formality (role calls, official duties, behavioral expectations, attire, civic ideals, and service opportunities) of yesteryear. Indeed, laidback fraternity and off-the-grid self-reliance became the hallmarks of surfers who had endured world wars and economic depression, and now sought to simply escape social problems.

During the 1950s and early 1960s, surfing became, if not mainstream, less subcultural than before, and in response surf clubs evolved. Lighter polystyrene foam surfboards (dubbed "chips") started to become mass-produced and cheaply available at coastal surf shops. Teens flocked to the beach in record numbers on newly paved highways. Hollywood churned out surf-themed flicks like *Gidget* (1959) and *Beach Blanket Bingo* (1965) aimed at adolescent audiences, while records by Jan and Dean, Dick Dale and Del-Tones, and the Beach Boys injected words like "stoke" and "gnarly" into the American lexicon. Surf clubs bolstered their appeal by highlighting not the sport but surf-themed parties instead. Guys in madras shorts and girls in smocked bandeaus showed up to parties to dance the stomp on sand imported from local beaches. Fish nets and beach blankets draped clubhouse walls. Surf fashion and lifestyle more generally were on the rise.

Not all clubs focused on surf culture, however. Members of the Newport Beach Surfing Association (*c.*1958) recoiled not at "Misirlou" or Birdwell boardshorts but at surf lineups packed with beginners or unfamiliar faces. Taking a stand, the Association emphasized their proprietary rights, or surf territorialism, a cliquishness that didn't exist amongst surfers earlier in the century. Longing for the sparse lineups of yesteryear, members traded waves with each other but barred outsiders from getting a turn. Giving a stink-eye, yelling insults, getting in the way, and in extreme cases throwing down fisticuffs became expressions of localism. On occasion, Orange County newspapers published dramatic stories of surfer violence for reader appeal. But as Newport Beach Surfing Association historian Rick Chatillon observed, by the mid 1960s localism had become a cultural norm. It was widely known that "you just didn't go where you didn't belong," (Connelly, 2015). Split outsiders—locals only. The Association's primary meeting place was 22nd Street beach, or Blackie's, named after a nearby pub that eventually became tribal headquarters. To bring law and order to Newport's crowded waves, in 1967 the city required surfers to join the Newport Beach Surfing Association, which had the authority to issue permits. Details about this arrangement—how it began, where the Association met, its agenda and minutes, and what club entrance requirements were—are unknown, but the club was likely composed of surfers who knew each other and put in their time at Blackie's or other local breaks. In effect, localism got a legal pass. Permits

granted access to waves, deterred lifeguards from issuing you a ticket, and locals from slashing your tires. Club T-shirts signified one's membership in the tribe.

Not all surf clubs were aggressively gang-like or provincial. The Windansea Surf Club, formed by Hobie surf shop owner Chuck Hasley, originated to compete against other clubs. Featuring local talent from Windansea and Pacific Beach (Pat Curren, Mike Diffenderfer, Carl Eckstrom, Butch Van Artsdalen, Joey Cabell, and Skip Frye), it soon attracted top-level surfers from throughout the state. Hasley printed T-shirts, jackets, and swim trunks to signal their presence at contests. Dominating events, but especially partying to and from contests, became staples of Windansea culture which soon found itself on the wrong side of police, parents, and the public. In 1965, perhaps due to public pressure, the tribe came under the leadership of Thor Svenson, a professional talent agent. A well-connected figure who operated behind the scenes, Svenson helped Windansea clean up its public image. No more sex, drugs, and rock 'n' roll. No more youth rebellion. Instead, Svenson turned the club into a nonprofit organization whose mission was to "promote the sport of surfing and the positive image of surfers as athletes and good citizens, through the sponsorship of competitive surfing events and charitable community activities" (Windansea Surf Club, n.d.). He helped establish international branches of the club in Hawaii, Australia, and Mexico and went as far as arranging an introductory letter from then California governor Ronald Reagan for Windansea's visit to Australia: "'I shall personally appreciate," Reagan wrote, "any courtesies extended to these fine Californians and ambassadors of good will'" (Warshaw, 2015). In addition, he encouraged the club to show up to city council meetings to support the creation of the Tourmaline Surfing Park. Until his departure for other pursuits in the late 1960s, Windansea embraced a host of other civic service opportunities, such as offering free surf lessons and raising money for the homeless.

The surf contests that Windansea and like clubs created proved to be detrimental to club life. By the 1970s, they were overtaken by surf companies that turned contests into systematic affairs that reduced surfing to objective criteria (speed, distance, number of rides, time spent on a wave, etc.) that could be scored. To highlight their drama, sponsors offered prize money to transform surfers into business-minded athletes, hyper-competitive, and strategic. Professional surfing was born. To tradition-minded surfers, surfing to win contradicted the spirit of the sport—sliding waves for fun, spiritual, and physical renewal. The surf industry grated against the quasi-bohemian life that clubs promoted—low key, communal, and cheap. Over time, as surfing became more competitive, corporate, and mainstream, many surfers ditched clubs for soul

surfing that emphasized individual experience and personal liberation from what they considered decadent modernity. In turn, surfers began subdividing into "competitive jocks" who showed up for contests and "soul surfers" who bailed on the rat race for Baja, Hawai'i, and Indonesia. In colder climes, they manifested their protest of surf companies by dawning plain, black wetsuits without logos, white or psychedelic surfboards—often shaped in their back-yards—and fashions more reminiscent of *Rolling Stone* than Hang Ten®. Drop-ping acid and surfing in the buff became behavioral norms, as did protesting the Vietnam War and other injustices in the streets. By the end of the Counter Culture, surf clubs had essentially folded. In the words of writer Steve Pezman, for many surfing had become "the antithesis of organized social behavior" (Pezman, 2021).

The world turns. By the early 1990s, surf tribes were making a comeback, albeit modestly. The teens who avoided clubs in the 1970s and 80s were now middle-aged careerists, busy with work and families. They surfed and saw friends less. They possessed social consciences that inspired their giving back to their communities. The environmental movement, precipitated by the Clean Water Act (1972) and creation of the Surfrider Foundation (1984), was in its second generation when the Sunset Cliffs Surfing Association in Point Loma emerged. The Association hosted annual clean-up events and raised awareness about ocean pollution and dying reefs. Generally speaking, it worked to inspire respect for the coastline. The club operated out of South Coast Surf Shop in Ocean Beach, coordinating activities by word of mouth, flyers, and by the late 1990s the Internet. Surf contests were sponsored to get local businesses involved. As most members were regulars in the lineup, they constituted a "who's who" of the surf community even if anybody, including families and kids, were invited to join. The club's mission statement reads, "promoting the spirit of camaraderie, family, community, and environmental preservation [...] and the history handed down to us" (Sunset Cliffs Surfing Association, 2021). Similar-ly, the Windansea Surf Club reassembled to become akin to a sundrenched, eco-minded Kiwanis club. Other tribes reimagined their purpose to support clean water initiatives, which by the early 2000s became the explicit mission of the Coalition of Surfing Clubs (CSC). In 2012, its website read, "The Coalition represents over 10,000 surfers of all ages and exists for the betterment of the citizenship of the surfer, to improve clean water locally and globally and to promote the sport of surfing" (Surf, n.d.). Sponsors for its annual Gathering of the Tribes contest included the Surfrider Foundation, Heal the Bay, Oceana, and the Salvation Army.

Today surf clubs exist for a variety of reasons and reflect the tensions, ironies, and historical evolution of surfing, culture, and society. Some emphasize community service and social justice, while more stress individual athletic competition. Membership is formal and activities organized, although some, like the Bay Boys of Lunada Bay, lack formality and resemble petty gangs that violenty enforce their claims to local waves (Sammon, 2020). At the annual Gathering of the Tribes, Doheny Surfing Association President Mark Gales, observed, "The parents of many of today's youths just want them to compete, without the labor of being a volunteer with the club. [...] They become 'club hoppers,' only joining clubs where the kids have more chance of competing or standing out for sponsors" (Connelly, 2019). According to Gales, parents seem willing to organize contests and encourage athletic ambition but show less interest in cleaning up beaches and serving the underserved. Such activities are inconvenient, large scale, and lack immediate payoff. Perhaps they also appear ideologically motivated, and thus too divisive in our politically charged times.

That hasn't deterred the creation of new identity-based surf clubs. LatinX Surf Club, formed in 2017 by Vanessa Yeager, and the Black Surfers' Collective (BSC), established a year later, seek to promote racial and gender diversity in surfing. LatinX's Facebook page currently has 3000 "friends," many of Chicano/a background, while over a thousand followers like the Black Surfer Collective's. Given that the vast majority of southern Californian surfers have figuratively belonged to a demographic tribe—White, coastal, middle-class, male, and able to access the beach with ease and without fear of racial isolation or intimidation—this is significant. They've been able to afford their own expensive surf gear as well. In contrast, members of BSC and LatinX possess darker skin, come from Latin and African cultures, and live in working-class inland and urban neighborhoods. Their clubs lack many accouterments of traditional club life (official clubhouses near the beach, elected officers, meeting minutes, etc.). At the same time, however, these new identity-based clubs have embraced historical and modern tensions to their advantage. Through social media, they've organized "courage" paddle-outs and beach parties, collection drives to purchase surf gear and T-shirts—all elements of mainstream surf culture and traditional club life—while at the same time maintaining core commitments to surfing (Resendiz, 2020). In providing rides to the beach and paddling out together, members of LatinX and BSC have also exhibited social support, an affirming type of tribalism harkening back to the 1930s, which in turn has made the act of wave riding for people of color feel more like solitude and less like isolation (Cardwell, 2021). As such, modern tribes like these have helped reveal new challenges, while providing fresh perspectives on historical ones in the sport and culture of surfing during the twentieth century.

# REFERENCES

Cardwell, D. (2021, August 31). Black surfers reclaim their place on the waves. *New York Times*. https://www.nytimes.com/interactive/2021/08/31/sports/black-surfers.html

Connelly, L. (2015, January 10). *Wave after wave, year after year, O.C. surfers stick together*. Orange County Register. https://www.ocregister.com/2015/01/10/wave-after-wave-year-after-year-oc-surfers-stick-together/

Connelly, L. (2019, April 16). *California surf clubs unite for Gathering of the Tribes contest, but their future may be at risk*. Orange County Register. https://www.ocregister.com/2019/04/16/california-surf-clubs-unite-for-gathering-of-the-tribes-contest-but-their-future-may-be-at-risk/

Levitan, C. (2018, August 29). *HOME SURF: How La Jolla and Pacific Beach surf clubs survived ... but could still wipe out*. La Jolla Light. https://www.lajollalight.com/lifestyle/sd-cm-ljl-surf-clubs-20180820-htmlstory.html

Pezman, S. (2021, December 12). *The antithesis of organized social behavior.* Instagram [The Surfers' Journal]. *https://www.instagram.com/p/CXYxTtxIjQ2/?img_index=2*

Resendiz, E. (2020, March 10). East Los Latina surfers start ourage Camps for aspiring Latino surfers. *ABC 7 News*. https://abc7news.com/surfers-surfing-east-los-angeles-day-camps/5789805/

Sammon, J. (2020, April 9). Appeals Court backs plaintiffs in lawsuit over alleged abusive surfers, 'Lunada Bay Boys. *Southern California Record.* https://socalrecord.com/stories/529084408-appeals-court-backs-plaintiffs-in-lawsuit-over-alleged-abusive-surfers-lunada-bay-boys

Sunset Cliffs Surfing Association 15th Annual Gromfest. (2021, September 8). Facebook. https://www.facebook.com/Gromfest15; http://www.surfclubs.org

Surf Clubs. (n.d.). Home. http://www.surfclubs.org/

Warshaw, M. (n.d.). The Outrigger Canoe Club. In *The Online Encyclopedia of Surfing*. Retrieved May 31, 2023, from https://eos.surf/entries/outrigger-canoe-club-the/

Warshaw, M. (2005). Alexander Hume Ford (p. 210). In *The Encyclopedia of Surfing*. Harcourt.

Warshaw, M. (2010). The history of surfing. Mariner Books.

Warshaw, M. (2014, January 25). John 'Doc' Ball: How to fix a trouble soul. In *The Online Encyclopedia of Surfing*. https://eos.surf/2014/01/25/john.doc-ball-how-to-fix-a-troubled-soul/

Warshaw, M. (2015, January 6). Windansea Surf Club. *Surfer*. https://www.surfer.com/blogs/eos/windansea-surf-club/; https://www.windanseasurfclub.org/history-of-the-club

Warshaw, M. (2021, September 2). Windansea. In *The Online Encyclopedia of Surfing*. https://eos.surf/entries/windansea/

# JAMES WICKS

James Wicks, professor of film studies at Point Loma Nazarene University, grew up in Taiwan and teaches narrative and documentary film, world cinema, scriptwriting, and Intro. to TV and film production when he is not skating or surfing in San Diego, CA.

# STREET, PUNK, DESERT, LIFE: FOUR STORIES OF TRIBAL STREETWEAR AND SKATE CULTURE

## JAMES WICKS

Tribal's position as an icon in the global streetwear and board rider economy emerged from "the antithesis of what we might expect" (Thompson, 2005, p. 25). Their creations from the outset were the opposite of popular shirts at department stores or "cool gear" in strip malls; instead, we find a punk resistance to easy commodification and commercial viability. By rejecting the mainstream, Tribal Streetwear established itself as an ally of and a source of inspiration for San Diego's countercultural skateboarding scene which today brings life to vibrant subcultures in urban areas across the world.

This essay focuses on Tribal Streetwear's inextricable link to skate culture in four vignettes: Street, Punk, Desert, and Life.

# STREET

Tribal's story begins in a year that many other stories begin, 1989. It's the year the Berlin Wall came down, after all. But the location where Tribal emerged is singular—Tribal could not have emerged from any other location or in any other city than the streets of San Diego. As Isaac Ruiz tells it, his father Bobby would skate down the street past the lowriders in Mira Mesa. And the lowriders would wish they could skate just like skaters wished they had lowriders. And all factions wore the same clothes, like original Z-Boyz' Jay Adams with his Pendletons buttoned like a cholo (Ruiz, 2021)

It's impossible to overstate how central this scene was to skaters on the outside looking in. It's the stuff of legend, as rich as those from any tradition. And I would know—I was one of those looking in during the late 1980s. My friends and I memorized San Diego skate spots by scouring the pages of *Thrasher* and by wearing out a VHS copy of the skate company H-Street's mind-blowing 1989 video *Hokus Pokus* which showed smith grinds down handrails that seemed impossible. We were so influenced by it that one day in class when our literature teacher tried to settle the class down by saying sternly: "no hokus pokus!" about seven of us skaters replied by shouting in unison: "YES HOKUS POKUS!" The images H-Street projected are etched into the annals of skate history like the scenes in *Recognize the Real* video by Tribal Gear in 1996 which opens with a montage of skating alongside scenes of hip-hop, street dance, lowrider, streetwear, and Chicano-style graffiti cultures.

Around that same time period that Tribal Gear was in formation, I remember ordering some skate shirts through the mail from a shop advertised in the back pages of *Thrasher*—I think there was a Ray Barbee shirt in that stack I'd begged my parents to buy—and wearing it to school the next day after it arrived meant the world to me. Somehow, with a board under my arm, a shirt that could get me beat up by the "skater haters," and a bunch of skate stickers tagged on anything within reach—not to mention a few bruises and scars on my body as proof— somehow I was a part of something going on miles away in southern California.

Tribal Streetwear was at the center of this vortex in terms of both location and philosophy, a punk f-you from the center of skateboarding to the culture of organized sports and school and maybe one day getting a job that I didn't have to just imagine as a teenager but which somehow I believed I could replicate by making a curb to skate in my garage.

The similar lines and contours that linked skaters like me to everyone else in skate culture in Tribal's San Diego were concrete. Cement. Lots of it. Poured like shit over the entire industrialized world on purpose and without purpose. Over rivers, trees, hills, mountains, lakes … poured over it all. High-rises blocking the sun. Dirty streets. Ugly as hell. But hey, since it's already there—in Berlin, Rio, Manilla, Taipei, or wherever else—might as well roll over it. And make it an art.

# PUNK

So this story begins on the streets and out of the streets came art. But more than this, it was art that didn't demand validation—because there were already people who understood it seemingly intuitively without explanation. Like a straightforward summary of Rilke's treatise on poetry: "if you have to explain it, they won't understand," people who understood across the globe caught on to what Tribal was doing. Because to skaters it has never been about "validation" from anyone, including the Olympic Committee's acceptance (who cares?) of skateboarding today. It's just a toy. A piece of wood with four wheels.

On the one hand, in pursuit of "It" skaters have always been willing to produce their boards, wheels, trucks, art, music, clothes, ramps, and videos with whatever equipment that they have on hand at the moment. Not everyone has a lever of corporate machinery ready to pull at their fingertips, and truth be told not everyone even wants that.

The willingness to pursue this thing—which if it can't be described is sure as hell not a sport—with 100 percent dedication without 100 percent of the supposedly requisite equipment is the essence of punk. One of the first punk zines in New York in 1976 stated, alongside illustrations of playing the guitar: "This is a chord. This is another. This is a third. Now form a band" (Thompson, 2005, p. 25). And when the US punk band Rocket from the Tombs recorded a tape in 1975, band member Peter Laughner recollects: "The reason we did this tape and the reason MMS is going to broadcast this stuff is to tell you that you can do it, too " (cited in Barnett, 2016). Anyone can do it. This is the nature of do-it-yourself (DIY) punk culture.

On the other hand, the skate culture's style and aesthetic are singular and unique. And this is quite frankly the magic of skate culture: that it cannot be replicated by non-skaters even with 100 percent of the money, tools, and equipment at their disposal. This is because the intellectual and emotional honesty, expressed seemingly from the core of the skater's subjectivity, is in part what is found so attractive. Skater/artist Mark Gonzalez calls it a skater's center. No one

else can have it. Each skater's style is both individually distinctive and part of the collective.

Tribal's contributions to skate culture are at once simple to describe because they don't come with a lot of bells and whistles—it's just one of their board graphics sprayed with graffiti, it's just an extra-large Tribal shirt on a guy laying down on this board headfirst pushing himself across the concrete like a low-to-the-ground Superman—yet the design is so particular and the approach so spontaneous that the aesthetic is an experience greater than the sum of its parts.

This description intersects with descriptions of the new punk cinema tradition in interesting ways as well. Nicholas Rombes (2005, p. 74) writes:

> What distinguishes and links many of the disparate films of new punk cinema is their ability to do both: to evoke a sincere emotional response while, at the same time, to create the possibilities for the audience to see through the very mechanisms that elicit this response.

In keeping with this description, Tribal's techniques are easy to identify even by those outside the subculture, yet the effect this style evokes is often imitated but rarely mastered. It can't seem to be faked. And part of that reason is that it's not only a knowledge of Tribal and skate culture that is required but an understanding of the location it emerged from as well.

# DESERT

Everything surrounding San Diego, except for the sea, is desert. Drive 30 minutes northeast, east, southeast…it's hot. It's brown, it's barren. The ground turns to mud when it rains. The golf courses hide this, the big suburban housing tracts with their $750K homes (these are the "cheap" ones) hide this, and irrigation diverted from the Colorado River waters it. But get close to the sea—and its marine layer that produces fog all of the tourists never factored into what they thought would be on a sunny SoCal vacation—and all of that concrete covered with a layer of desert dust, you find a city where every ethnicity and culture and

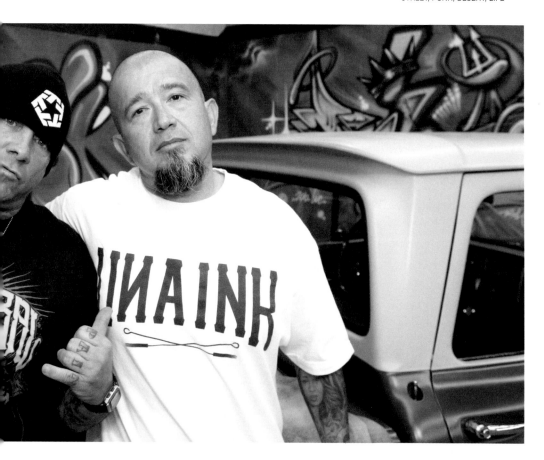

ideology happens to exist. And this is where things can get a little bit bleak, but it's just a fact:

San Diego is wealth, poverty, the border, high rises, drug dealers, human trafficking, churches spread around like a midwestern town, racist vigilantes, and the military complex. Understanding this is essential to get an inroad into the variegated, diverse, and exciting work of Tribal: it emerged from a native American homeland, a site of a hostile colonial takeover, an elite architect's dream of building the Venice of the United States, a World War that brought a flood of people searching for jobs after the depression but before an infrastructure for them was in place, a series of small towns of varying degrees of wealth wedged together into today's conglomerate. There is a lot to love, but a lot to hate if your eyes are open.

The intimacy generated within skate culture between the location of San Diego and its punk aesthetic is based on a rejection of its local teleology found in various guises: political power at the expense of marginalization, the pursuit of a technological utopia despite ecological devastation, globalization, and its

coterminous gentrification. Tribal punk artists have called attention to these societal factors consciously and unconsciously, building a mutual solidarity with skaters like Kien "Donger" Liu along the way (Rombes, 2005, p. 6). It's a voice in the desert.

Today the location of Tribal on 17th Street is in the same building as Slappy's Garage Skate Shop. The two are linked by both location and camaraderie. It is a physical representation of the ways Tribal has always gone against the grain, against what is considered "normal" like skate shops in outlet malls. Tribal's inextricable link to San Diego while carving out its own space in it, reminds me of Hamid Naficy's (2007, p. 222) statement regarding the independent transnational film genre with characters who "become neither the society's others against who its overarching identity could be formed nor its full citizens who could be pressed into servicing its values." Psychically and socially, these skaters and artists are on the edge of San Diegan society (Naficy, 2007, p. 222). But out of this desert, Tribal created life.

# LIFE

And here is where things get a bit brighter again. Tribal's story and products are fueling creative grassroots street culture movements across the globe. The strategy Tribal stubbornly held on to 30 years ago—rejecting deals with huge clothing chains along the way (Ruiz, 2021)—has been replicated elsewhere despite national borders and geopolitical differences. Each iteration outside of San Diego is always embedded at the local level in the politics; it engages with directly and specifically—this is the transnational dimension of skate culture.

Punk again sets the example. The founders of Rocket from the Tombs reacted against bland top 40 music on the radio because it projected something that was always out of reach: "You know, we weren't interested in being pop stars 'cause being a pop star was totally unrealistic for a kid in Cleveland in the '70s," band member David Thomas reminisces (Barnett, 2016) This same narrative found its way into innovative articulations in urban bunkers from London to New York to Tokyo at times when economic prospects were bleak. In each new environment, punk songs gave a voice to frustrated youth entering into adulthood but desiring no part of a workforce that seemed mechanistic and heartless.

Similarly, skateboarding maintains universal connections globally while remaining true to its identity locally. Take for example a segment in Jeff Grosso's (RIP) final *Love Letters to Skateboarding* featuring skate culture in Japan. Throughout the episode, Japanese skaters talk about how they were ostracized

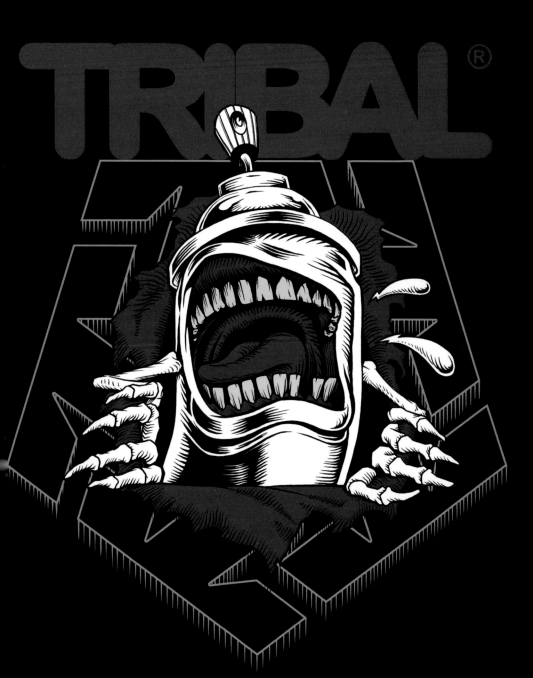

by the culture at large, but this separation is felt even more so by women skaters there. As skater/filmmaker Yuri Muri—producer of all-women skate videos entitled "Joy and Sorrow" since 2013—explains, women skaters experienced a double marginalization not only from the culture but from men as well: "Some people told me that we suck but I wanted to show that there is more to skating than just skills." In places like Tokyo and elsewhere, feedback isn't always supportive but in the fringes and cracks life keeps blooming with the like-minded. Muri goes on to say: "I get motivated because I know I'm not alone " (cited in Vans, 2021).

So if we see skate culture as a direct engagement with concurrent local politics by a particular community's adamant about living out an alternative way of life—even if it's seemingly as simple (and thus ignorable) as pushing the body's limits against gravity on DIY transitions at Washington Street—and we squarely place Tribal as a formative influence within this articulation, we discover a unique way of understanding the brand's global reach. It's about honesty, authenticity, and what Isaac Ruiz calls giving "people without a voice a sense of freedom" (2021). Even in something as unassuming as a T-shirt can mean the world to a young person, even in art. It's cross-pollination in the desert.

Streetwear always works as a confluence of overlapping factors which are not identical but always recognizable among skateboarders. Once it's on it creates an intimate connection based on complex aesthetic and economic factors. Regarding punk style, Dick Hebdige (cited in Rombes , 2007, p. 75) once stated: "the sensibility which punk style embodied was essentially dislocated, ironic, and self-aware" in a way instantly recognizable to others. Skaters in Tribal gear today are connected and linked as well, part of a "Worldwide Clique Since 89."

Ella Shohat and Robert Stam have written, "within an ongoing struggle of hegemony and resistance each act of cultural interlocution leaves both interlocutors changed" (Ba & Higbee, 2012, p. 6). In the case of Tribal, it is for the better. And even though there's a long way to go—abandoning videos where people are called f**s or the objectification of women come to mind—theirs is a story of locating and irrigating new signs of life growing in the desert. Today what Tribal has created is part of a life-sustaining community that has stemmed far beyond the small band of diehards who had the insane idea to start watering the soil in the first place.

In the end, the connections between Tribal and skateboarding will always defy description but at least we can trace some of the ways it's tied together: street, punk, desert, and life.

# REFERENCES

Barnett, D. C. (2016, January 3). Punk before it had a name, rocket from the tombs releases an album. *NPR*. http://www.npr.org/2016/01/03/461818478/punk-before-it-had-a-name-rocket-from-the-tombs-releases-an-album

Hebdige, D. (1984). *Subculture: The meaning of style*. Methuen.

Bâ, S. Maty, & Higbee, W. (2012). *De-westernizing film studies*. Routledge.

Naficy, H. (2007). Independent transnational film genre. In E. Shohat & R. Stam (Eds.), *Multiculturalism, postcoloniality and transnational media (pp. 203–26)*. Rutgers University Press.

Rombes, N. (2005). Introduction. In N. Rombes (Ed.), *New punk cinema* (pp. 1–18). Edinburgh University Press.

Rombes, N. (2005). Sincerity and trony. In N. Rombes (Ed.), *New punk cinema* (pp. 72–85). Edinburgh University Press.

Ross, J. I. (2018). Reframing urban street culture: Towards a dynamic and heuristic process model. *City, Culture and Society, 15*, 7–13.

Ross, J. I. (2021). Introduction: Disentangling street culture. In J. I. Ross (Ed.), *Routledge handbook of street culture* (pp. 1–7). Routledge Publishers.

Ruiz, I. (2021). Interview by James Wicks. September 3.

Thompson, S. (2005). Punk cinema. In N. Rombes (Ed.), *New punk cinema* (pp. 21–38). Edinburgh University Press.

Vans (2021, July 2). Grosso Forever: Loveletter To Japan | Skate | VANS. YouTube. https://www.youtube.com/watch?v=AABIqccSOh4

**Section 5 Figure Credits**

Page 144–45: Photographs of Kien "The Donger" Lieu
Page 146–47: Eddie Castro
Page 150–51: Sal Elias
Page 158: Taste
Page 162–63: Jay Adams and Bobby Ruiz photographed by Willie Toledo
Page 165: Maxx 242

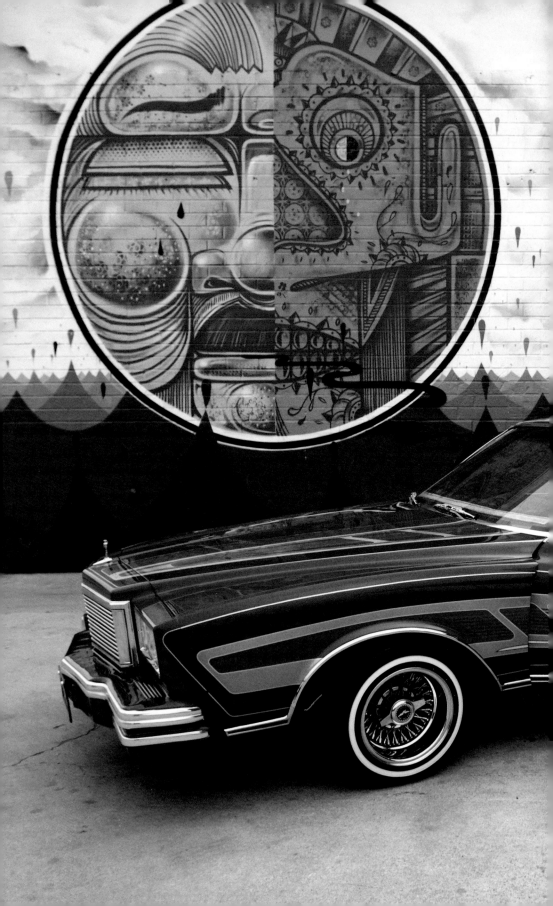

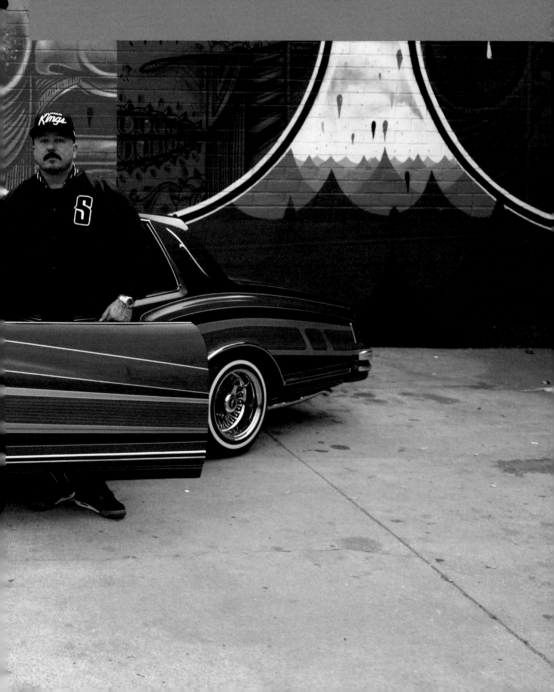

# SECTION 6

## LOWRIDERS AND CULTURE MAKING

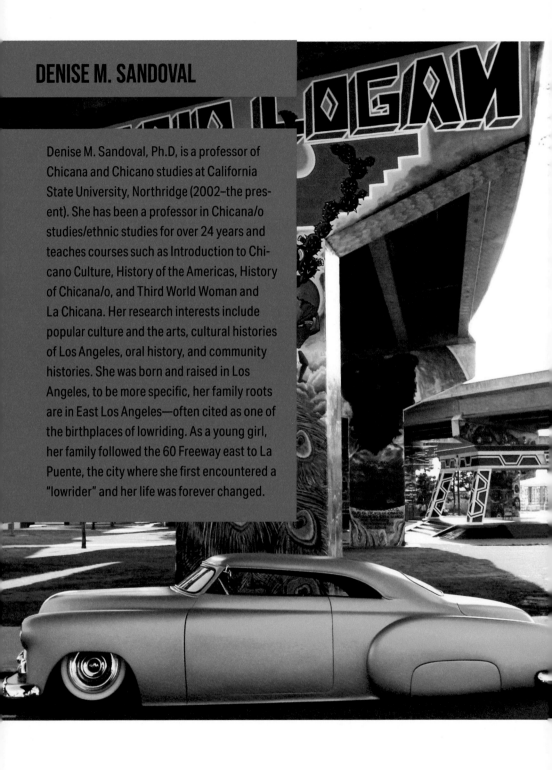

# DENISE M. SANDOVAL

Denise M. Sandoval, Ph.D, is a professor of Chicana and Chicano studies at California State University, Northridge (2002–the present). She has been a professor in Chicana/o studies/ethnic studies for over 24 years and teaches courses such as Introduction to Chicano Culture, History of the Americas, History of Chicana/o, and Third World Woman and La Chicana. Her research interests include popular culture and the arts, cultural histories of Los Angeles, oral history, and community histories. She was born and raised in Los Angeles, to be more specific, her family roots are in East Los Angeles—often cited as one of the birthplaces of lowriding. As a young girl, her family followed the 60 Freeway east to La Puente, the city where she first encountered a "lowrider" and her life was forever changed.

# *LA LOCURA CURA:* LOWRIDERS, CHICANISMO AND BOBBY TRIBAL

## DENISE M. SANDOVAL

*Locura Lo Cura*

(José Montoya, The Royal Chicano Airforce [RCAF])

## LA ENTRADA/LA LOCURA CURA

I attended St. Joseph's Catholic School in La Puente, CA and every Friday after mass, this breathtaking candy-yellow lowrider with a mural of La Virgen de Guadalupe would cruise slowly in front of the church. I remember thinking it was the most beautiful car I had ever seen, and I just wanted to know more about this car as a young kid. As the years passed, I often thought I had imagined the entire memory. I never would have foreseen that some twenty years later, as I began documenting the history of lowriding in Los Angeles, I would actually meet a lowrider owner from La Puente who told me that the car had really existed. He also told me that the owner had died and "who knows what happened to that *firme ranfla.*"

As a result, I became fascinated with oral history and interviewing lowrider car owners while in graduate school working on my doctorate in cultural studies at Claremont Graduate University. Through my research and participation in lowrider culture (since 1998), I have learned that every car has a story, sometimes many stories. Lowriders reveal not only their passion for classic cars but these cars and their owners document the rich and vibrant social and cultural history of our communities. These cars are then not only visual testaments to multicultural American and Chicana/o history but also can be tools to teach others, especially youth, another avenue to learn about and re-think history. My research interests in Chicana/o history and lowrider culture allowed me to curate three exhibitions at the Petersen Automotive Museum in Los Angeles: *Arte y Estilo: The Chicano Lowriding Tradition* (February–May 2000), *La Vida Lowrider: Cruising the City of Angels* (October 2007–May 2008), and *The High Art of Riding Low: Ranflas, Corazón e Inspiración* (July 2017–September 2018). Museums are important spaces for us to infiltrate and to tell our stories on our own terms, and I am excited and energized by all the museum exhibits and art shows that are happening within the last few years across the United States which document and complicate lowrider culture and history.

I share with you my personal story because it intersects with the person who we are celebrating in this edited text: Bobby Ruiz aka Bobby Tribal. When I was asked to contribute, I thought about what we shared: we both grew up in Chicano communities that were important centers for Chicano art and culture (San Diego and Los Angeles—though interesting enough he also lived in La Puente for a bit); we both from a young age were observers of the streets and of the cultures that surrounded us; we both were majors in Chicana/o studies in college; we both loved lowrider culture; we both curated Chicano art and museum exhibits; we knew a lot of the same people; and we were passionate about educating others about Chicana/o culture. So, when I had the chance to interview him for this essay and the Smithsonian Lowrider Project,[1] I knew that I wanted to connect my love and passion for Chicana/o studies and lowriding to the story of Bobby Tribal.

*La Locura Cura* is a phrase often used in the streets in various ways across Aztlán, more specifically in gang culture, otherwise known as *La Vida Loca* ("the

crazy life"). It was the latter definition that influenced the late and legendary Chicano poet and artist of the Royal Chicano Airforce (RCAF) José Montoya (1932–2013) to say "locura lo cura/craziness cures," to explain how the streets and gang culture mentality helped Chicano soldiers survive wars in the 1950s to the 1970s (in Korea and Vietnam) and brought them back home. Montoya had a particular connection to San Diego, he settled there after serving in the Navy (Korean War), and he attended San Diego City College where he was encouraged to further his studies in art. In the 1960s and 1970s, as students and faculty of the Chicano Movement were protesting and fighting on college campuses for access, resources, and the establishment of Chicano Studies, Montoya argued that "la locura" was a tactic of Chicanismo to survive the fights with the university administration, as well as the "psychic development" tensions of asserting a Chicano identity (Diaz, 2017). Montoya and his artistic collective RCAF returned to San Diego to paint murals in Chicano Park in 1975, therefore José had a particular affinity for San Diego and the community of Barrio Logan. When José Montoya died in 2013, *La Bloga* posted an announcement on January 6, 2014 on Jose's memorial in Sacramento which explained *La Locura Cura* further:

> The literal translation of "la locura cura" is "craziness heals" and was coined by Montoya as a way to explain the unconventionally successful creativity of the RCAF, the Royal Chicano Air Force, a group he co-founded of Chicano artists—mostly professors and students who were and still are prolific Sacramento artists devoted to advancing social justice through visual and performing arts.

(para. 3)

Therefore in this essay, I am interested in focusing on *Locura lo Cura*, or what today is more often used "La Locura Cura" as a cultural survival tactic and ethos of the Chicana/o/x experience in the United States, and one that is historically connected to art-making practices in our communities, especially around issues of social justice. I also believe that it operates on an intuitive level in our communities, and you know *La Locura Cura* exists when you feel it or see it. It is very much anchored in the community, in the streets, and in our homes—the people give these words meaning(s) and life. One of the best definitions of *Locura Cura* is in the documentary *Pilots of Aztlán: Flights of the Chicano Airforce* (1994) where RCAF member Stan Padilla explains:

> Locura Cura. It's like a mantra, the craziness cures. In a world that's out of balance, if you put beauty and harmony, it does not cure as much as

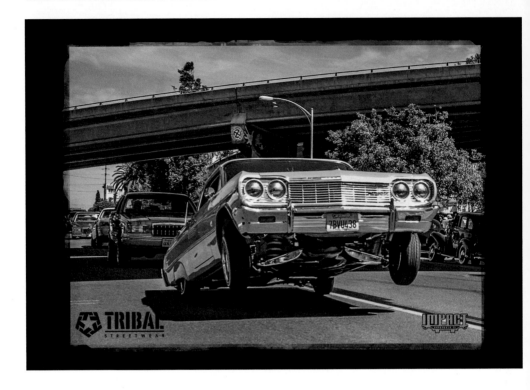

more craziness. And that's part of the sacred tools by being part of the craziness, that we can heal the world and the wounds of the world.

There has not been much writing within Chicana/o/x academic circles on the history and impact of "La Locura Cura" outside of some brief mentions in work on Chicana/o/x art history, and again some of the difficulty is trying to define it in an analytical way when there are visceral and intuitive levels to how it manifests in our everyday lives, especially within Chicano cultural spaces. That being said, this essay is an attempt to trace how both the politics and expression of *La Locura Cura* influence the history and work of Bobby Tribal and how it connects to both lowrider culture and Chicana/o/x art aesthetics and practices.

# RAICES/ROOTS, *PRIMERA PARTE*: LOWRIDER HISTORY

*Bajito y Suavecito*. Low and Slow. These words capture the innovation and creativity of this American cultural practice. Lowriding has a style and art which is distinctly its own. It is more than just customized cars; it is also a way of life. Familia, honor, pride, and respect are more than just words; these are social codes of the lowrider car clubs and the boulevards. They are also the building

blocks of the history and spirit of the lowriding tradition which crosses regional, national, and international boundaries.

In many ways, lowriding in Mexican American/Chicano communities is both writing our own American stories (through cars) and responding to US historical forces of prejudice and discrimination, since it dates back to the early 1940s when pachucos cruised the boulevard (Alvarez, 2009; Bright, 1995; Chappell, 2012; Lipsitz, 1990; Mazon, 1984; Mendoza, 2000; Obregon Pagan, 2003; Penland, 2003; Plascencia, 1983; Pulido & Reyes, 2017; Ramírez, 2009; Sandoval, 2003; Stone, 1990; Tatum, 2011; Trillin, 1978; Vigil, 1991). Mexican Americans/Chicanos through the years have been associated with popularizing lowriding, mainly due to the national and international popularity of *Lowrider Magazine* and other culture industries, such as television, movies, and social media. Other cultural groups have marked out a space within the lowriding scene adding to its vitality and evolution, such as African Americans, Asian Americans, and Anglo-Americans. What has evolved over the years is a multicultural practice that involves crossing cultural borders through a shared passion—lowriders.

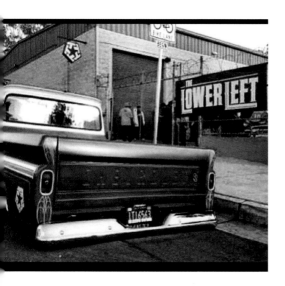

Lowriding is a direct result of the post-World War II car culture boom as automobile manufacturing resumed and the demand for new cars increased. Southern California was the perfect location for the explosion of car culture activities with its consistent sunshine and freeways/interstates. More importantly, the post-World War II economy created an environment that fostered a postwar love affair between American males and their cars. Both hot-rodding and lowriding began as inherently masculine activities. As an expressive form, lowriders can be seen as "oppositional aesthetics" to hot-rodders of the 1930s and 1940s. Whereas hot-rodders customized their cars by raising them off the ground and built them for speed, lowriders reversed the aesthetic by lowering their vehicles and cruised as slowly as possible (low and slow/*bajito y suavecito*). Lowriders transformed the style of an already manufactured item, an American automobile, by infusing it with certain meanings of everyday life in the barrio. The speed, the look, and the sound of one's car became a symbol of cultural resistance, and working on one's car became a means of artistic expression.

Automobiles allowed mobility, not just economically through the purchase of a car, but also created an avenue for Chicano lowriders to transgress the boundaries of racially segregated neighborhoods in Los Angeles.[2] Their participation in car leisure activities forms a collectivity with other lowriders and maintains the link found in many popular cultural forms, where the individual uses popular culture to create a community with others. For lowriders, the cultural space they created in the 1950s created a place within the barrios of Los Angeles to socialize and belong—much like our ancestors did in the plazas—and used their cars to redefine what it meant to be "Mexican American." As Ruben Ortiz-Torres (2000) elaborates:

> With the advent of lowrider culture, the individualistic American dream of driving away to escape it all has been replaced with the notion of driving together. Lowriders organize in car clubs and go cruising on the weekends on specific boulevards, updating the old Mexican practice of walking around town plaza on Sundays in order to socialize and flirt with girls. They drive slow, pumping their music and blocking traffic, messing with a social system that is not eager to accept them.
>
> (p. 37)

Hydraulics marked the beginning of a new era of lowriding in Los Angeles. In 1958, Ron Aguirre, a Chicano from Los Angeles, installed the first hydraulic system in a 1957 Chevrolet Corvette. The setup allowed his car to be lowered or raised with a flip of a switch, an important innovation in the lowriding scene. The hydraulic parts, which consisted of hydro air pumps and dumps, were surplus parts from World War II fighter planes that assisted in lowering and raising the wing flaps. During the 1960s and 1970s, a large number of lowriders would purchase government surplus parts at Palley's Surplus in Vernon (a setup costs $40 in the 1960s) and have them installed at places such as The Ruelas shop in South Los Angeles, Dick and Ron's in Hawthorne, Bill Hines's shop in Compton, and Al Sullivan's in Hyde Park. These surplus parts were a valuable asset to the lowriders since they could ride as low as they wanted to on the boulevard and then return their cars to a legal ground clearance with the flip of a switch if they saw the police. Because the California vehicle code stipulated that no part of a car could be lower than the bottom portion of the wheel rim, the police often wrote tickets to lowriders who were among their favorite targets of this code violation. The lowrider label began its use in the 1960s, and, according to *Lowrider Magazine*, the term was first coined by the police after the 1965 Watts Riots. Jack Kennedy relates in *Lowrider: History, Pride, Culture* (2003) that

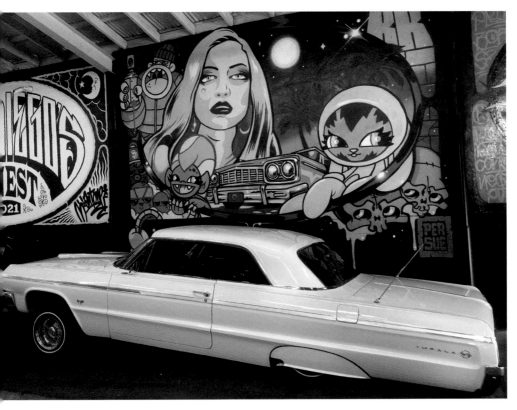

[t]hey [the police] were using the term "lowrider" as a derogatory term for the young black kids that were causing all the trouble [...] They said that they were kids who drove cars with no springs and no seats so they could ride low.

(p. 26)

San Diego has always been an important and vibrant space for lowriding in southern California. I do not wish to give a definitive history of lowriding in San Diego, but for the purpose of this essay, I would like to provide some significant highlights. San Diego, much like Los Angeles, was influenced by hot-rod culture and custom car culture post-World War II, as social jacket clubs and car clubs formed in the 1950s and 1960s. Some of these early clubs cited by Pulido and Reyes are Los Villanos, Coachmen, and the Baja Kings; and the authors later list some of the early lowrider car clubs (1969–71) of San Diego and Barrio Logan, such as Nosotros, Latin Lowriders, Chicano Brothers, Brown Image, Regents, and Classics. The establishment of the San Diego Lowrider Car Club Council in 1979 follows the history of other lowrider communities, as lowrider car clubs begin to work together to promote a positive image of lowriding, as well as organize car shows. Other important spaces in San Diego where lowriders created community were cruising Highland Avenue and participating in events in

Chicano Park. "Low-n-slow" for Pulido and Reyes (2017) documents San Diego lowrider history and connects San Diego lowriders to other lowrider communities in Aztlán through the politics of *bajito y suavecito*:

> Therefore in telling the history of lowriding, which emerged from the Chicano barrios in San Diego, California, we identify three levels of space that organize and guide lowrider life and living: 1) gathering places, 2) vehicles and 3) activities performed within spaces. We believe this best captures the life of living "low-n-slow" in the heart of the borderlands.
>
> (p. 19)

Therefore, the politics of low and slow/*bajito y suavecito* is an important one for lowrider communities in the United States, especially in cities like San Diego and Los Angeles. "Low and Slow" is not only a "leisure activity" but a system of cultural knowledge grounded in the everyday practices of urban life and the streets/boulevards of our Chicana/o/x communities. Lowriders in choosing a particular aesthetics of car customizing created a subculture that moved them beyond the barrios through the performance of mobility and creativity. As lowriders cruise the boulevards, they visualize their style and culture to people outside their communities, and transform the use of public space and the streets into "community-enabling place" (Villa, 2000). Therefore, the politics of low and slow/*bajito y suavecito* is very much aligned with *La Locura Cura* as it situates Chicana/o/x cultural practices and histories at the center of knowledge and action.

# RAICES/ROOTS, *SEGUNDA PARTE*: THE CHICANA/O MOVEMENT

The Chicana/o movement (1962–75) was the political arena in which Chicanos engaged in activism in regard to civil rights, social justice, and equality. They also developed a collective identity that challenged the status quo of oppression and inequality that many Chicanos experienced in the United States (Acuña, 2000; Blackwell, 2011; Chávez, 2002; Garcia, 1997, 2015; Marin, 1991; Montoya, 2016; Munoz, 1989; Rosalez, 1997). The term "Chicano" was a political label adopted by many Mexican Americans. They named themselves

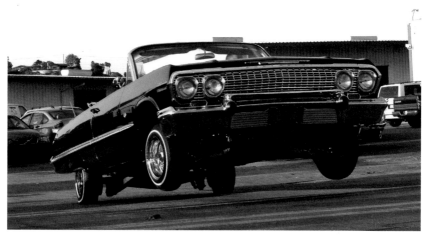

on their own terms (instead of having a label placed on them by the dominant Anglo American culture) as well as connect their lives to both their Indigenous and Mexican heritage through "Chicano." Chicanos fought in their communities for social change, while embracing the philosophies of self-determination and empowerment. There were diverse Chicano movements occurring throughout the Southwest—many with different leaders and political agendas—yet all were defined under the umbrella label: "The Chicano Movement."[3] More important-ly, the Chicana/o movement directly influenced much of the work of Chicano artists and community members throughout the barrios of the Southwest.

The Chicano art movement was tied to this important political and artistic era by creating art that was grounded in "resistance and affirmation," and the art gave a visual language to the Chicano Movement and Chicanismo (pride in being both Mexican and American). The use of "cultural space" within the barrio was one of the tools used to challenge the dominant culture, as empty walls in the community were converted to canvases for artistic expression (La Torre, 2008; Sperling Cockcroft & Barnet-Sánchez, 1993). The Chicano mural movement was "community based" and the community decided what they wanted on the walls as they reclaimed their cultural heritage through art (self-determination). Murals were painted all over the barrios of the Southwest and they became both a method of social commentary and education, as well as a celebration of Chicano cultural pride/Chicanismo. Chicano public art was political and it was able to express a cultural identity and aesthetics often overlooked by the White dominant society. Most importantly, the art movement

identified certain cultural symbols as sources for Chicano art; it created a visual language for the Chicano movement and "Chicanismo."

The history of Chicano Park is one that exemplifies Chicana/o activist work to reclaim land in our communities for use by our community on our own terms (self-determination and resistance). It was also and is an important center of art and activism, particularly using murals to visualize and celebrate Chicano history and culture (self-affirmation). On April 22, 1970, the community of Barrio Logan in San Diego took over land they were promised for a park when they were alerted that land would be used to build a California Highway Patrol station. The community used their bodies to create human chains around bulldozers and occupied that space for twelve days. There are many excellent writings and documentaries that trace the history of Chicano Park, but what interests me in this essay is how the land was central to creating "space and place" to empower and celebrate a Chicano community like Barrio Logan. In the 1950s, Barrio Logan was rezoned and there was an increase in junkyards and other environmental generators of pollution. In the 1960s, the community suffered another environmental attack when Interstate 5 and the Coronado Bridge ran right through the Logan. Therefore, the potential building of a California Highway Patrol station in Barrio Logan was the ultimate *Ya Basta* ("Enough is Enough") moment. Equally important to this history was how the artists played a central role in its development and how the park is registered as a National Historic Landmark in 2017.

In 1975, members of the Sacramento-based artist collective, RCAF, were invited to paint murals in Chicano Park as part of an artist invitational, and José Montoya painted an important mural of a farmworker family entitled, *Leyes–La Familia*. Chicano Park then is a living and breathing testament to the history of the Chicana/o/x community to demand their civil rights and social justice and also demonstrates the power of the arts as tactics of liberation and cultural affirmation. Every year around the anniversary of the land takeover on April 22, there is a big community celebration, Chicano Park Day, and lowrider car clubs have always been invited. In my own research, so many lowriders outside of San Diego have shared with me that they love coming to this annual celebration of Chicano Park since it is filled with "Chicano Pride." This sentiment is echoed in Bobby's interview below, as well as in the lyrics of the song "Chicano Park" written by the Los Alacranes Mojados in the 1970s:

It began in 1970, under the Coronado Bridge
En mi barrio, in San Diego

Where my people began to fight
For Chicano Park, for Chicano Park
Under the bridge, under the bridge, under the bridge ...
We shall continue to live my brother,
We shall continue to fight my friend
For Chicano Park, under the bridge ...

A new Chicana/o aesthetics was created by artists during this time period in the late 1960s and 1970s that anchored the lived environment and everyday cultural histories of Chicanos as the primary inspirations for the creation of art. Chicano art historian Tomas Ybarra-Frausto ([1990] 1993) labeled the art *un nuevo arte del pueblo* ("a new art of the people") which made use of and was inspired by existing art forms, rituals, and traditions found within Mexican and Chicano history and culture, some examples include *pulqueria* art "colorful public murals"; *Estampas* "chromo-lithographed calendar"; *altares* "altars"; *almanaques* "chromo-lithographed calendar"; and Chicano artistic folk forms such as graffiti, tattoos, pinto art, and lowrider art (pp. 59–61). As a result, many Chicano artists embraced the lowrider car and infused it with political and cultural meanings, particularly around questions of cultural identity, history, and *Chicanismo*. The lowrider car and its aesthetics became then part of the iconographic language of a Chicano barrio sensibility—a sense of self worth that is defiant, proud and rooted in resistance (Ybarra-Frausto, [1990] 1993).

Ybarra-Frausto ([1990] 1993) clearly defines Chicanismo through a barrio sensibility within Chicana/o art history and practices that through the years has given many Chicanas/os/x methods or tools to celebrate, resist, and create cultural forms that complicate the understanding of our identities, both on an individual and a collective level. This introductory essay and interview highlight the relationship between lowrider culture and history of Chicanismo using the life and experiences of Bobby Ruiz. His story speaks to a complicated and fascinating way *La Locura Cura* is both embraced and embodied in his work as a culture maker/influencer, businessman, lowrider, proud Chicano, and more importantly a community leader in San Diego and beyond. As stated earlier in this essay, "La Locura Cura" is a term that is often difficult to define in an analytical way since it is a cultural survival tactic and ethos (often intuitive and/ or visceral ) of the Chicana/o/x experience within the United States, and it is historically connected to art-making practices in Chicana/o/x communities throughout Aztlán. I am hopeful that there will be more scholars writing about "La Locura Cura" since the craziness of life in Chicana/o/x barrios around social justice issues such as police brutality, immigrant rights, access to healthcare, women's rights, and homophobia to name just a few, means that artists and

other cultural workers will be at the forefront of the challenge Stan Padilla of the RCAF proposed to us all: By being part of the craziness, we can heal the world and the wounds of the world.

¡La Locura Cura!

C/S

## INTERVIEW WITH BOBBY TRIBAL:

**Do you remember when you saw your first lowrider?**

I have always been into skateboarding. When we moved to south San Diego, my brother and I would skate around the neighborhood. I was still in elementary school, like fifth grade. One of our friends was Manuel Enriquez, and he had two sisters Maggie and Sylvia. Sylvia had a boyfriend Freddy Lozano and his friends had lowriders. Freddy had a '57 Nomad with hydraulics and his homies had other cars and they would hang out at Manuel and Sylvia's house. We would skateboard and I remember sitting across the street on the curb just in awe of these dudes. They would be washing the cars in their front yard. I would pay attention to what they were wearing, what they were listening to; they had cool girlfriends and cool cars and music. I was just Wow, this is it! It hit me like a ton of bricks; this is like the coolest stuff ever and I wanted to learn more about this. And that is when I started to notice lowriders in the neighborhood. I started noticing the plaques, there was Brown Image, Latin Lowrider, and in junior high school (seventh grade), I saw my first club jacket and it said Casinos. Again I thought it was the coolest thing ever and Casinos turned into Amigos Car Club.

I had a friend, Abel Chavez (RIP), and his brother Tony was a member of Latin Lowriders. Tony would pick us up from junior high in his 51 Chevy Coupe and he is still active in streets today and still shows that car. That was the first lowrider with hydraulics that I had ever ridden in. That was pretty much what grabbed me—the music, the color, the movement, the style, the energy—everything about it! And back then it was all Chicano, this was early to mid 1970s.

**What do you remember about lowrider style and aesthetics in the 1970s?**

We would always go to LA to visit friends and family back then. Back then you would see lowriders at weddings and quinceañeras are done up with tissue paper flowers, that was also the time of rainbow tape. Rainbow tape is basically like a pin striping tape and it's really vibrant. It was the most amazing thing I had seen—as the car moves and the sun hits it, the tape illuminates in different colors—it was multicolored. That was impactful and then later saw Gypsy Rose on Chico and the Man. It was a very colorful era and I just dove in—the style of dress, the music, the cars, the lingo. Those girls (Maggie and Sylvia) also taught me how to write Chicano Cholo writing. They showed me the alphabet and how to do the lettering. At first, Abel Chavez's sister Esther taught me how to iron my pants and how to crease them, cuff them, and look good.

**Was your first car a lowrider?**

My dad was always into cars. He had a lowrider growing up and he loved cars. He obviously paid attention to what was going on in car culture. My brother and I always worked the swap meets since we were little kids. All throughout high school we worked the swap meets, we made money, and we knew how to hustle. We knew you had to spend money to make it. We learned how to talk to people and give good customer service. When it was time for me to build a car, I was 15, and there was this guy in the neighborhood who wanted to sell his 64 Thunderbird. I liked it, and my dad liked it. I knew if I could sell some stuff I could get $1500 and the guy wanted $2000, and my dad goes "I can kick in the rest and you can just pay me back." I never did pay him back. So we bought the car, and it had no hydraulics; it needed paint and chrome. We took the whole car apart, my brother and I did the hydraulics in the garage and we just learned as we went along. We did get help from these dudes from Reds Hydraulics, they became iconic, they helped us mount the cylinders, but everything else I could do myself, and we made a lot of mistakes but we learned as we went along. We painted it in the garage and it came out beautifully. By 1982, it was the first time I showed it at Chicano Park and that day I got recruited by Groupe Car Club.

**How did you learn the skills to build a lowrider?**

There were guys who were older than me and who lived in the neighborhood. They would buy new cars off the lot, we would call them "TV dinners" because they would buy, for example, a brand new Monte Carlo or a Lincoln; this was in the late 1970s and early 1980s. We call them TV dinners because they would take their cars to the hydraulics shop, and then put wheels on them, and they were done, easy peasy—a TV dinner. But they were good cars and the hydraulics would break down and I would be like, "bring your car over, I'll figure it out." I started climbing into the trunks and learning as we went. We learned by taking things apart. I started working on people's cars in high school. Again, the guys from Red's Hydraulics were friends of the family through one of my dad's compadres, and those dudes helped me a lot too. They taught me some stuff and showed me how to do some things. They were cool. Then my friend's older brother was a painter, and he showed us how to block the car, so I learned how to block and prep the car. And I worked in the car shop for a while with them. I had the Thunderbird when I was in the club [Groupe CC], and I stayed in the club until took it's toll financially, and all the obligations started affecting my relationship with my wife. I didn't have the time to be involved, so I started going to San Diego State.

When I joined Groupe car club, the guys I really respect like Danny Boy and Joe Abeyta, I was told that if you join this club, you don't join any other clubs later because it's like a slap in the face to the past club. I took that stuff seriously. I have respect for these guys. I never found a desire to join another club. And being in the position I am in now with curating shows and doing car shows and art exhibits, it's better for me to be Bobby Tribal than in a club and inherit the politics those clubs have among themselves. When I do these events, I get all the support from all these clubs.

**How is lowrider culture part of Chicano history in San Diego?**

Lowriding is a space that brings people together. Primarily in the 1970s, it was Chicanos and Blacks, and there were even some White dudes … You had Latin Lowriders, Brown Image, Amigos,

and these are Chicano clubs. The scene has changed; it's more diverse; everybody is into lowriding. It's not just a Chicano thing. … it's progressed and people can be from any walk of life, any part of the world, and you love lowriding. Its roots are Chicano but now we live in a time where there's acceptance across the board based on unity.

The first time I went to Chicano Park, there was another friend of mine Chris Cano (she later went on to start another club called Ladies Pride) and she took me to Chicano Park. She had a '65 Impala and I believe it was an aqua-turquoise color and 560s with hubcaps. It was a cool car and didn't have hydraulics. Chicano Park was a focal point—cars hanging out in the park, Fridays and Saturdays cruising.

**Did you always identify as Chicano?**

One of my *tias*, Tia Olivia, we called her Tia Beebee, when we were kids she was going to college and she would always be about Chicano Power, the Brown fist, and Viva La Raza. It was instilled in us primarily by her. My mother and father always taught us to be proud of who we are, our heritage, our family, and our lifestyle. We were Chicanos. I identified with it because it almost was like a badge I was proud to wear; it had some rebellion attached to it. We did experience some racism, some prejudice as kids, and some things that hit us in a certain way. And you know I am Mexican, I'm Chicano, I'm proud, and I'm going to go at it harder.

One thing I learned early on is that people expect if you are a Chicano or a lowrider or even if you are a surfer or a punk rocker that you are only supposed to listen to this kind of music. How can you be a lowrider and a skateboarder? You just can't, but I did and I didn't care. I was listening to Van Halen, Jim Hendrix, Led Zeppelin, ZZ Top, and later I started listening to ska, new wave, and punk rock when I was in high school, like The Specials, Madness, and English Beat. My head would not allow me to live in a box. The older I got, the more I realized, even with some of the shows I curate, there are a lot of people who are like me. A lot of people were Chicanos, and we dressed a certain way and we listened to Pink Floyd.

**What has been the impact of *Lowrider Magazine* on the culture?**

The first time I saw *Lowrider Magazine* I was still living in south San Diego. It was all we had, that was our handbook, our bible, that's how we saw what was going on, how the scene was changing, who was building what, or what the best cars were. There were no social media; it wasn't on television. We waited every month for that new *Lowrider Magazine* so that we could see what was happening. It was an important period of time; later on it became less relevant because of social media, YouTube, and other magazines. In the beginning, though it was extremely relevant and important for the culture, lowrider art, learning who's who, the builders, and what products are available—it was all the knowledge we needed to partake in this culture.

**Usually, LA gets all the attention when it comes to talking about southern California lowriders, but San Diego is an important locale/space. What is San Diego's contribution to lowrider history and culture?**

If you look at lowriding where it is now, we've been here all along. Maybe since San Diego geographically is not as large as Los Angeles, our numbers aren't the same, but we've been doing it just as long. San Diego clubs all get along, and everybody supports each other. There's a lot more camaraderie, support, less drama, and politics. The quality of the cars is up to par. You are getting builds in San Diego that compare to anything built in LA; you look at 58 Caliber, SD Tones 63, Maton 58, Final Judgment 64. There are cars coming out of San Diego that are right there with LA. But the shows here, a lot of guys from LA come down to shows because we have shows by the Bay and Chicano Park Day. In my opinion, that's the show in southern California; it's a tough one to actually show your car and that's Chicano Park Day. People from all over the world come to Chicano Park Day. What's bigger than Chicano Park Day? There's the cultural element, being on the streets in that park, among those Chicano murals, underneath the freeway and being in the middle of the barrio—that's what makes Chicano Park what it is. It's become a huge event, at least 20,000 people at the last Chicano Park Day.

**Japan has a long history of being part of the lowrider history and you were out there early on, how would you describe lowrider culture in Japan and their love of Chicano culture?**

I first started going out there in 1994 and early 1990s. The Japanese have always had a fascination with southern California lifestyle and culture, skateboarding, surfing, punk rock, hip-hop, lowriding, and tattoos. So back then we started seeing little glimpses of lowrider culture and saw a lowrider here and there in Japan. As time progressed, you started seeing more cars out there. They were known for buying a lot of the known cars from LA and San Diego. So the quality of the cars started going up. They started re-doing some of the cars and buying cars that weren't finished. And the Japanese are very meticulous, very hard working, and extremely disciplined, and their clubs started forming. There are some clubs that have been around for a long time. And the quality of cars I have seen in Japan, primarily at Classic Legends, which in my opinion is the best car show that I've ever been to, not just because of the quantity but quality, they are up to par with us. And they are right there with what's happening in southern California. They are going beyond us sometimes, engineering some things with suspension and getting cars to lay rockers, and they're doing some things with paint jobs that we have not seen out here yet. There are some three-dimensional patterns that no one knows for sure how it's being done. The Japanese also know the culture, they know the history, and they study it. The one thing I always say about Japan there are some hardcore traditionalists there that only roll on 13s, gotta have Daytons, hydraulics and all the rules the hardcore traditional guys follow here. There are rules to it, or the so-called rules; personally, I'm not one for rules, and I do whatever I want. The Japanese, a lot of them, do whatever they want to, they break the rules, and the rules go out the window. And that is what helps the culture evolve and change and move forward. They are innovating and adding to the culture. We are being inspired by them too, as well as they are being inspired by us. Out of all the countries in the world, the Japanese are doing the best job carrying the culture.

**You also brought the Tribal cultural experience out to Japan, what was that like?**

When we went there to do a promotional tour in the early 1990s, we took tattoo artists, graffiti artists, break-dancers, lowriders, Estevan and Cartoon, the guys from Psycho Realm … we were pioneering and sharing our culture with them. We would have a hip-hop DJ, and homies and Tony Touch from New York and we would even take pro-skateboarders. We would bring these cultural experiences to Japan and we would be out there for a couple of weeks just hitting cities and leaving these kids blown away. They had never seen anything like this stuff. In the early 1990s, that's one of the things I take a lot of pride in. We were pioneering and sharing this culture which was not on television, and there were no social media then. You can see this on the Tribal VHS tapes we were producing early on. There was really no way to experience it, but to be in it and these tours in Japan became the hot ticket for a while. Even to this day, we still go back and represent who we are.

**How do you view lowrider culture today and how has it evolved?**

You go to some of these car shows today, it's become a scene of too many spectators, and too much of a costume party because people will show up and dress up to a show, go to a lowrider event, or a cruise. And they think it's cool to dress up like a cholo or chola. People don't understand that some people dress a certain way because of an economic situation. A way for us to identify who we are, it's almost disrespectful for them to try to mimic us.

Lowriding has become a hobby or a lifestyle that a lot of us have had since we were teenagers. Some of us are in our 50s, in our 60s, and guys are in their 70s too. Somebody that is in their 30s to us is considered like a youngster. But back when we were 15 or 16 we were lowriding, but today kids cannot afford to build a car, to really have an Impala, a bomb, or whatever. So, it's become something for older dudes pretty much. Kids that show up, they're spectators, they like it, and they think it's cool. It's cool that they like it and that they're curious about it. But at the same

time, there is saturation because some people like the costume party aspect, but they don't know the history. If you know the history and you know the lifestyle and respect it; cool, I'm down with that. Then there are people that are almost mocking the culture and it's a spectacle to them. But on the other hand, what if nobody was into it? Lowriding today is bigger than it's ever been.

**How has social media impacted the culture of lowriding?**

Social media has a big part in disrupting lifestyle and culture. I had this conversation with Estevan [Oriol] recently. You can't get too mad about it because we are partially the cause of why people have become infatuated or curious, or falling in love with the culture. We have been feeding it to them for so long with our projects, our shows, our brands, our photography with imagery, and art. Pretty much we have been promoting this culture and lifestyle for the most part of 30 years. So, we are partially responsible for keeping the culture alive.

**Today it seems like Chicano/Latino culture is hot with the popular culture industries and Hollywood is taking an interest again. What would you like to see for the future of lowrider culture?**

I would like to see it be honest and real. And to realize that a lot of these guys are professionals, we own our businesses. We work hard. We are family men, fathers, and grandfathers—respectable people. We are also multicultural. There's a lot of diversity to it, not just the quality of the cars, but the types of people that are doing it. It definitely has become more of an older guys' thing because of the monetary costs, with younger spectators.

**What does it mean to you personally to be part of the lowrider culture? How has it impacted your life?**

It's made my network of friends bigger, being part of this community, especially when you're building a car, sharing things and you meet a lot of people and make new friends. You become part of a community. When I get around my friends, we talk about cars; it's like any other hobby. You become passionate about it. It's a lifestyle, and you hope to pass it to the next generation, either family or kids, and hope it survives. And if it survives, you hope

it survives intact. You don't want it to be distorted. There are traditions that we are hoping can remain authentic. Authenticity is very important for people to know the history of the culture.

**What is your favorite memory of being in a lowrider, one that captures what it means to be part of the culture and the community?**

There's a feeling, and I have said this before, there's that golden hour in Chicano Park on Chicano Park Day when the spectators aren't there yet. It's like 6:30 or 7:00 a.m. The dudes are setting up their cars, the sun is coming up, you hear music in the background, and the vendors are starting to cook carne or make salsas so you have aromas. Then you have the rides, and people are walking around drinking coffee and greeting each other, people you maybe have not seen in years, but there is camaraderie/friendship. There is happiness, excitement, that's it ... Chicano Park. It's an energy that you will never experience anywhere else.

Special thanks: As I was trying to understand the complexity of *La Locura Cura* and how it was practiced in the art-making and activist practices of José Montoya, I am indebted to conversations with key people who knew Jose and his work. I would like to thank his sons Richard Montoya and Tomas Yin Montoya for taking time to have deep and thought-provoking conversations with me about their father and *La Locura Cura*. I also appreciate my friend and mentor the poet Luis J. Rodriguez for taking the time to talk about the phrase and its impact. And finally special thanks to Rudy Cuellar, a member of the RCAF, who was the first call I made and who was very helpful and connected some of the dots for me. In the end, this essay is an attempt to not only honor José Montoya's contribution to Chicana/o/x studies and the world of art and activist art-making, but draw a direct connection to the next generation of Chicano cultural workers.

# REFERENCES

Acuña, R. F. (2000). *Occupied America: A history of Chicanos* (4th ed.). Longman.

Alvarez, L. (2008). *The power of the zoot: Youth culture and resistance during World War II*. University of California Press.

Blackwell, M. (2016). *¡Chicana Power! Contested histories of feminism in the Chicano movement*. University of Texas Press.

Bright, B. J. (1995). Remappings: Los Angeles low riders. In B. J. Bright & L. Bakewell (Eds.), *Looking high and low: Art and cultural identity* (pp. 89–123). University of Arizona Press.

Calvo, W. (2011). *Lowriders: Cruising the color line* [Ph.D. dissertation, Arizona State University]. Research Gate. https://www.researchgate.net/publication/34252779_Lowriders_Cruising_the_Color_Line

Chappell, B. (2012). *Lowrider space: Aesthetics and politics of Mexican American custom cars*. University of Texas Press.

Chávez, E. (2002). *"Mi Raza Primero!" (My People First!): Nationalism, identity, and insurgency in the Chicano Movement in Los Angeles, 1966–1978*. University of California Press.

Diaz, E. M. (2017). *Flying under the radar with the royal Chicano air force: Mapping a Chicano/a art history*. University of Texas Press.

Donnelly, N. (Ed.). (2002). *Customized: Art inspired by hot rods, low riders, and American car culture*. Abrams.

Galan, H. (prod.). (1996). *Chicano!: The history of the Mexican American civil rights movement* [TV series/Video], Episodes 1–4. National Latino Communications Center. http://www.guadalupecardona.com/chicano-documentary-series-by-pbs.html

Garcia, I. (1997). *Chicanismo: The forging of a militant ethos among Mexican Americans*. University of Arizona Press.

Garcia, M. T. (2015). *The Chicano generation: Testimonios of the movement*. University of California Press.

Gradante, W. (1982, April). Low and slow, mean and clean. *Natural history, 91*(4), 28–39.

*La Bloga*. (2014, January 6). Remembering José Montoya. https://labloga.blogspot.com/2014/01/remembering-jose-montoya.html

La Rosa, S. (Director). (1994). *Pilots of Aztlán: Flights of the Chicano Airforce*. 53 mins. KVIE, Inc.

Latorre, G. (2008). *Walls of empowerment: Chicana/o indigenist murals of California*. University of Texas Press.

Lipsitz, G. (1990). *Time passages: Collective memory and American popular culture*. University of Minnesota Press.

Los Alacranes Mojados. (1979). "Chicano Park." *Rolas De Aztlan*. Vinyl. Alacran Productions.

Marin, M. V. (1991). *Social protest in an urban barrio: A study of the Chicano movement, 1966–1974*. University Press of America.

Mazon, M. (1984). *The zoot suit riots: The psychology of symbolic annihilation*. University of Texas Press.

Mendoza, R. (2000). Cruising art and culture in Aztlán: Lowriding in the Mexican American Southwest. In F. A. Lomelí & K. Ikas (Eds.), *US Latino literatures and cultures: Transnational perspectives* (pp. 3–35). Anglistische Forschungen 290. Duncker & Humblot GmbH.

Montoya, R., & Preciado, S. (Eds.). (2016). *José Montoya's abundant harvest: Works on paper works on life*. Fowler Museum of UCLA and Regents of University of California.

Mulford, M. (Director). (1988). *Chicano Park* [Film]. 58 mins. Redbird Films.

Munoz, C. Jr. (1989/1991). *Youth, identity, power in the Chicano movement*. Verso.

Obregon Pagan, E. (2003). *Murder at the Sleepy Lagoon: Zoot suits, race, and riot in wartime*. The University of North Carolina Press.

Ortiz Torres, R. (1998). Cathedrals on wheels. *Art Issues, 54* (September/October), 26–31.

Penland, P. R. (2003). *Lowrider: History, pride, culture*. Motorbooks.

Plascencia, L. F. B. (1983). Low riding in the Southwest: Cultural symbols in the Mexican community. In M. T. García & B. N. Corona (Eds.), *History, culture, and society: Chicano studies in the 1980s* (pp. 141–175). Bilingual Press.

Pulido, A. L., & Reyes R. "Rigo." (2017). *San Diego lowriders: A history of cars and cruising (American Heritage)*. UNK edition. The History Press.

Ramírez, C. S.. (2009). *The woman in the zoot suit: Gender, nationalism, and the cultural politics of memory*. Duke University Press.

Rosalez, F. A. (1997). *Chicano! The history of the Mexican American Civil Rights Movement*. Arte Publico Press.

Sanchez-Tranquilino, M. (1993). Chicano murals and the discourses of art and Americanization. In E. S. Cockcroft & H. Barnet-Sánchez (Eds.), *Signs from the heart: California Chicano murals* (pp. 84–101). Social and Public Art Resource Center.

Sandoval, D. M. (2003). Cruising through low rider culture: Chicana/o identity in the marketing of *Low Rider* magazine. In A. Gaspar de Alba (Ed.), *Velvet Barrios: Popular culture and Chicana/o sexualities* (pp. 179–196). New Directions in Latino American Cultures. Palgrave Macmillan.

Sandoval, D. M. (2013). The politics of low and slow/*Bajito y Suavecito*. In J. Kun & L. Pulido (Eds.), *Black and Brown in Los Angeles: Beyond conflict and coalition* (pp. 176–200). University of California Press.

Sperling Cockcroft, E. & Barnet-Sánchez, H. (1993). *Signs from the heart: California Chicano murals*. Social and Public Art Resource Center.

Stone, M. C. (1990). '"*Bajito y Suavecito*": Low riding and the "Class" of Class. *Studies in Latin American Popular Culture, 9*, 85–126.

Tatum, C. M. (2011). *Lowriders in Chicano culture: From low to slow to show*. ABC-CLIO.

Trillin, C. & Koren, E. (1978, July). Low and slow, mean and clean. *New Yorker, 10*, 70–74.

Vigil, J. D. (1991). Car Charros: Cruising and lowriding in the barrios of East Los Angeles. *Latino Studies Journal*, 2(2) , 71–79.

Villa, R. H. (2000). *Barrio Logos: Space and place in Urban Chicano literature and culture*. University of Texas Press.

Wolfe, T. (1965). *The kandy-kolored tangerine-flake streamline baby*. Farrar, Straus and Giroux.

Ybarra-Frausto, T. ([1990] 1993). Arte Chicano: Images of a community. In E. S. Cockcroft & H. Barnet-Sánchez (Eds.), *Signs from the heart: California Chicano murals* (pp. 54–67). Social and Public Art Resource Center.

# ENDNOTES

1. The Smithsonian Lowrider Project is a new research endeavor, collecting and exhibition project that looks at the history and legacy of lowriding which has played a key role in the creation of Mexican American communities since the 1940s. The Smithsonian's National Museum of American History (NMAH) and the Smithsonian Institution Traveling Exhibition Service (SITES) have joined in this multiyear research project with the national lowrider community to assemble a collection of images and to conduct oral histories leading to a traveling exhibition and other educational products at the Smithsonian Institution. The Lowrider Project has received federal support from the Latino Initiatives Pool, administered by the Smithsonian Latino Center. I would like to thank the Smithsonian Lowrider Project, especially Steve Velasquez at NMAH for their permission to use portions of the interview with Bobby Ruiz for this essay.

2. Winslow Felix first opened his Chevrolet dealership in 1922 and is considered the first Mexican American car dealership owner in southern California according to numerous sources, including Felix Chevrolet Dealership owner Darryl Holter. Winslow Felix was a friend of film maker Pat Sullivan, whose animation studio created the Felix the Cat character, and Winslow was given special permission to use this image for his dealership. In an early time of consumer discrimination against many minorities in Los Angeles, this dealership provided opportunities for many first-time car owners. Winslow also created a "trial purchase plan," founded the Greater Los Angeles Motorcar Dealers, organized the annual southern California auto shows, and staged midget-car races. The Felix the Cat image represents Los Angeles' love affair with Chevy cars. Even today, a sign of cultural authenticity is having a Felix the Cat sticker displayed in the window of a restored vintage GM vehicle. The beautiful neon sign was erected in 1957 at the Felix Chevrolet in Los Angeles on the corner of Jefferson and Figueroa.

3. For a more complete examination of the Chicano movement, I suggest watching *Chicano!: The history of the Mexican American civil rights movement*, Episodes 1–4 (Galan, 1996).

### Section 6 Figure Credits

Page 168–69: Mister Cartoon photographed by Bobby Ruiz
Page 170–71: Bobby Ruiz
Page 172: Dave Lively
Page 174: Impact Images
Page 175: Tribal C10
Page 177: Graffiti by Persue, car owned by Ryan Gamboa and photographed by Bobby Ruiz
Page 178: Craig Stecyk
Page 179: Bobby Ruiz
Page 194–95: Ben Grillo and Tribal C10
Page 196–203: Lowriders at the Legacy Show photographed by Craig Stecyk

# JOHN ULLOA

John Ulloa teaches in the Department of Latina/Latino Studies at San Francisco State University. A lowrider and academic, John uses lowriding as pedagogical practice as an entry point to discuss issues affecting communities of color and create calls to action. He speaks regularly on lowriding, and he has conducted workshops in São Paulo, Brazil. His research examines the global diffusion of lowriding culture from the Mexican-American barrios to various countries outside of the United States including Japan, Brazil, Australia, New Zealand, Guam, Saudi Arabia, France, Germany, Russia, Sweden, Denmark, and Thailand. He is a member of Low Creations Car Club, and he has owned six lowriders, his current build is a 1973 Buick Riviera.

# BOUNCING ACROSS BORDERS: THE GLOBALIZATION OF LOWRIDING

## JOHN ULLOA

This chapter is intended to be an overview of the burning question to explain the mushrooming of lowriding culture outside of the United States, "How did that happen?" The work is formulated by a multidisciplinary approach, but rooted in anthropological participant observation. It is qualitative in nature and written from the emic perspective, the "insider's" perspective. This research is informed by the fact that I am an active participant in the global lowrider community, and my life has been filled with lowriding as an active lowrider. I am currently building my seventh lowrider, a 1973 Buick Riviera. As a lowrider and academic, my ethnographic fieldwork has been conducted outside of the United States in Mexico, Japan, Cuba, Colombia, and Brazil. Within the United States, fieldwork has been conducted throughout California, Las Vegas, and Miami. Cyber ethnography has been essential in this work, using the Internet and social media platforms to interact with the greater global lowrider community including conducting interviews online in a synchronous modality via video conferencing with lowriders in Saudi Arabia, Australia, New Zealand, Brazil, Russia, and Chile.

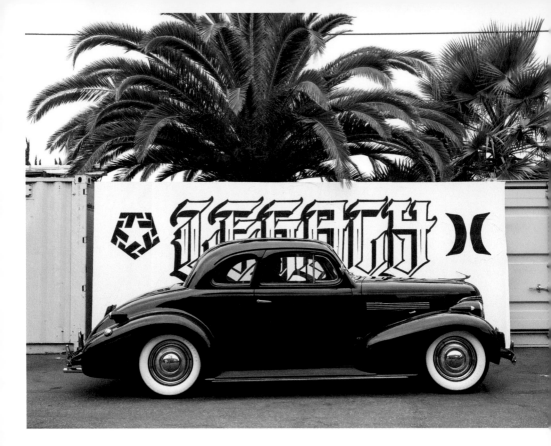

## THE BACKSTORY

This project "officially" came about in 2004 while in my graduate program in cultural anthropology at San Francisco State University. I was taking a seminar on the theme of globalization from Dr Bernard Wong, and I was tasked with selecting a topic that could be interpreted through the lens of globalization. When I approached my professor with the idea of looking at lowriding as a topic, he was somewhat taken aback. He could not get his head around why I would want to do lowriding as a global study. I explained to him that lowriding made its way to Japan, and he was hooked.

In the early 1990s, I opened the pages of *Lowrider Magazine* (*LRM*), and I was struck by the fact that there were car shows happening in Osaka, Japan, and that they were sanctioned by *LRM*. Japanese youth were depicted in the pages of *LRM* dressed Cholo-style as though they could be "cholos" in any barrio of the southwestern United States. Their garb included white T-shirts, khaki pants, Converse All-Star sneakers, and Pendleton shirts. Outfits were accessorized with baseball caps with "Compton" in Old English lettering and Locs sunglasses (Lopez, 1993). This completely blew my mind, because in my experience, I had only seen people from the barrio dress like this. Something was clearly going on; it was just a matter of finding out "what" that was.

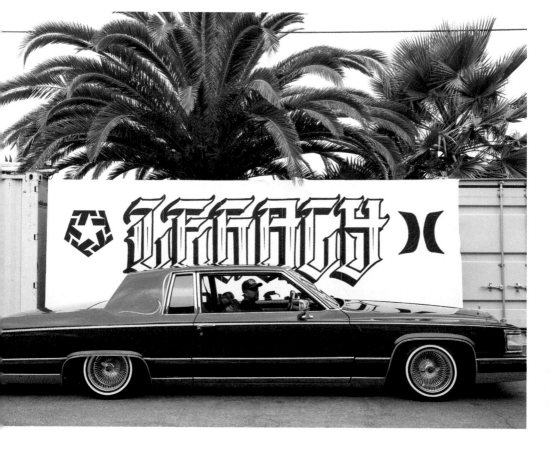

*LRM* gave adequate coverage to the Japanese lowrider scene in the 1990s, and for good reason. Things were taking off in Japan. *LRM* was promoting shows there, and they started a Japanese version of the magazine. All of this seemed "good for the sport" of lowriding. That period of lowriding was different from the scene today. Japanese lowriding enthusiasts would travel to the United States to purchase show-winning lowriders. Cars that were shown wound up on the streets of Japan as drivers. In today's global lowriding scene, Japanese builders have three decades of hindsight, eBay, Craigslist, social media, and the Internet at large that have contributed to the acquired knowledge of building their own show-quality, high caliber of lowriders (Oshawa, 2017).

## SIGNIFICANCE OF LOWRIDING

Lowriding since its inception (and exactly when that continues to be debated) has been an expression of Mexican American culture, history, and pride. Rooted in the Pachuco era of the 1940s, modern lowriding has mushroomed from the barrio experience to a worldwide phenomenon. Though the origins of "ground zero" for lowriding are hotly debated, it is safe to say that it began in the barrios within the southwestern United States. San Jose, CA, and Los Angeles have historically been the two "big scenes" for lowriding, with Story and King and

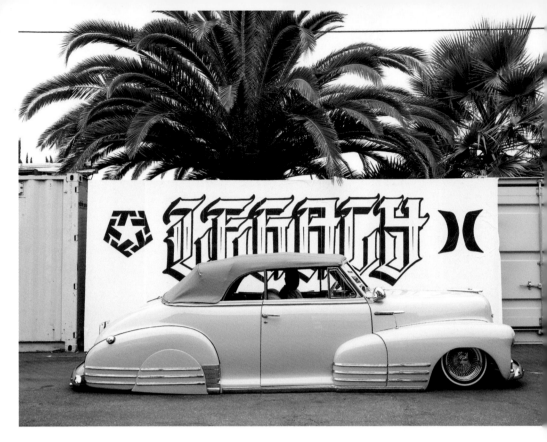

Whittier Boulevard, respectively, have been the cruise spots for these two cities. In California, San Diego has had a thriving scene, and arguably the first international lowriding scene with its proximity to the border, and the cultural and commercial flows in the early 1970s as lowriding was percolating on both sides of the border (Pulido and Reyes, 2017, p. 18).

## CHICANO MOVEMENT

The Chicano movement of the late 1960s and early 1970s was a subset of the Civil Rights Movement in the United States. While messages of Black empowerment were coming from the African American communities in the United States, the Mexican American communities were articulating their own expressions of heritage and cultural pride (Tatum, 2011, p. 54). Lowriding was an integral part of the Chicano Movement, especially as gatherings, student conferences, and celebrations punctuated the landscape as communities celebrated their past as well as present conditions. However, nothing is more American than Cinco de Mayo.

## CINCO DE MAYO

Cinco de Mayo recognizes and celebrates the Mexican victory over the French army at the Battle of Puebla on May 5, 1862. The historical and symbolic significance of the victory is that the Mexican forces were outnumbered, outgunned, and out-resourced in comparison to their European adversary, thus making the Mexican forces an unlikely victor. The fact that Mexico pulled off the win, makes this battle very symbolic historically.

In the 1970s within the context of expressions of cultural pride, Cinco de Mayo celebrations began to materialize throughout the southwestern United States. These community celebrations included parades, park celebrations with food, and folkloric as well as popular Mexican music.

Lowriders were integral in the early Cinco de Mayo parades as they were a visual expression of Chicano Pride. Mexican folkloric dancers (Baile Folklorico), mariachis, charros, and lowriders were included in these parades as visual representations of pride. Over time, Cinco de Mayo has become heavily co-opted by alcohol corporations, and as a result has become "watered down." The end result is cultural appropriation and misrepresentation of culture. This differs greatly from the era of the 1970s where Chicanismo and cultural pride were the main motivations for the celebration, not profit.

## LOWRIDING AND CULTURAL DIFFUSION—MAPPING TRAJECTORIES

"Lowriding in Japan!?! That's crazy! How did that happen?" This is a common reaction when I tell people about my research and work. My response is quick and quite simple. I often respond, "It's no crazier than a Caucasian kid taking karate lessons in any suburban strip mall across America." However, I would argue that those who lowride in Japan know more about the culture that they have assimilated into rather than little Timmy and Sally practicing front kicks in the dojo next to Starbucks Coffee.

Simply put, cultural diffusion maps the ways in which aspects of culture move and flow throughout spaces. In the times in which human beings were hunters and gatherers in nomadic bands, following resources was the motivation for traveling on foot. As these small groups of people came into contact with one another, conflict ensued as a result of the competition over resources, usually sources of protein. However, as these groups clashed, they were each exposed to the other's resources, and ideas, be it weapons, tools, fighting techniques, etc. Those interactions reshuffle an individual's cultural deck (Appadurai, 1996, p. 33).

As humans transitioned to a sedentary lifestyle, and they established civilization, they amassed surplus goods and domesticated animals. Surplus leads to wealth accumulation and class distinction as the control and distribution of resources were administered by an individual, and thus access to resources became controlled.

With the accumulation of wealth comes luxury, and often the want or need for more wealth. Empires were formed and needed to be sustained. In the late fifteenth century, history experienced a significant race to divide and conquer the world through exploration, imperialism, colonization, and conquest. The cultural exchanges that resulted changed the course of history.

Today, the world is well carved up and accounted for. People do not need to move in order to engage in the processes of cultural exchange. One merely needs to log in or download a social media app in order to connect with people virtually anywhere on Earth. As previously mentioned, in human history people had to physically move in order to come into contact. Sometimes that duration was long due to typography, climate, geography, etc. Nowadays it is instantaneous. We are more connected than ever, and the digital age allows us to tune in, follow, like, and participate in globally connected communities more rapidly than ever.

## GLOBALIZATION

Appadurai's discussion of mediascapes encapsulates much of how one might account for lowriding's global spread and influence (Appadurai, 1996, p. 35). The diffusion of lowrider culture can be traced back to the 1970s sitcom television show, *Chico and the Man*. The famed 1964 Chevrolet Impala, Gypsy Rose, "The World's Most Famous Lowrider," built by the Late Jesse Valadez can be seen moving across the screen in the opening credits of the show as part of the depiction of everyday barrio life in the East Los Angeles City of Boyle Heights (Valadez, 2018). Although the show is long out of syndication, the opening credits sequence is forever immortalized on various YouTube channels, available for a global audience to view. The significance of Gypsy Rose's presence in those opening credits was huge during that time as it was the first time that lowriders were featured on primetime television on a weekly basis, especially in a positive and non-criminalized depiction.

When people learn of my research, they are puzzled by the fact that lowriding can be found outside of the United States, thus suggesting that lowriding ought to be confined to the United States, or more specifically kept within the confines of the Mexican American community. It's important to note that while

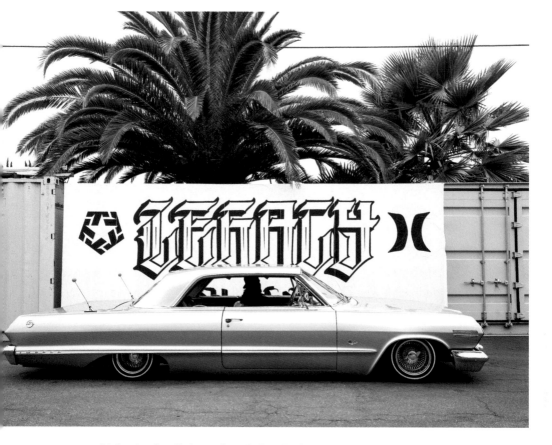

Majestics Car Club was founded as the first African American lowrider car club, they now have a global presence with club chapters all over the world. However, lowriding has historically been associated with Mexican Americans and thus racialized, contributing to the questioning as to how lowriding could or would spread throughout the globe.

## MUSIC

The early musical "anthems" of the lowriding scene were hits by the Latin Soul band hailing from Compton, CA, WAR. Their most notable hit was "Low Rider" on the album *Why Can't We Be Friends?* The song would be sampled heavily throughout the 1990s, and it would eventually become the theme song to the *George Lopez Show*. Now considered to be a faux pas to be played while cruising, the song is a timeless classic, and it is a testament to brilliant songwriting in its catchiness and simplicity.

While "Low Rider" was an early hit and anthem of the community, it was really Gangster Rap coming out of south-central Los Angeles in the 1990s that helped to facilitate the global spread of lowriding. Groups like N.W.A., and the solo work of Eazy E., Ice Cube, and Dr Dre featured lowriders in the music videos. These forms of media making their way around the globe, either through the

airwaves, fiber optic cable, and/or live performance tours allowed for the world to be exposed to glimpses of lowriding culture in various ways.

# MAGAZINES

As far as publications are concerned, *LRM* has always set the standard, and to this day it is the authority on lowriding culture. Established in 1977 in San Jose, CA by Sonny Madrid, *LRM* began as a publication that promoted lowriding as well as history, social commentary, and cultural pride. Throughout the decades, the magazine has gone through many shifts, ebbs, and flows, and at times it was arguably softcore pornography. Today, the magazine is owned by The Motor Trend Group, and lowriding legend and long-time Lifestyle Car Club President Joe Ray is at the helm as editor-in-chief. Under Ray's tenure, *LRM* has returned to a classy publication, removing models altogether. In addition to print media, *LRM* has a significant online presence with a website, Instagram, and Facebook page. The saving grace of the magazine is its Low Rider "Role Models" video series on YouTube. These are short ten-minute videos that showcase community leaders emphasizing positive images and community role models who lowride.

Swimming with the global COVID-19 pandemic, Joe Ray and *LRM* began and continue to do "Garage Visits" on social media outlets. These are approximately one hour in length, and they are interviews with various legendary figures and car clubs in lowriding from throughout California and the southwestern region of the United States.

Nowadays, you will find many publications throughout the world. Historically, *Q-Vo* and *Orlie's Lowriding*, *Street Low Magazine*, and *BOMBS* were "alternatives" to *LRM*, but they did not come close to the presence and influence that *LRM* had, and that the brand recognition of the publication maintains to this day. However, with the big media acquisition of *LRM* and the need for lowriding culture to be covered on the streets from within, there have been magazines established such as *La Cultura Magazine* and *Chingon*. In Japan, *La Cultura's* affiliate and "sibling" publication *ONE LOW Magazine* has made a significant impact with its first two issues. With the fast rise and immediate content available on social media and decreased demand for subscriptions, coupled with high printing costs, these more recent publications are a return to the origins of the "spirit" of *LRM*, grassroots, by lowriders, and sold at events, mail order, and with no newsstand presence or distribution.

# MOVIES

The intent here is not to mention every film that contains lowriders, but to high-light the most influential. There are numerous films that feature lowriders and lowriding; the first and most influential is *Boulevard Nights* (1979). The produc-tion is the first feature-length film to feature lowriding. The film is set in East Los Angeles, and it chronicles the lives of two brothers, one lowrides, and the other is a gang member. Throughout the course of the film, it highlights the golden era of Whittier Boulevard in Los Angeles and the lowriding/cruising scene there. The film seems to equally depict the realities of gang culture at that time of the late 1970s/early 1980s as it does show lowriding. One thing can be said about the film is that it inspired people throughout the southwestern United States to low ride after its release, and the film's star Danny De La Paz was featured on the cover of *LRM* upon the release of the production (Madrid, 1979).

Cheech and Chong's early films, *Up in Smoke* (1979), *Next Movie* (1980), and *Nice Dreams (1981)*have lowriders, and that 1970s aesthetic and influence were key in shaping how lowriders in Nagoya, Japan built their cars. With Cragar Wheels and True Spoke wheels, furry dashes, crushed velvet interiors, glass pinstriping, and glass etching, the Nagoya "Chicano Style" of lowriding was born from the influence of those early Cheech and Chong productions.

Other films that have featured lowriding are *Walk Proud* (1979), the story of cho-los and lowriders in Venice in West Los Angeles, CA. The film stars Robby Ben-son, who plays Emilio, a member of the gang, "Aztecas." The film is a depiction of life in Venice during the late 1970s. The opening credits sequence is filled with cars on Cragar Wheels and True Spokes, correct to the period of the film.

The decade of the 1990s was rich in bringing south-central Los Angeles to the big screen. There were numerous films that depicted life in south-central, and film maker John Singleton's *Boyz n da Hood* (1991) was arguably the biggest. The feature film cast includes Ice Cube, Cuba Gooding, Jr, and Lawrence Fishburne. Ice Cube's character, Doughboy drives a gold, droptop 1963 Impala, and the car is used at the end of the film to conduct a drive-by shooting. Baby Boy, and the Ice Cube's *Friday* franchise (1995–) all feature lowriders, too. These films depict lowriding in a negative light, as do most films.

Denzel Washington delivered an Oscar-winning performance in *Training Day* (2002) also starring Ethan Hawke, Eva Mendes, and Tom Berringer—antagonist Alonzo drives a juiced Monte Carlo, and while a Los Angeles cop, the car is used for criminal activity. Opposite of the aforementioned, films that show lowriding

in a positive light are *MacFarland, USA* (2015), *Selena* (1997), and *Napoleon Dynamite* (2004). In these films, lowriders are depicted as having nice cars and helping others or making solid community contributions in their local environments.

Granted, not all lowriders have backgrounds that are without criminal activity, yet not all lowriders are gangsters. The use of lowriding and depictions of the culture in the mass media have been criminalized. It is important to note that the more recent films in cinematic history grapple with this conundrum *La Mission* (2009), set in the Mission District of San Francisco, CA, has lowriding in it, but is more a story of issues that the protagonist of the film is wrestling with: addiction, gentrification, and his son's sexuality. *Lowriders* (2017) which is set in contemporary Los Angeles has family at the center of the screenplay, but intergenerational conflict and criminal behavior overshadow what could have been an opportunity to depict lowriding in a totally positive light.

# SOCIAL MEDIA

The role of social media in all of its platforms has accelerated the diffusion of information, allowing people to share and see content in real time, or immediately thereafter. With video calling and conferencing, "live" functionality of YouTube, Facebook, and Instagram, or Facetime on an iPhone, the world is connected in an instantaneous, synchronous modality. Social media pages and online communities allow people to post for the world to see. This is leaps and bounds and worlds away from the early years of *LRM* when the process of covering and sharing information was laborious, and through "snail mail"—using the US postal service to send letters to the editor, dedication, etc. Sonny Madrid and his team traveled to cover events, and the content creators today also work hard to travel to events, sometimes several in a day, covering northern and southern California on the same day. In today's scene, anyone with a smartphone can click, upload, and hashtag, technically "covering" the same events. The results are a global diffusion of cars and fashion, repeated throughout the world with varying degrees of authenticity.

# THE MECHANICS OF GLOBAL LOWRIDING

There are many "parts" of lowriding. There are the cars themselves, the people, the aesthetics, i.e., fashion/clothing, and music. In short, all aspects of the culture function as interchangeable parts. How these parts function together is another story. Remove and or change one part, the overall system functions differently, and for some, not at all. The purpose of this chapter is to explore the parts of the global lowriding schema.

## ORIGINS OF GLOBAL LOWRIDING SYSTEMS

Global lowriding systems are fluid. With the flows of people, goods, and services, there has been a noticeable pattern that has shaped the various lowriding scenes throughout the world. Originally, the television show, "Chico and the Man" went into syndication, and the famed Gypsy Rose exposed a global viewing audience to its graces as it moved across the screen in the opening credits of the show. Another process of getting information to people was to bring *LRM* from the United States back to its countries of origin. This is true in the case of Saudi Arabia and Brazil. Tata (2018), the first Brazilian lowrider (and club founder/President of Vida Real Car Club), told me that he was in Walgreens in Miami, and he saw *LRM* on the shelf, purchased them, and returned to Brazil to show his colleagues. Thus, the beginning of Brazilian lowriding. Ultimately, Tata, and his associates, Antônio Carlos Batista Filho, known as "Alemão" and Sérgio (Japonês), now based in Miami, FL, would become the stars of Discovery Channel's reality show, *Lowrider Brasil*. The largest and most significant development for global lowriding, globalization, and cultural diffusion proper was the onset of the Internet.

The World Wide Web allowed people to instantaneously search for information in text, photograph, audio, or video mediums. The Internet happened. Thus, rapidly accelerating the obtaining of information. A person in any corner of the world with access to the Internet could see, watch, hear, music videos, or view photographs. In the case of nearly all countries in this ethnography, the big shift comes just at or after 1998, or immediately following the Internet boom. Therefore, technological access to information exponentially increased a spike in lowriding activity around the world post Internet. This phenomenon is akin to the post-"Boulevard Nights" boom of lowriding throughout the southwestern United States.

Prior to the release of the movie *Boulevard Nights*, Whittier Boulevard in Los Angeles was the largest cruising epicenter in the world. Other cities throughout the southwestern region in the United States had their own happening cruise spots. However, once Whittier Boulevard was shut down by law enforcement, the epicenter shifted to Story and King in San Jose, CA. Post-*Boulevard Nights*, the number of cars, and people wanting to be a part of lowriding street culture mushroomed. This is to conclude that the media is a very powerful and influential tool in getting people to buy into a culture or lifestyle. *Boulevard Nights* provided exposure of lowriding to a larger viewing audience, thus representing the first "wave" or "spike" in popularity. The Internet boom represents the second wave, and I argue that Instagram and social media represent the third wave.

For those just getting hip to lowriding, it may seem like a big deal. For those who have lived the life for decades, it's nothing new. Those on the inside recognize and acknowledge that Japan has had a history of lowriding going back just over 30 years. *LRM* covered some international scenes, including a Japanese version of *LRM*. *LRM* has featured Mexico and Canada; however, it is the onset of Instagram that has given rise and exposure to lowriding scenes throughout the world. Therefore, as a result of Instagram, one no longer has to wait a month to find out what is happening in the lowriding world through magazine print media, nor does one have to wait for a blogger on the web. One merely may look at their phone to connect to lowriders throughout the world. The result is the immediate connection, inspiration, and/or exchange of ideas.

# THE "RULES AND LAWS" OF LOWRIDING

All cultures operate within certain parameters, be they laws, spiritual, and/or moral codes. Lowriding is no different. There are varying points of view regarding the criteria of lowriding, i.e., what makes a lowrider such. For some, there are "must haves," such as a modified suspension on hydraulics. Others say that thirteen-inch wire wheels are a necessary criterion to be considered a lowrider. One of my favorite lowriders and crowd favorite is the famed "Ugly Car" built by Tyler Pullen of TP Customs in San Bruno, CA. The Ugly Car is a 1954 210 two-door sedan. It sits on thirteen-inch wire wheels, and a modified suspension on air ride as opposed to hydraulics. No one can dispute the fact that the car is a lowrider, and it is a crowd favorite, and internationally recognized as such.

Lowriding dating back to the 1940s was a way to express one's individuality and cut against the grain of the dominant paradigm. Lowering a car in the back was the antithesis of the "California Rake," where Anglo car enthusiasts lowered the front end of the car. Mexican American youth put weight in the rear, thus lowering the back, giving their cars a different look, posture, and attitude. Later, cars were lowered by cutting the coils on the cars by heating the springs with torches. Ultimately, hydraulics were introduced as a way to raise and lower a car at will, avoiding tickets from law enforcement and preventing the undercarriage of the car from being damaged by scraping over speed bumps or negotiating driveways. Then, air ride suspension developed, and airbags became an available alternative to hydraulic suspension modification systems. Regardless of the methods of how one rides, it is in the heart and mind of the owner, passenger, and observer as to how one is lowriding. In the words of Lowrider Hall of Famer and *LRM* editor, Joe Ray, "Whatever gets you there" (Reimers, 2014).

# LOWRIDING "ORTHODOXY"

Purists within as well as outside of the United States have very strong opinions and attitudes as to how all of this should go. I was recently in an exchange with a local artist and lowrider regarding my 1948 Fleetline. He asked me if I was going to put hydraulics in my car. When I responded that I am opting for a C Notch and air ride setup, his response was, " And I had such high hopes for you." He was joking, however, what followed was an exchange through social media about preferences in old school vs. "new." I indicated that I travel with my family in my car with frequency, thus foregoing orthodox tradition for comfort. The car eventually had hydraulics installed with a two-link suspension, with a smooth ride.

The orthodoxy in lowriding can come across as somewhat dogmatic at times. "If it doesn't have this or that, then it's not a lowrider." These statements are made without considering one's economic situation, limitation of parts, goods, services, technical abilities, etc. My experience in Brazil is that the younger, newer participants in the culture are very concerned with how they are representing the culture so as not to disrespect or go against tradition. This stems from a purist orthodoxy that has existed in Brazilian lowriding since the beginning in that country. The keepers of the flame established authority from the beginning as they controlled the flow and disbursement of information. Post-Internet, they lost the monopoly on information, thus allowing for other sources to act as "authority."

On a recent trip to Brazil, I was asked by my friend Hugo, "John, what exactly is a lowrider?" I recognized immediately that he was seeking validation. I told him that lowriding is an attitude. It is a way of life, and it is in the heart. I reminded him that we cruised literally all the way across the city of Sao Paulo, and with a population of 12.11 million people and one of the most densely populated cities in the world, that was no short trip. Further, we scraped the bottom of the car all the way across town. We were cruising, and thus we were lowriding. Regardless of the fact that he has no hydraulics in his car, he is lowriding. Further, he is a lowrider. No one can take that away from him.

What may seem to purists as "breaking the rules" outside of the United States is the result of local conditions that may prohibit orthodoxy in lowrider cultural practice. For example, in Brazil it is very expensive to import cars and parts from the United States, so Brazilians will purchase cars within the country or get them from other South American countries, Chile, specifically. The result is that there are many more four-door sedans on the road than two doors due to the affordability aspect coupled with the fact that the Brazilian economy has been

struggling lately with an extremely devalued currency. With the economics and import taxes working against the Brazilians, many have no choice but to get into a four-door as a viable option. While this may be less than desirable in the United States, for some abroad, it's the only option (Di Felippo, 2018).

What may get passed off as lowriding abroad could be scoffed at domestically through the types of cars used, rim choices, etc. These are what sociologists call "localizing" a cultural phenomenon. Think of a localized McDonald's menu. It may not have exactly the same menu items, and it varies from country to country. The same is true with lowriding. The local population sets the parameters for its local interpretation of a global phenomenon.

In short, orthodoxy is a myth. It is a wonderful idea that many cling to, and others stretch the freedoms of the imagination to unprecedented levels. I cannot imagine someone telling Jesse Valadez, "You can't do that!" while building Gypsy Rose or Joe Ray's "Las Vegas." Lowriding is all about individual expression. The cars and bikes function as blank canvases to create and express individual freedom. In other words, there are rules and simultaneously there are none. What functions as a well-established technique very well may have developed as an accident, i.e., colored chrome and webbing paint schemas. Resourcefulness has always driven innovations in lowriding culture. Outside of the United States, lowriding has common denominators, yet each with its own unique flair indicative of a local cultural interpretation or "spin" on lowriding.

Necessity is the mother of invention, and lowriding is an appropriate example of this idea. The pachucos in the 1940s began lowering with sandbags, and now we have state-of-the-art hydraulics and air ride suspension setups. What began as raising and lowering vehicles from World War II salvaged and surplus parts is now a thriving industry driven by Internet commerce. The humble beginnings of lowriding as simply lowering the back of the car have morphed and evolved into highly specialized labor in the way of paint, upholstery, wheels, glass etching, metal engraving, and suspension modification. If this is where lowriding has arrived in 70 years, the possibilities are mindboggling as to where it will be in another 70!

# REFERENCES

Appadurai, A. (1996). *Modernity at large: Cultural dimensions of globalization*. University of Minnesota Press.

Chappell, B. (2012). *Lowrider space: Aesthetics and politics of Mexican American custom cars*. University of Texas Press.

Cross, Gary S. (2018). *Machines of youth: America's car obsession*. The University of Chicago Press.

Di Felippo, H. (2018). Interview with author, Sao Paulo, Brazil, November 10.

Alberto, L. (Ed.), (1993, January). *Lowrider Magazine*.

Lopez Pulido, A. & Rigoberto, R. "Rigo." (2017). *San Diego lowriders: A history of cars and cruising*. The History Press.

Madrid, S. (Ed.). (1979, May). *Lowrider Magazine*.

Oshawa, S. (Founder and President of Primera Car Club). (2017). Interview with author, Nagoya, Japan, March 27.

Reimers, D. (Producer). (2014). *La Vida Low: Rollin' Till the Wheels Fall Off*. C2C Visuals.

Tata (Founder and President of Vida Real Car Club). (2018). Interview with author, Sao Paulo, Brazil, November 6.

Tatum, C. M. (2011). *Lowriders in Chicano culture*. Greenwood.

Valadez, J. Jr. (2018). Interview with author Los Angeles, CA, July 25.

# SECTION 7

## PERSONAL HISTORIES

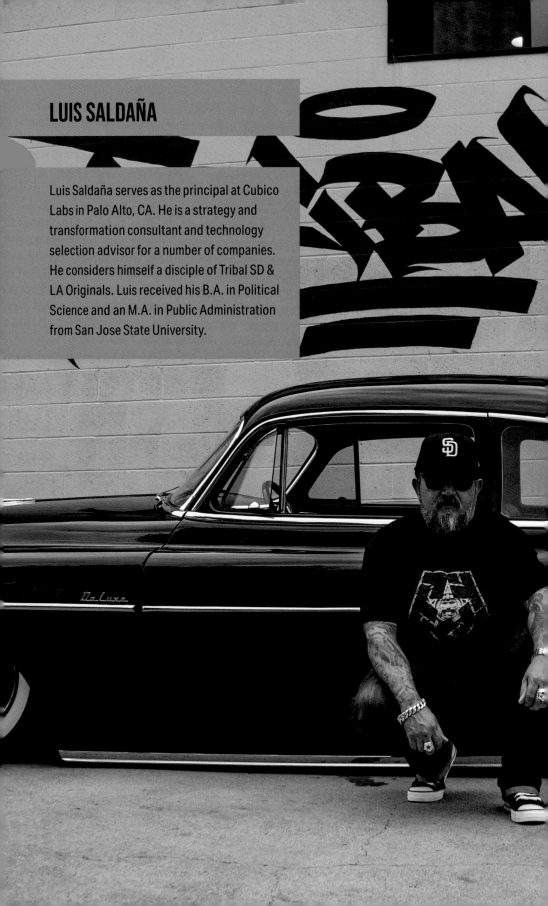

# LUIS SALDAÑA

Luis Saldaña serves as the principal at Cubico Labs in Palo Alto, CA. He is a strategy and transformation consultant and technology selection advisor for a number of companies. He considers himself a disciple of Tribal SD & LA Originals. Luis received his B.A. in Political Science and an M.A. in Public Administration from San Jose State University.

# EVERYONE BELONGS TO A TRIBE

## LUIS SALDAÑA

### AN INTRODUCTION

Every once in a long while, someone walks into your life and changes its course forever.

It was one fateful day in the Spring of 2000, when I was working at San Jose State University, that two students from southern California walked into my office. They told me about a pair of San Diego Chicanos by the names of Bobby Ruiz and Carl Arellano who were revolutionizing streetwear. Little did I know that this simple conversation would send me on a path of discovery that would find me at the heart of southern California street culture just as it was beginning to catch on outside the state.

At the time, I was in the process of creating a company called Cubico Labs. I soon left San Jose state to devote myself full-time to the company. The first thing I did was to hire a few students with backgrounds in art, journalism, graphic design, broadcasting, and film.

In order to attract followers to our website, we needed fresh content that was relevant to young college students. We bought two Canon XLRs, which were considered state of the art back in 2000, and we made a list of people we wanted to interview. Among the names on the list were a few up and coming

Bay Area artists along with a Latina Rapper by the name of Ivy Queen based out of New York.

To be honest, we had no clue what we were doing at the time, but we somehow secured a phone interview with Ivy Queen nevertheless. Soon after, I made the suggestion that we go find Bobby Ruiz at Magic in Las Vegas. At the time, it was one of the biggest showcases for fashion anywhere on the planet—a place where buyers from Macy's and Nordstrom to small boutiques would go to place orders from various brands.

When we got to the section Magic termed "Urban" at the time, we couldn't decide whether we were amazed more by the creativity on display in the booths or by the DJs and B-boys we found ourselves rubbing shoulders with. We soon found our way to the Tribal booth and asked for Bobby, but we were told that he was not available for interviews until the afternoon. We said that we would be back and went to look for the people behind the New York-based label Triple 5 Soul. Eventually, somehow, we found ourselves face to face with Camella Ehlke, who was the founder of Triple 5 Soul at the time. Just as we were beginning the interview, someone by the name of Mos Def stopped by to say hello to his friend Camella. No big deal, right?

After the interview, we headed back to the Tribal booth, where we met Bobby Ruiz and the members of the Tribal Clique. A tall, lanky, tattooed guy with long blonde hair immediately stood out from the bunch. Bobby, sensing that his friend was attracting our attention, said to me, "Hey, I want you to meet Mike Giant." He is deep into Chicano culture and low riding. Then, changing gears, Bobby said, "Come with me. I want you to meet two of my vato loco friends from LA who are going to be the real shit one day." He took me to the Joker brand booth, where he introduced me to Estevan Oriol and Cartoon, who was in the midst of inking a tattoo on Big Boi of Outkast when we walked in—a surreal sight, to say the least. On the way back to the Tribal booth, seeing someone walking by with what appeared to be posters wedged under his arm, Bobby says to me, "Hold on. I want you to meet Shepard." Imagine my surprise when I saw that he was talking about Shepard Fairey from Obey.

By the end of the day, my head was spinning. But my adventure was not over yet. When I thanked Bobby for the interview as the expo was wrapping up, he shot back, "Hey, in a few weeks we are going to have a BBQ at the Tribal headquarters in San Diego. I want you guys to come." I attended the Tribal BBQ about two weeks later. It was overwhelming. I had never seen such a diverse display of creative backgrounds, cultures, and ethnicities. There were skaters, surf-

ers, rockers, lowriders, bikers, DJs, graffiti artists, tattoo artists, B-boys, and countless more. A truly global range of styles were on display, so it was perhaps not surprising in retrospect that also in attendance were clothing industry luminaries from Tokyo, New York, Brazil, Mexico, Chile, Spain, Germany and the Netherlands (to name just a few hotspots). That September afternoon, I was introduced to Crazy Legs from the Rock Steady crew, OG Abel, Brian Reid of Osiris, Wuv Bernardo of the metal band POD, Louie Perez of Los Lobos, and Big Lepke from the Soul Assassins. I knew even at the time that I was witnessing something fresh and spectacular.

What I did not know—what I could not know until much later—was how many of the artists present that day would play a pivotal role in the unstoppable spread of southern California style. At the forefront of this spread was Bobby. In the following years, Bobby and the Tribal Clique went on to preach the gospel of SoCal culture all over the world. Their efforts were in no small part responsible for the widespread embrace of Chicano style and cultural elements throughout America and around the globe. While many other LA, Orange county and San Diego style creatives played a significant part in this, no one had their hand on the throttle of the rocket ship to the extent that Tribal did.

# TRIBAL

Though many creatives are known for eschewing mainstream political stances, outré creative trends have more in common with political movements than their iconoclastic leaders may like to acknowledge. Prevailing style trends can appear unchallengeable for years, but when the proper conditions arise at the grassroots, transformative change can come so swiftly that the previous status quo can come to seem quaint and naïve overnight. In short, shit can happen quickly. However, as is also the case in politics, the rise of a new creative movement is rarely planned or orderly. Creativity is an organic force with a life of its own. And, like political movements that have lost their connection to their constituents, creative movements that ascend too high, too rapidly risk losing their authenticity.

This is why Tribal's story is so remarkable—the company is one of few that can still hear the beats from the streets after more than three decades. This is perhaps due in part to the company's roots in traditional elements of Chicano culture. Just like the Wu Tang Clan was inspired by the Shaolin warriors in the kung fu films adored by RZA and ODB, Bobby and Joey Ruiz were initially influenced by imagery of Aztec and Mayan warriors. These influences are apparent

in some of the first Tribal shirts, which were proudly adorned with patterns and graphics reminiscent of traditional Mexican art.

This aesthetic has resonated in locales far from the homeland of the Aztecs and Mayans. On a recent Tribal podcast, Bobby Ruiz mentioned that Chicano culture has even played a role in modern Russian youth movements. Bobby compared the appeal of Chicano culture to that of the punk movement in the 1970s and 1980s as represented by bands such as the Sex Pistols, Black Flag, Bad Brains, and the Dead Kennedys. Like the punk movement, Chicano style represents rebellion. The imagery of the vato locos y cholas, tatted up and wearing Dickies and Nike Cortez sneakers, rejects a mainstream vision of an American society that, to countless young Americans in barrios across the country, have felt they have not been given them their rightful place in the American dream. Then and now, disaffected young people all over the world were looking to reject mainstream style in favor of a new cultural movement that spoke to their experiences. Tony Wilson started such a movement in the late 1980s and early 1990s in Manchester England when he founded Factory Records and the Hacienda nightclub (Mortley, 2022). In time, that movement grew to a globe-bestriding colossus, the details of its rise became a celebrated history, and its early figures became household names (for a glimpse at that legend and a humorous portrayal of those early figures, see the semi autobiographical 2002 film *24 Hour Party People*—a personal favorite).

# GRATEFULNESS

I am profoundly lucky to have met Bobby, Joey, Carl Arellano, and everyone else in the Chicano style subculture before they started a movement that influenced so many creatives in the street culture world. These people have had an immeasurable effect on my career, my creative pursuits, my sense of style, and my overall life outlook. Just as Bobby and Joey enact the legacy of those who came before them—prior generations of Chicano artists, earlier So Cal style pioneers, like "Los Four/Murals of Aztlán" that included Frank Romero, Carlos Almaraz, Robert de La Rocha (Zack de La Rocha's dad), and founder Gilbert Lujan who were responsible for bringing the Chicano Art movement to a worldwide level.

As of September 2021, Bobby Tribal was still watering the roots of southern California street culture in the Netherlands, Berlin, and Paris along with fellow creatives Tim "Pablo Pistolas," Tone Anderson, Isaac Quezada, and Bert Custodio. In the past three decades, Tribal has established a creative legacy that is to the world of street culture what The Velvet Underground's legacy is to the

world of music. To see the reach of this legacy, look no further than the throngs of up-and-coming creatives who now cite Tribal and the SoCal street culture, it ignited as their primary influence. Though Bobby Tribal may not be a household name—among the Tribal Clique and others he is the stuff of legends.

# REFERENCE

Mortley, P. (2022, April 5). *From Manchester with love: The life and opinions of Tony Wilson*. Faber & Faber.

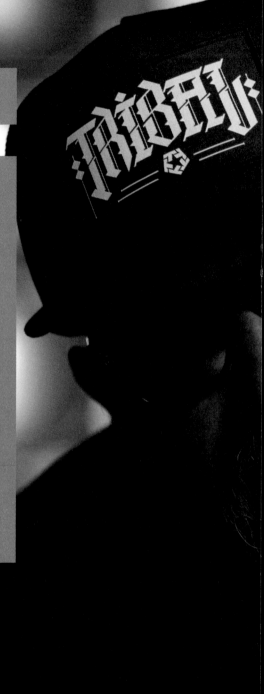

# MICHAEL 'TANK' GONZALES

Michael "Tank" Gonzales was born and raised in Los Angeles county, graduated from Pepperdine University School of Law in 2008, and now serves as the managing partner of the West Coast offices of a national law firm. Tank is also the co-founder of The Raven and The Wolves, a world-renowned tattoo studio and art gallery, which he owns with Carlos Torres. He has a passion for the community, serving in multiple countries with World Central Kitchen on several disaster relief projects. Tank has also been a guest speaker at many colleges, high schools, and groups of troubled youths, attempting to illuminate a path to a successful future. Tank has a deep love for travel and has adventured across every continent on Earth. His love for his family and friends is at the center of his existence and inspires his every move through life.

# A PERSONAL ACCOUNT OF TRIBAL AND TATTOOING

## MICHAEL 'TANK' GONZALES

### WHO IS BOBBY TRIBAL?

Bobby Ruiz and Tribal Streetwear are arguably so intertwined that the brand of "Tribal" has replaced Bobby's last name "Ruiz." In pop culture and within the business world, it's rare to find such a dynamic crossover between an individual's identity and their company. After all, we don't talk about Jeff Amazon or Elon Tesla … but the nickname "Bobby Tribal" rings bells in street cultures around the world. Bobby Ruiz may be known to friends and family as Bob or dad, but the name Bobby Tribal is a brand—he is Tribal.

From hip-hop to the skate world to lowriding to surfing, the name Bobby Tribal resonates with the upper echelon of each of these worlds. CEOs, famous musicians, and cultural icons— Bobby has them all on speed dial but maintains a true grasp on what matters in life. It is his humility that has earned him respect in the boardroom, but also in the street world. Despite having helped break some of the biggest bands in the world, creating a worldwide empire, accumulating a ridiculous car collection, and raising a beautiful family, Bobby's perspective doesn't permit the success to inflate his ego. Rather, Bobby

asks questions, leads with curiosity, doesn't feel the need to tout his own accomplishments, massive as they are. No matter if you're royalty or a homie from the street, you get the same Bobby. Warm, endearing, caring, and wildly intelligent in the most subtle of ways.

The OG of OGs, Bobby is more than a streetwear legend, more than a business-man—Bobby is a painter of culture, influencing those who have created wave after wave of cultural movements. To maintain not just cultural relevancy, but taste making at such a high level for such a long time propels him into very rare air. That shirt you're wearing? Chances are Tribal influenced the entrepreneur that made it. The song you are listening to? Chances are that artist was influ-enced by a band Bobby helped put on. Reels, documentaries, and behind the scenes visuals? Tribal did that first. Despite not actually being an artist in the traditional sense, Bobby is admired by your favorite artist's favorite artist and his influence is as pervasive as it is respected. This particularly holds weight in the tattoo realm, particularly my personal experience.

## THE RAVEN AND THE WOLVES

Bobby and I met through mutual friends in the tattoo industry years ago. In a room full of posturing vatos in black shirts, tattooed head to toe, Bobby stood out. Not for any physical reason, his presence was more than sufficient. There was no pretense to him, no ego. We immediately sparked a rich, long-term friendship. Little did I know just how much influence Bobby would someday have on my future ...

I ran out of my office one day to grab a coffee and happened to see my favorite tattoo artist, Carlos Torres, walking directly toward me. I stopped him, intro-duced myself, chatted for a few minutes, and then went on my way. Naturally, I called Bobby immediately upon walking away. Bobby owned a few art pieces and a tattoo from Carlos and I wanted to share my excitement meeting him, never imagining I would actually be able to get tattooed by him. Unbeknownst to me, Bobby immediately called Carlos, asking if he just met a dude named Tank. "Big guy in a suit? Just met him!" True to form, Bobby's intuition was ring-ing and told Carlos that he should tattoo me, that he and I should know each other.

Three weeks later I was sitting down for lunch with Carlos, planning my tattoo, but also planting seeds that after a three-year war with the City of Long Beach led to Carlos and I opening The Raven and The Wolves tattoo studio and art gallery. Many of the world's best tattoo artists have tattooed there since, hung

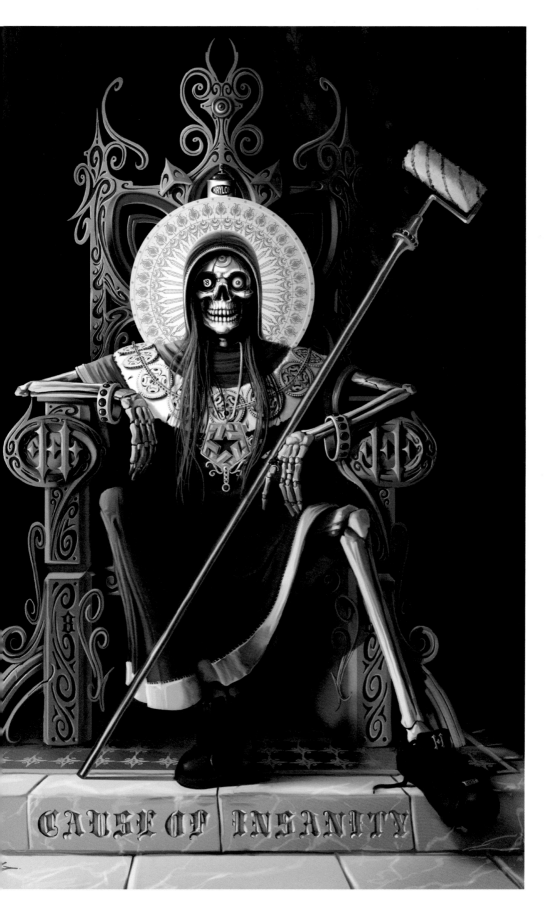

CAUSE OF INSANITY

their paintings in our gallery, and exchanged ideas and pushed the culture and art form forward ... none of which would be possible without Bobby seeing the big picture and connecting Carlos and myself. In his typical invisible way, Bobby and Tribal once again facilitated or perhaps curated culture that no one else could see, synchronicity that he perceived in the ether.

Bobby asked for no money from this has given himself no credit for this and sees

his connecting us as a small thing he had a hunch would work. But my story is not unique to Bobby. In fact, I know I am one of the many lives he has touched, even with the most casual of efforts.

# TRIBAL'S TATTOO ROOTS

Stretching back to the 1970s, the roots of Tribal are in tattooing. In fact, Bobby's dad Joe was in the military and has a bunch of tattoos, including a "4" tattooed on his wrist in stick and poke, representing the neighborhood he ran with in Laredo, Texas. Bobby's brother Joey started getting tattooed and tattooing very early in life, little did the Ruiz family know where tattooing would take them.

The first shirts Tribal ever made featured graphics from Joey Ruiz's tattoo flash, as well as lettering that Bobby did. Bobby knew silk screening and graphic design from classes he took in school, took a bunch of blank T-shirts and began putting tattoo flash on there. Aztec/Mayan style motifs, one or two colors, and an empire was born.

Graffiti and tattooing were still counterculture in those days, nothing like today's popularity, and from the very beginning Tribal embraced the counterculture. Tribal's first VHS tapes had tattooing in them—unconcerned about the mainstream perception, Tribal marketed directly to those on the fringe of society, fed a market everyone else was ignoring, and used it for fuel to do more.

Around the same time in the late 1970s, black and grey tattooing was beginning to emerge from prisons and spreading via legends like Mark Mahoney and Jack Rudy at Tattoo Land in East Los Angeles, owned by the legendary Good Time Charlie. The single needle, fine line tattoos created by homemade machines in prison were being replicated, the art form shifting and spreading. Just down the coast in San Diego, Bobby recalls seeing his first neck tattoo in 1979 on a vato fresh out—influences shifting the ground beneath his feet.

From the outset, Tribal wasn't just a cholo brand, a lowrider brand, or any other specific niche. Streetwear didn't exist as a concept yet, but Tribal was feeding the streets, calling on influences not just from the neighborhood, but including punk rock Chicano skinheads Bobby skated with at the park, who were rocking full sleeves and neck tattoos before anyone else. Tribal drew influence from these outcast, anti-Nazi Chicanos, as well as the vatos fresh out of prison. Tribal's birth was in the sprawling landscape of southern California, all the shirtless cultures in the sunshine adorning themselves to signify their own tribal roots.

Tribal was at the cutting edge of all of it, developing a streetwear brand that represented all of the lifestyles under one roof, far before any such thing existed. All the elements came together in the initial marketing – skating, hip-hop, graffiti, tattooing, lowriders—this birthed an entire generation of brands that focused their marketing on tattooing. Proudly, Tribal was the first clothing brand to use tattooed females in print ads.

Now marketing everywhere screams out all these specific elements without giving credence or credit to the cultures that Tribal as a brand has supported in deep, meaningful ways. But that is the difference between cultural bedrocks such as Tribal and the latest brand trying to capitalize on a craze.

## TRIBAL AND TATTOOS EXPAND

By the early 1980s, the fine line, black and grey tattooing developed in garages and prisons of southern California was growing virulently, changing the way tattooing was expressed on skin, going bigger and bolder and more defined. Bobby was front and center, personally getting to know all the originators and the developing culture. Before accountants had neck tattoos and kids on social media were getting their faces blasted, tattooing was counterculture, was subversive, and was taboo to the world. Being heavily tattooed was an indicator of being an outcast in modern society, the thought of being both heavily tattooed and successful would have been considered patently ridiculous—which is where Tribal came in. Through its prodigious platform, Tribal helped make tattooing more visible and respected as an art form, but also helped elevate obscure artists to worldwide renown.

Unlike many other brands, rather than create a business model based on exploitation of young, ignorant kids, Tribal uplifted unknown artists by broadcasting their artwork across the world via apparel, posters, and multimedia. Bobby instructed all the young hustlers to be smart with your money, build your brand, invest in yourself, and create multiple streams of revenue. Bobby may not have created the tattoos himself, but continuously sought out artists, gave them a platform, and created so many lanes and opportunities. Many legendary artists created art for Tribal at the onset of their careers.

Humans spanning the globe rock Tribal T-Star tattoos. Think about that. A clothing brand started in a garage, hustling at swap meets and lowrider shows, now has its logo tattooed on humans all over the earth. Bobby birthed a worldwide culture so strong that people that have never met him have the logo he designed 25 years ago tattooed on them. And that loyalty has been repaid time and time again.

# TRIBAL WORLDWIDE

The 1990s had now arrived and Tribal and the cultures it represented began progressing from subversive art forms to worldwide, mainstream acceptance. Bands like Cypress Hill and Limp Bizkit were amongst the hottest on earth, representing Tribal everywhere they went across the globe, while Tribal itself was making its own international moves. Once again, Bobby was front and center in taking Tribal and all it represented to Japan, which was an entirely new level of counterculture.

Mr Cartoon may be the most prominent name in American tattoo culture, and in the 1990s Bobby was traveling with Cartoon on tattoo tours, representing Tribal, doing his own business deals, while also helping Cartoon with the day-to-day of tattooing in a new country, especially since all the tattooing had to be done quietly and privately. Tattooing's legal status remains questionable to this day in Japan, but in the early 1990s it was strictly illegal. Despite this truly underground status, the real players in the underground tattoo scene in Japan would invite Bobby and Cartoon to their shops, into private areas that are only discussed in hushes to this day. The realest of the real welcomed Bobby and Cartoon into their own secret society. While being in the room with such serious people may have intimidated the regular Joe, Bobby, and Cartoon were the Chicano dudes from southern California that they wanted to befriend, whose culture they wanted to learn.

Bobby was present for Jose Lopez's first trip to Japan and just happened to be there with OG Abel, Tattoo Tony, and Wuv from POD. Before all the tattoo hype. Before social media. Bobby, Cartoon, Psycho Realm, hip-hoppers and tattooers and all the real dudes from all the worlds were in Japan together. It wasn't on social media. It wasn't on YouTube. It wasn't on TV. It was on Tribal VHS videos that you could find in Germany, Japan, Mexico, tapes getting shared around the world. Tribal was there.

Before Instagram, the tattoo industry revolved around in person affairs. At conventions, you would see Tribal shirts on people from countries no one had ever

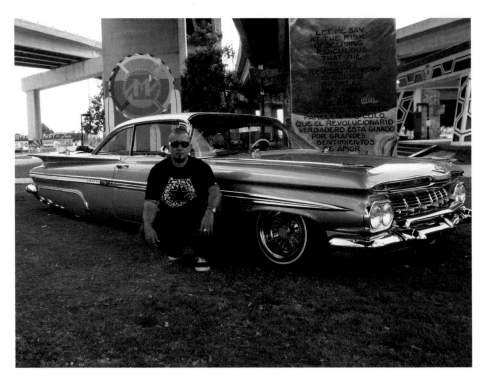

been to. The great unifying brand of Tribal was an indicator of belonging to the culture, whether you were a cholo from Japan, a skater from Mexico, or a punk rocker from the Phillpines.

Tribal went on to sponsor shows at Ink N Iron, Musink, curate the cars of the show, bring the Tribal crew of tattooers, and set up a booth. Fred Durst was a tattooer before the fame and had a bunch of ink. Graffiti artists like Cartoon and Mike Giant went from hitting up walls to tattooing. The hip-hop scene, graffiti scene, and tattoo scene all merged and exploded.

Bobby has not only supported an incredible amount of artists, but was himself a collector before collecting tattoos was even a thing. Bobby isn't the walk around shirtless type, but had a full torso done by Mr Cartoon before Eminem and 50 Cent, was living the life before it was popular on social media.

# DUTDUTAN

While Tribal's tattoo ties run deep, veins in the culture of tattooing, Dutdutan is the most prominent display of Tribal's

tattoo ties. Dutdutan is the Philippines' biggest and grandest tattoo convention, held annually by Tribal Gear Philippines and running sixteen years strong.

The convention began as most do, a small group of tattooers and trying to make a go of it. A few years into the convention, Tribal's partners in Manila formed a partnership with the convention and set out to create a transformational event. Unlike the many places in the world, tattooing has a long history in the Philippines and is woven into Filipino culture. In yet another revelatory moment, Tribal shifted gears away from southern California tattoo style and energy to meet Filipino tattoo aesthetics—the desired Filipino Astig style.

The Philippines had never seen anything like Dutdutan once Tribal was involved. Immediately the search began for bigger venues, local rock bands were recruited to perform live, international artists invited, and did it ever grow … LED screens, huge stages, a Tribal Star shaped MMA ring, over 20,000 humans visiting over a weekend. Tribal's involvement revolutionized a small, local convention to an international event.

Dutdutan moved to the largest venue in the Philippines in the World Trade Center, began selling out every year, as the names of bands and tattooers grew, so did Dutdutan. To this day tales are told about the incredible, wonderful people of the Philippines that rolled out the red carpet—the hospitality was second to none. OG Abel, Steve Soto, Luke Wessman, Big Tiny, Dago Dane, and Eric Gonzalez—so many more faces and names on billboards, screaming legions of fans—the scale of Dutdutan blew away everyone who stepped foot into it.

# TRIBAL SIMPLY DOES IT RIGHT

## TRIBAL CLIQUE

Tribal helped bring tattooing to a worldwide stage while also creating a lane for people that never dreamed of doing so to travel the world. Kids from the hood arrived in the Philippines to massive fanfare, seeing their faces and names on billboards, being treated like rock stars. This is all because of Bobby. Because of Tribal. That is the true leader of a tribe—everyone gets their lives changed, dreams come true, you see what is possible—all because of Tribal. All because of Bobby.

It is for these reasons that within the tattoo community, it means a great deal to rock a Tribal T-Star tattoo. In the inner circle of tattooing elites, the Tribal T-Star comes only with Bobby's blessing and approval. That tattoo means more than branding, more so an indicator of closeness to the man behind the brand, to an ethos of loyalty, integrity—belonging to a tribe, the tribe of Bobby Tribal.

Tribal created a lane that had never existed before, a path to owning your own destiny, taking a concept and turning it not just into a brand, but a movement. For an entire generation of young men, Tribal showed what is actually possible if you are willing to work hard enough. In the 1980s and 1990s, nearly no men that look like Bobby Tribal achieved financial freedom, let alone did so blazing an independent trail outside of the normal system paradigms. Via Bobby and Tribal, we learned that you can be a tattooed kid from the hood and still live out your wildest dreams.

Tribal is a worldwide brand born in the barrio, created by the culture, made for the culture, and never sold out, despite many offers to do so. One man has his fingerprints all over the blueprint. For that reason and so many others, Tribal is bigger than streetwear, bigger than clothing—Tribal speaks to the possibilities that exist with enough self-belief, determination, and hunger. Tribal represents the true life tale of grinding your way to the top by your own means, allowing

your own style to shine, and achieving all of this without having to dilute or tailor your brand to corporate overlords that will take what you built and strip away your individuality.

# CONCLUSION

That is the story of Tribal and tattooing as I know it. Bobby is the originator of a tribe of rebels, creatives, hustlers, and thinkers. Within that loyalist tribe lie a high percentage of the worlds' most renowned tattoo artists. So many of them were kids from the hood with prodigious talent but no one to look up to, no one to advise them, guide them. That is where Bobby and Tribal come in.

Tribal is a representation of what is possible if you believe in your dreams enough and are willing to grind to get there. No one encapsulates that more than Bobby Tribal himself.

**Section 7 Figure Credits**

Page 212–13: Herman Plasencia
Page 214: Photograph of Bobby Ruiz outside Tribal headquarters in San Diego
Page 220–21: Bobby Ruiz photographed by Isaac Ruiz
Page 223: Huit
Page 224: Chuey Quintanar
Page 226–27 (top and bottom): Bobby Ruiz and his Homies photographed on Highland Ave in 1980 by Greg Marquez
Page 228 (top left): Photograph of Bobby Ruiz in Chicano Park
Page 228 (bottom): Early Tribal Streetwear design by Joey Ruiz
Page 229: B-boy Casper photographed by Willie Toldeo
Page 232–33: Ata Bozaci by Toast
Page 235: Photograph of Bobby Ruiz and Carey Hart
Page 236–37: Booby Ruiz at MAGIC Trade Show photographed by Willie Toldeo
Page 246: Photograoh of Bobby Ruiz

# BOBBY RUIZ

Bobby Ruiz, CEO of Tribal Streetwear Inc., developed an early interest in southern California lifestyle and culture. This eventually transpired into a degree in Mexican American studies and an international streetwear brand that landed him on five continents. Through Tribal Streetwear Inc., he has worked with hundreds of creatives, including several multi-platinum recording artists. He has cu-rated and co-curated art shows in San Diego, Tokyo, New York, Melbourne, Australia, and Los Angeles. Bobby also has been involved in curating multiple car shows and cultural events, and Tribal Streetwear has been a proud sponsor of Chicano Park Day in San Di-ego for 24 years. Over the last 30 years, Bobby has established a strong network of business professionals, graffiti artists, street artists, DJs, dancers, tattooers, skateboarders, car builders, and clubs. Bobby and his wife have three children and reside in Escondido, CA. Bobby enjoys spending time with his family, traveling, and working on his car collection. He is very proud of his San Diego and Chicano roots and the opportunities he has had to represent them globally.

# TRIBAL STREETWEAR: A PERSONAL HISTORY

**BOBBY RUIZ**

## FAMILY BUSINESS

I was in my junior or senior year in college when my brother Joey and I got a hold of some blank T-shirts from this random dude. I'm not sure where this guy got these T-shirts from, for all I know is they could have been "Hot", or whatever, but he was giving us a deal. It was good enough that we could flip them for a profit. We were young, and we didn't have much money to invest in anything, but we knew how to hustle.

My brother and I got the capital for merchandise from our daily jobs. Ever since we were kids, we were hustlers, not hustlers in the negative connotation like ripping people off. I mean we had a strong work ethic, we knew about sales, and we knew what it took to turn a profit.

Some of my earliest memories were at the swap meet with my dad. When we lived in Los Angeles (LA), he used to take my brother and I to the Paramount Swap Meet and other such events to help him sell clothes and whatever else he could get ahold of. We even sold breakfast burritos wrapped in tin foil that my mom would make to other vendors and customers.

Later, and into our teens, after we had moved to San Diego, we used to work the National City and Spring Valley Swap Meets. We would sell everything from fabric, hair care products, ribbons, lace, lotions, and everything in between. We were able to see our parents do business and that taught us that we had to be nice to people and put money in to get money out. So as we got older, we were able to take those swap meet lessons and apply them to what we were trying to do in very early streetwear.

This is why we invested some cash into buying these blank T-shirts; well, most of them were blank. It went well enough and we were turning a decent profit. I am sure we sold at least 1000 unprinted pieces. This same guy that we bought the T-shirts from ended up burning us in the end for $2000 after purchasing about $5000 in stock from him. A hustle turned sideways, I wrote it off as a life and business lesson, so we kept moving forward.

At around that time, 1989, I was studying Mexican American studies and business at San Diego State University. My brother was getting into tattoos and tattoo flash. He would trip out on neighborhood and Indigenous Aztec and Mayan designs and put together his own graphics. At that time there wasn't much out there that we knew of that was in this style. All we were familiar with was what we would see in the Varrios as well as military-style tattoos and Hand Poked like my dad had. Joey's first designs for tattoos had the Aztec and Mayan influence, something we were both into, especially since I was heavily into studying these cultures at SDSU. I remember the first design, a Quetzalcoatl, the Aztec feathered serpent deity, with a little motif that represented water around it. At the time we were still pushing the blank T-shirts and one day, we just had a bright idea to silk screen these unique tattoo flash designs on the shirts. See, I was familiar with silk screening because all through high school, I took graphic arts class. I would silk screen T-shirts, stickers and mirrors with stuff I'd seen in *Lowrider Magazine*, Carlos Santana album cover shirts, basically whatever I was into during high school. I was also into ska music and rock, so I had a few items with those influences on them as well. So anyways, we decided to put some of my brother's tattoo flash on shirts. As soon as I saw the first T-shirt get printed, I knew we were onto something. The first shirt was the Quetzalcoatl design. The second shirt we printed was a bird of Aztec influence that my brother also got tattooed on him. After the second T-shirt, I started digging through books finding other graphics that I thought would look good on a tee. Since we were doing good at that point, I stuck with what worked, Aztec and Mayan type graphics. During this time we were throwing names around. We didn't know what to call the business. Like anything, we went back and forth and then finally my brother Joey came up with the name, Tribal. I thought it was cool, so we took it from there.

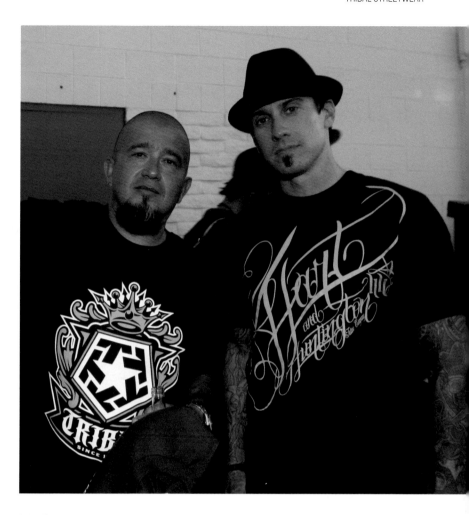

I don't remember exactly how we brainstormed or how it came about, but I do remember thinking, everyone came from tribes and at what point did people stop being from a tribe. In the past, you had tribal people expressing themselves with hieroglyphics, dance, clothing and other mediums of art that would show self-expression. I thought it was a cool name and so now we had a brand with a real name and we reached a point where we could just put TRIBAL on a shirt. The first sales were to neighbors, family, people at my parents shop, anyone who liked it. We were selling wherever we could at that time, always hitting up different spots, neighborhoods, and people around San Diego. We never really had an official account until the legendary Hamel's Surf and Skate Shop, right on the boardwalk of Mission Beach started stocking some of our gear.

This was followed by our second account at La Luz de Jesus on Melrose Avenue in LA. La Luz de Jesus is a store and art gallery that has a good reputation in the art world and is known for its wacky aesthetic and as an early supporter of pop surrealism. They were into Tribal products because of the Aztec and Mayan influence, something that didn't exist at that time in apparel.

I've been into lowriders since I was a kid and joined the GROUPE car club in San Diego about two years out of high school. I also loved to skateboard and it was not easy to be put me in any particular box. I was listening to everything from hip-hop, rock, and ska music and there wasn't really any clothing brand that I could sport that fit all those things that I enjoyed. There were urban brands, for example Cross Colours, although from the West Coast, the bright colors and designs didn't fit the lifestyle I was living. I would also occasionally wear Stussy, Santa Cruz, Powell Peralta, and Dogtown stuff.

In college, Stussy was a big influence and to me was cool and represented youth in the streets. My belief is that Stussy was the dopest brand out there, but as far as anything that catered to a West Coast lifestyle or a street Latino lowrider kind of market, there wasn't anything. I am hesitant, but I guess I'm proud to say that I believe, we pioneered true West Coast style streetwear and pioneered it in a way that it was diverse enough to encompass the West Coast Southern California lifestyle including Latinos. It was real to the culture that my brother and I were actually involved in, we lived and breathed it. We both used to skate, we both were into lowriders, into the music culture, and graffiti. It was real.

## TRIBAL'S NEXT CHAPTER

A couple years after 1989, business really slowed down. My brother lost interest in Tribal as his lifestyle got in the way. In my senior year at State, I began curating an art exhibit at the Centro Cultural in Balboa Park. That was about the time I really started noticing East Coast style graffiti out here in San Diego, especially the handstyles, full color burners and pieces with bubble letters.

Around that same time I would go to Hollywood to go buy clothes on Melrose when Melrose was still cool, stores like Let It Rock, Posers, La Luz de Jesus, just to name a few. I started seeing some of what I believe was Risk and Dante pieces. Both artists are pioneers of the LA graffiti scene and were known for their full color pieces. I remember being in awe, and thinking how in the hell is this all done with spray paint. All we used to do was one or two colors and simple block letters posting up our names or neighborhood. We weren't doing a lot

with colors, and this whole graffiti thing with color was pretty amazing, so then with a little bit of time, I started seeing it a lot more around San Diego.

While I was curating a show at the Centro Cultural, the show was called Calles Vivas, is when I began meeting local San Diego graffiti heads. This guy named Bust One aka Buster, Jesse Ortiz, started showing me who was who in the scene. From that point I began meeting all kinds of local talent, like Sake, Quasar, Zodak, Dyse, Zard, Bom, Severe among others. At that time Zodak, Sake, and Dyse were really making noise, blowing up the scene at that time. Then of course, there were the Chicano OGs from the neighborhood, like the homies Oldie aka Pablo Pimental, Victor Cordero, who are still remain active in the art community to this day.

The Calles Vivas Show was a success and featured a diverse lineup that included lowriders, photography, and graffiti. I didn't know it at the time but according to the Centro that was the show that had the biggest attendance of any show at the Centro since the early 1970s when they opened. I believe it was because it was fresh, it was young, it was new, it was diverse, and no one had seen anything like it.

After the success of the Centro Show I was approached by The San Diego Food Bank to curate a show at the Food Bank for the purpose of having a canned food drive. This is how I first met my future business partner, Carl Arellano. An acquaintance of mine introduced me to Carl, who owned a silk screen shop in National City called Baja Arts. Carl and I started talking and shooting ideas back and forth. Baja Arts, his shop, was a trip. I remember first going there he had loud music, centerfolds on the wall, it was kind of like a party/silk screen shop. The energy was high and busy. Along with the high energy was high productivity, with jobs and accounts. The setup wasn't too elaborate, and he had two manual silk screen presses, but that was two more than I currently had access to. I broke it down to Carl. I told him I have a name, I have graphics, I have artists, and I have a vision. At that point, I was willing to give Carl half of the company, because he had a silk screen shop, credit with manufacturers, and the ability to print shirts. Carl was able to bring all that to the table and I was going to bring the graphics, the marketing ideas, the artists, and the cultural network.

The Food Bank show created a lot of buzz which resulted in a lot of people showing up to see what all the buzz was about. We ended up having a big tall, long wall full of graffiti that got bombed on by Quasar, Sake, Zodak, Dyse, Cheno, Baba, Richard Martinez, Daze, Buster, and a few others. The day of the show, I had given everybody a new graphic called the "Trylon" shirt to wear and showcase. Well, as it turns out, the show and this shirt caught the eye of a couple of graffiti writers, Power and Skate who represented a magazine called Can Control out of LA, and they featured us in their magazine.

That is when we started getting more stores asking for clothing. We soon began doing more graffiti inspired graphics with letters and characters. The first graffiti graphic was done by Zodak. It was a piece that had some letters and a skull and cross bones. The second by Dyse was letters with a spray can as the letter I in Tribal. It was really cool stuff and back then there really wasn't much out there like it.

# CAR CULTURE

I've been involved with the car scene for at least 45 years now, not only my love of cars, but actually working on and building cars. I've always had a fascination with cars since I was little, especially the lowriders I would see around San Diego. My brother and I also developed a pretty substantial Hot Wheels collection due to my parents. My dad, my uncles, my brother, our neighbors were all into cars when I was young and we all used to help each other out in the garage. I believe all of this helped propel me into the car scene when I got older.

I had never seen an actual lowrider on a shirt. We started putting lowriders on shirts and one thing started leading to the next and business started coming in. I believe we were innovated with the lowrider shirt concept. Tribal has always had some sort car aspect attached to it, especially the Tribal videos. So I think when people see a T-Star or when people see the logo or hear the name, they know the brand, they know the history of the brand, and they automatically attach lowriders and the West Coast lifestyle to it.

# TRADE SHOW AND TRIBAL'S GROWTH

In 1992, we did our first Action Sport Retail (ASR). By then, we had enough money and enough knowledge to finally release a catalog. At ASR, we stood out like a sore thumb. Not because we had whack product, but because we were ethnic. We had Mexicans, Blacks, Asians, we had a lowrider bike in our booth, we had a DJ, and B-boys. ASR had never ever seen anything like that. Remember ASR was primarily a surf and skate show. We tried to build up to it because we always heard that if you can rise up and do that show, you could write like $15,000 in orders. We were like damn, if we could do that, we would be rich. So the ASR people kept sending security over to settle us down. This was all fresh, new, and exciting, we invited all the homies to roll through, so they were trip'n. They would tell us that we were too loud, we cant have break dancers in the booth, we cant have the DJ too loud, we can't do this, and we can't do that. It was pretty lame. Sure we turned it down, for a second.

ASR was cool overall and we did it about 30 times over the years. We met a lot of great people there as the streetwear industry began to grow like Kelly Gravel aka Risk from Third Rail at our first ASR in 1992. Their booth was maybe 50 yards from ours. We had a good visual of each other, we could see each other booths, ours were both small booths, ten feet by ten-feet. He had his crew and we had our crew and then all of a sudden he sends somebody over from his crew to our booth and asks for a catalog. I told him no. "No, I'm not going to give you

a catalog unless your going to give me one of your catalogs." That guy walked back to Kelly's booth and I could see them talking, when Kelly starts walking over with his catalog. We exchanged catalogs, and hit it off from there. Neither one of us knew anything about the clothing business. We learned together and shared a lot with each other over the years, everything from customers, sourcing, manufacturing, and other stuff that we were acting like we knew about. We didn't know cotton from polyester, wool from nylon. We started learning how to produce clothes, making a lot of mistakes along the way, but we shared a lot.

It was at this show that we started seeing some international interest from Germany and Japan and we ended up writing $45,000–$50,000 worth of orders, we were blown away because back then that was more money then it is now. This was when we pursued our first loan and eventually enough capital to push product. This is what enabled us to grow quickly around 1993–94.

Held twice a year, these shows helped us grow and meet amazing people along the way like Mr Cartoon, Estevan Oriol, OG Abel, Mike Mattox, and countless other artists and celebrities.

An important development in the early 1990s, began with a group of guys from San Diego: Bill McMullen, David Lively, Richard Hansen, and Mike Pickel. That started an alternative show to ASR called 432F. The reason it was called 432F is because the show was going to take place at 432 F St. in downtown San Diego. ASR, which was mostly geared around the surf and skate apparel industry, they saw an opportunity to embrace the diversity, hip-hop, rave, graffiti, skate and the lowrider stuff we and others were doing. They held it at the same time as ASR and did a great job of promoting it and actually got a lot of traffic and a lot of attendance.

That initial show got the attention of a young bleached blonde Japanese business man named Satoshi Furuya who owned a company named CCC Triple Crown in Japan. He was very inspirational in building the brand because later on he would be the guy that sponsored multiple promotional Tribal tours overseas.

Our first tour to Japan was in 1994 and that led to at least a million dollars worth of product sold in Japan for the first three years. The Tribal tours were new and unique. There was nothing like it at that time in Japan or anywhere else. We were pioneers and we brought hip-hop in all its forms such as B-boys graffiti artists, DJs, rappers, MCs, as well as skateboarders and tattooers.

We ended up doing over a dozen of these tours and they collectively were inspirational, not just for the brand and the events, but with creating a clique, the Tribal Clique. Being on tours with so many different people from different walks of life, you just become friends. Friends that are down enough for you and represent. I was still young, so it was a great time for all of us. We were breaking ground out there with bringing southern California culture to the far east.

The 432F shows were cool because those shows began attracting international companies that would send their buyers from all over the world. There were numerous other brands there as well, and over time, we became friends with each other. I met people like Shepard Fairy, Stash and Futura, Doze Green, Easy E, Ice-T, and the Booya Tribe. While 432F was growing, it eventually was consumed by ASR.

As ASR started embracing streetwear, they also changed their business practices and encouraged us by doubling our booth size for free. It was not hard to see why Tribal started to pull in the rock stars and celebrities into our booths. We had the guys from Cypress Hill, Korn, Limp Bizkit, P.O.D. all come through and chill with us at our booth. B-boys and DJ's all kept our booth hype. They weren't coming to hang out with Quicksilver, they were coming to hang out with us. We had the excitement and energy that none of these other booths had at that time. Our guests were so popular at the shows that ASR started asking us if we would move some of the performances to the main stage. This is when I realized that what we offered was truly unique.

## TOO STREET FOR STREETWEAR

For the first few years, we didn't fit in anywhere within the industry. Without a doubt, we were at the forefront of what was considered to be real "streetwear." We labeled ourselves as such from our very first stickers, hang tags, labels, etc. In my opinion, the 432F show was the first official streetwear show anywhere in the world and the birthplace of it was San Diego, our hometown. We held the prime spots in the show for the first few years and contributed to them as much as possible.

Eventually streetwear was embraced by ASR and The MAGIC show in Las Vegas, and we were there as well during this period, again at the forefront along with our peers. I didn't know too much about or anyone from Fuct other than Slick. I also didn't know anyone from X Large; we simply were not in the same circles and our brands were very different. I can say we rolled much deeper and had a greater presence at the trade shows. However, for the first ten years, I would say

there were five brands that truly represented the West Coast lifestyle other than just rave or skateboarding. Those Brands were Third Rail, Joker Brand, Sucker, Black Flys, and Tribal. During that first decade, these five brands attempted to show side by side or in the same areas at the tradeshows, we sponsored events together, shared customers, and information regarding manufactures, we even helped and promoted for each other when we could and the energy around us was always the freshest.

As time went on, the term streetwear, what it was and what it meant became distorted alongside something called "urban." Most of us considered urban to primarily be African American inspired and rooted on the East Coast. This eventually became the time of the Giants. These were brands with big money garment industry investors and mega booths at the shows. This was a very ethnic period especially at Magic, the West Coast brands were bringing more of the Chicano, White and Asian flavors while the East Coast brands brought more of the urban inspired styles and a Puerto Rican and Black flavor to the shows. Rarely did I see any conflicts or beefs. The energy at these shows was actually fresh, new, fun, and cool. Celebs, rock stars, and rappers were all over at these shows, some because they were looking for endorsements, some just to hang out and others because they were hired by or owned a piece of a brand. I can say however that even with all these urban giants, our booth was still one of the hypest and with one of the biggest crews. Las Vegas is much closer to California than New York, so we always had our B-boys, DJ's, and homies holding down and hyping up our spot.

Streetwear brands eventually began to pop up all over the place including Europe and Asia. They became a bit more digital, artsy, fashion, and much (much) less street. The definition began to change and we began to be looked at as too hard, too street, too ethnic, or maybe even too gangster for this new "streetwear." I really don't know what it was but once again the crispy clean fresh new definition of streetwear occasionally would try and exclude us even though we pioneered it, aint that about a bitch?

We pushed on regardless, born decades before them and now years later 95 percent of them are long gone. Streetwear magazines and blogs run by "experts" were popping up and never asked to include us or our lifestyle. They preferred just the fake ass shit they would generate for their whack ass images. Maybe it was because Tribal always represented with the sickest B-boy crew, dopest DJs, had some of the best graf artists in the world designing for us. Or maybe because we had some of the hottest bands and rap groups in the world rocking it. Maybe it was our A-list of tattooers and badass lowriders that we

were actually out on the streets and genuinely representing worldwide as we still do. Regardless, we're still here and it's odd to me that even to this day we are still at times occasionally considered to be too street or too who knows what for streetwear.

# TRIBAL IN EUROPE

Around the mid 1990s we began working with a company out of Hamburg Germany called Yukon. One of the owners, Steveo Spahr, was also very influential in moving our brand to Europe. We had dozens of accounts in Europe, but Yukon helped us with distribution and later a license deal that expanded into France and most of Europe. These European licensees and distributors allowed us to further expand the brand and our circle of artists who worked for Tribal. I think our first European trips were to Germany and Paris, then eventually we landed in the Netherlands and Spain. Overall, we did the most business out of Hamburg, Germany; Bordeaux, France; and later with a Company Called Urban Trends out of Amsterdam in the Netherlands.

When we first started in Europe, the style out there was more geared towards the East Coast flavor. It was hot and a lot of the urban brands from New York were killing it in the late 1990s and early 2000s. Europe was more into hip-hop and into brands like Karl Kani, Pelle pelle, FUBU, Rocawear, you know, more on the East Coast tip. It wasn't until later that we started seeing a West Coast direction out there. Europeans began getting into the West Coast style, images, and clothing. I feel we helped to expose southern California Chicano culture to them as well. We were different, our lifestyle, the Chicano element, and the tattoos were all different than what they had been exposed to before. Our diversity and street culture crossover is what I would consider a major contributor of what really helped Tribal internationally, so if a country wasn't into one thing, they were into another. We had them covered with credibility, a reality, we could back our shit up then and still can.

In the United States, it's kind of a little of everything but in other countries they tend to find their interest in one or more aspects of what Tribal represents. A great example is the Philippines, which is now one of our biggest markets in the world. The Filipinos are into rock 'n' roll and the tattoo aspect of Tribal and not so much of the other parts. Yet in Taiwan, they are still really into the hip-hop scene but are now trending toward the Chicano flavor and rock 'n' roll. The more I travel, I see a lot of the West Coast Chicano looks and styles becoming more desirable in Europe and of course in Asia, especially in Japan, where there has long been a strong love of the Chicano and West Coast lifestyle.

# A PHILOSOPHY OF RESPECT

One thing I hold true to not only Tribal, but myself, is that I believe in treating artists and people with respect and integrity. The moment you attempt to burn somebody or you don't treat them with the respect they deserve or you're not paying them what they deserve especially when you're making money, your name becomes trash. A lot of the business is word of mouth, and that definitely has a lot to do with how long you're able to survive in the business. Once you start to disrespect people and not pay people their worth, being unfair, or maybe your ego gets out of control, that's when people start to talk and your reputation goes south. I hold a lot of pride that I'm still on good terms with about 95 percent of the artists and musicians that Tribal has worked with over the last 35 years.

A big part of this philosophy is maintaining a respect for the individual's art, craft, or whatever it is they do. This is why I think Tribal was able to work with so many great artists over the years. Artists would say "Yeah I did graphics for Tribal and they paid and treated me well." It's through this word of mouth that our network of artists and contributors grew. So much of Tribal's growth happened over a beer, at a dinner table, a BBQ, a convention, or on the golf course. You have to bond with people and that's what the Tribal tours were about, connecting with people on a social level, and I'll tell you what, it's been a fun ass ride.

# SELLING OUT

We all need money and usually we want more than we actually need. However, remaining in that cool brand position as long as possible is a definite challenge. Turning down the large accounts and chain stores with those Big POs isn't easy, especially when you want that new ride or pad.

We understood this concept early on and figured out where we wanted to be and where we didn't want to see Tribal. We knew if we were going to remain cool we couldn't be in more than two stores in the mall and most definitely not in any of the major department store chains unless it was a high end one like Nordstrom (which we never landed nor attempted to). We also didn't want to be seen in swap meets or whack ass shops since we knew that would cheapen the brand.

I understand that some brands are all about the money and I can respect that. It's a business. They develop a business plan, create a strategy, a target market, and have financial obligations. It's the finance, marketing, and design that eventually determine your customer, placement, and longevity. Some brands

decide to cater to the lower income bracket and make it not only affordable for them but available where they shop, places like indoor swap meets, bodegas, mercados, and neighborhood spots. This is cool too and I understand it. Other brands intentions are to exploit a culture, flood the market, and sell to whomever, wherever, get paid and cash out. Besides when you sell like that a brand loses its coolness and desirability real quick. I guess it really depends on your goals and what you're in it for. Obviously we are all in it to get paid but some of us are also into it as a genuine form of expression and representation of a lifestyle or culture. We use our brand as clothing as our medium.

Over the past decade, I've seen several brands go from super cool, highly desirable and sought after to available at five to ten shops in the mall and every person that thinks they're cool rocking it. At this point, the core streetwear kid or person who wants to remain one step ahead is already looking for the next up and coming brand or look. Respectfully if these brands can hold on, grow, or prepare a proper exit strategy that pays, then more power to them. However if the brand is primarily in it for money and to exploit or misrepresents a culture or lifestyle that they don't live, support or contribute to, then I have no respect for them or their brand. I also have a problem with brands that lack originality and become over inspired by others. Originality is key, hammers are necessary and a genuine street presence is required.

What we wanted was for when a person wore Tribal clothing that he or she would get asked, "where'd you get that?" or "Do you know somebody down with Tribal." It wasn't cool when someone showed up to school or an event and had the exact same shirt on as somebody else, at least not for our customer. They mostly wanted to be on the edge, ahead, unique, and feel like they're a part of a movement that is REAL, genuine, and rooted in southern California that represented a lifestyle they lived or admired.

To be honest when I look back to the 1990s and the early 2000s and remember all the stacks of orders that we didn't ship because of our own mismanagement, I wonder if that actually hurt or helped us in the long run. By this I mean, maybe if we would have shipped them all we could have potentially flooded the market and lost our edge. I believe it's that edge that has helped us to last internationally like we have. I also think that making those decisions to not sell to Millers Outpost, Anchor Blue, etc. or to follow Tillys and their direction really helped us to protect ourselves and our image in southern California.

So there is a lingering question: what is selling out? A brand can exploit a culture and they can saturate the market. Both of these decisions may benefit

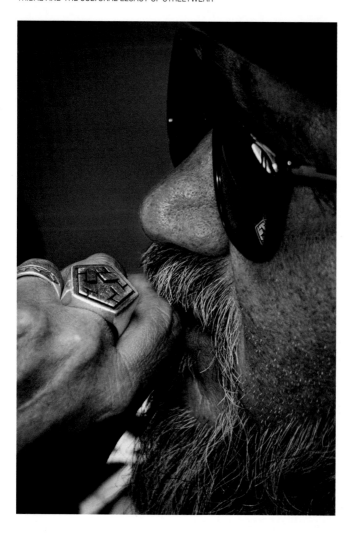

the brand in the short term but in the long term it points to their demise. I've seen both and I believe that I understand it better. There is no perfect formula to remaining cool and relevant while still being able to pay the bills. It's a careful balance of growing and not "selling out" on your ideals.

## SHARING TRIBAL WITH THE WORLD

In college, I studied photography, television, and film production, so I have always been interested in filmmaking. Skate videos from H Street and Powell Peralta were very popular in the subculture in the 1980s and 1990s and I saw an opportunity to do videos and dvd's that encompassed everything that I was living at Tribal. The first produced video was with a clumsy VHS camera and is

called "Peep the Techniques." The video featured B-boying, graffiti, tattoos, lowriders, rock 'n' roll, hip-hop, and of course skateboarding. Now 35 years later, if you look at the latest Tribal videos, we still feature and support the same elements.

When technology advanced and the Internet came to life, we developed our YouTube channel and eventually became active in our social networking. We've always supported those cultures featured in all our media and have lived and contributed to those lifestyles. The early videos were another way to share what we were curating in all of these areas and continues to this day in other formats. People always participated in the filming because they were just down to support based on the love and respect for what Tribal represented. The early videos were pretty basic but we were blowing people's minds because so many viewers had never seen lowriders and tattoos on video before, well at least on a very limited scale. We combined those two elements with hip-hop, skateboarding and the concept shined through. The realness of these films stood out. It wasn't staged or a paid for marketing campaign; it was the real lifestyle that we lived and these were the people that we associated with and that participate in it.

## THE GOOD ONES

Some people in business call them angels. They are usually someone that shares and understands your vision and appreciates your accomplishments up to that point. They are willing to join in the journey whole heartedly, contribute work and help with the most difficult parts of building the brand. Basically these people are a blessing outside of your blood family. They've somehow gravitated in your direction and you into theirs. I'm a strong believer in these good ones and could have not have accomplished as much without them. With this I'd like to mention Wilfred Siy as the one person besides the other contributers and family who has had my back and believed in the Tribal vison 110%.

If you are fortunate enough to have one of these good ones, do your best to recognize and appreciate it .

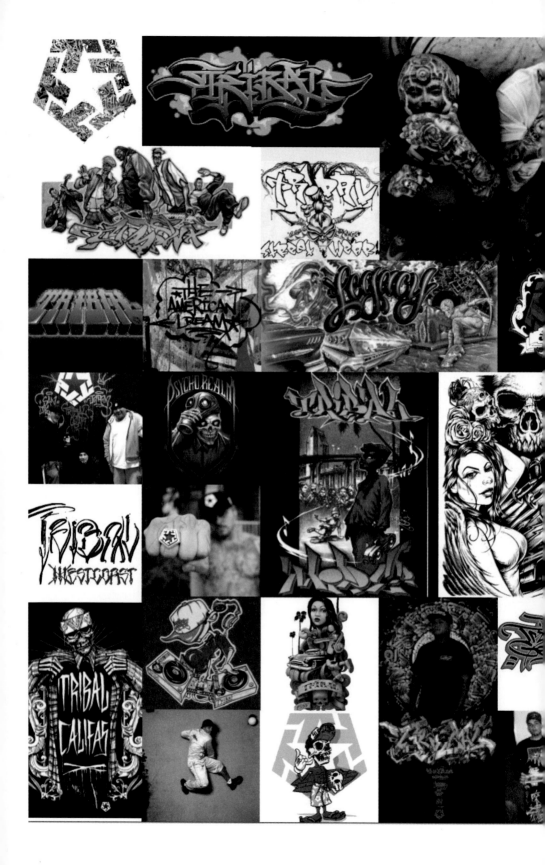

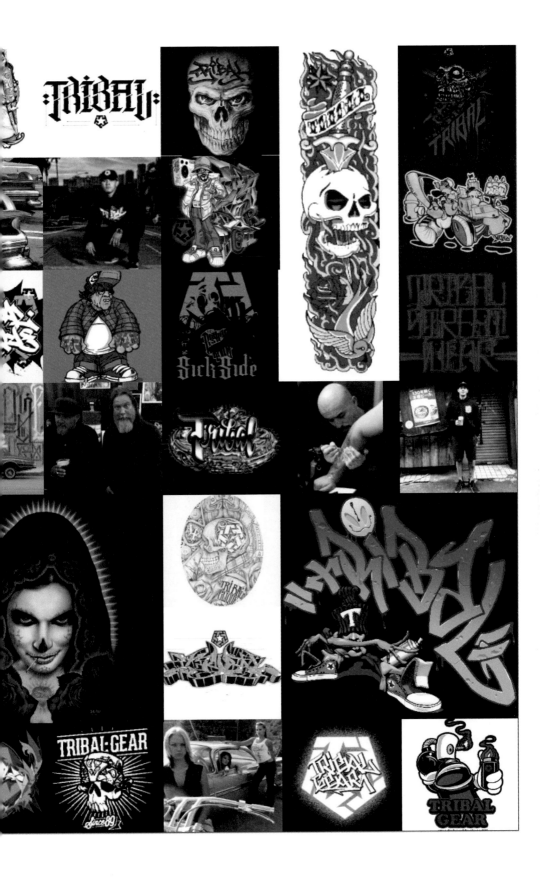

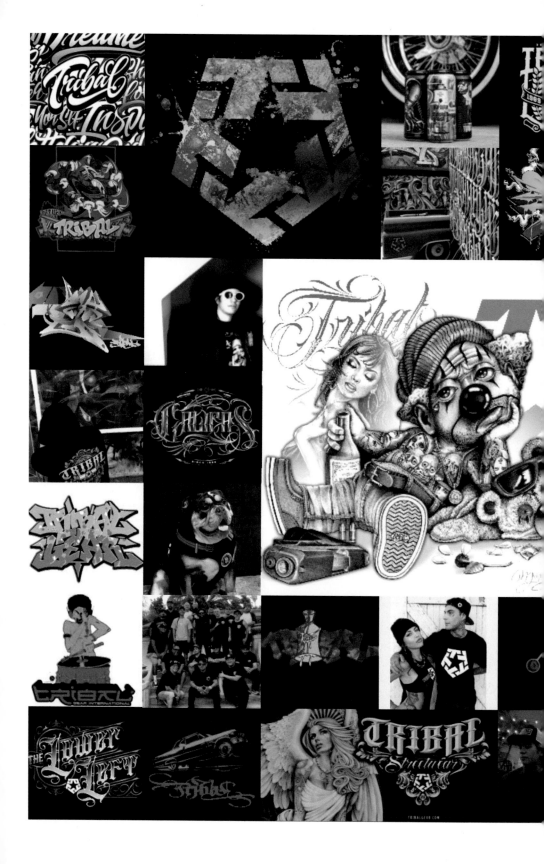

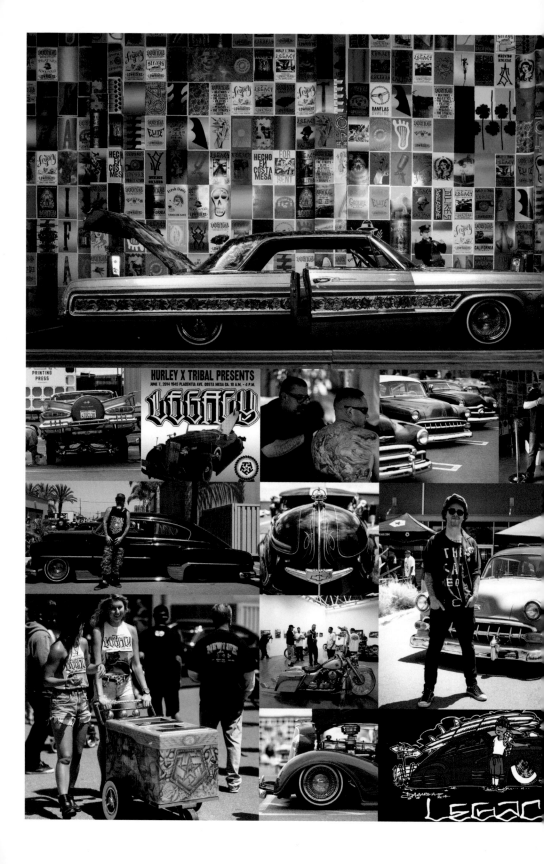

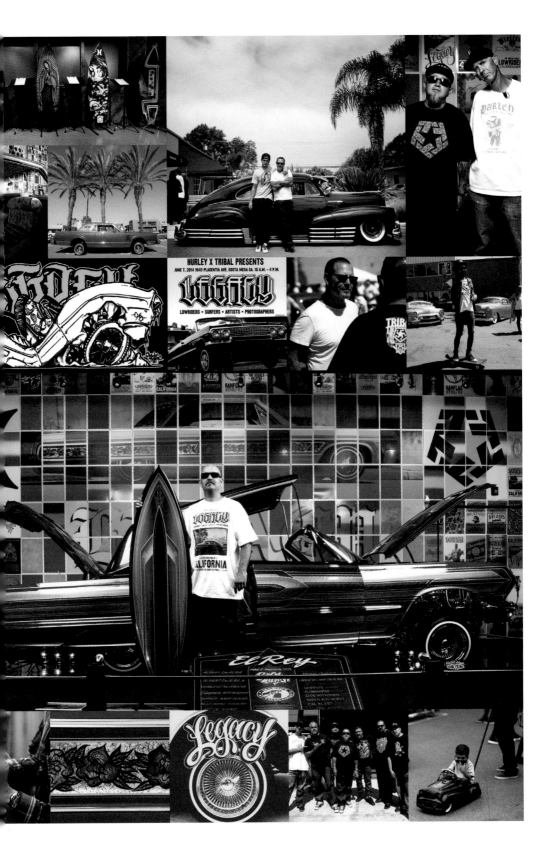

HURLEY X TRIBAL PRESENTS

JUNE 7, 2014 1945 PLACENTIA AVE. COSTA MESA CA. 10 A.M. - 4 P.M.

LEGACY

LOWRIDERS • SURFERS • ARTISTS • PHOTOGRAPHERS